# The Madwoman in the Academy

## 43 WOMEN BOLDLY TAKE ON THE IVORY TOWER

# The Madwoman in the Academy

## 43 WOMEN BOLDLY TAKE ON THE IVORY TOWER

*edited by Deborah Keahey and Deborah Schnitzer*

**Published by the University of Calgary Press**
2500 University Drive NW, Calgary, Alberta, Canada T2N 1N4
www.uofcpress.com

*National Library of Canada Cataloguing in Publication Data*
Main entry under title:

The madwoman in the academy : 43 women boldly take on the ivory tower /
edited by Deborah Keahey and Deborah Schnitzer.

Includes bibliographical references.
ISBN 1-55238-081-5

1. Women college teachers—Biography.  2. Women in education.
I. Keahey, Deborah Lou, 1961–  II. Schnitzer, Deborah
LB2332.3.M32 2003        378.1'2'082        C2003-910180-0

We acknowledge the financial support of the Government of Canada through the Book
Publishing Industry Development Program (BPIDP) for our publishing activities.

Printed and bound in Canada by Houghton Boston
∞This book is printed on acid-free paper.

Cover design by Sona Khosla; page design and typesetting by Mieka West.

*The authors wish to gratefully acknowledge the following: all the contributors to the volume for their courage and wisdom; Patty Hawkins for expertly and cheerfully preparing the typescript; the University of Calgary Press for its work in making these words public; and their families, Mendel, Zach, Ben, Michael, Rob, Robin, Erin, and Quinlan, for unwavering personal support and inspiration.*

# CONTENTS

# Introduction: Professional Girth

*Deborah Keahey and Deborah Schnitzer*

*Ste. Geneviève, Manitoba, and Winnipeg, Manitoba, October 2000*

DK:

*My two-month-old daughter, Erin, has just fallen asleep under her play gym, its dangling collection of mice and mirrors, rings and rattles falling silent. So I have half an hour or so, if I'm lucky, to work on this introduction …*

Like all my work, this project now has to fit into the schedule dictated by the newest member of the family, and like all my work, its importance has shifted for me in contradictory ways since her birth. It feels both more urgent, as the pressures of coordinating personal and professional demands mount, and entirely irrelevant, as most language-based action does when dealing with an irreducibly physical newborn. I hate that I have agreed to teach again this fall when she is still so small, too young to see her mother in these various distortions of what we call humanity, and I'm struggling to remember why I said "yes" to this insanity, again.

When I went back to teaching after my first daughter was born, I quickly realized I was not the super-woman I had always assumed I would be. I grew up with stories of my mother returning to teaching and performing within weeks after the births of each of her four children, and I was completely unprepared for the intensity of my daughter's need for me, and of my need for her. As someone who had rarely been sick, I was shocked to find myself with some sort of illness nearly every week, and blocked milk ducts were a frequent and painful reminder that I was always needed elsewhere. Five minutes before the end of every class my breasts would swell up and boomerang my thoughts back to the baby waiting for me.

At least technology now allows me to teach on-line courses from my home, so I've given up my public presence to be with my children, changed from real life person to cyberprof. Most days it is worth it, but I still feel the sting again each time the department brings in someone new to teach a course I once taught, and I wonder if there will ever be a place for me again "out there" if or when I decide to rejoin the world

of walking, talking academics. But at least this way I can nurse Erin in one arm while typing e-mail responses to students with the other hand. It's slow, but it works. Except, of course, when she nurses on the right side and I can't do a thing with my uncoordinated left hand so I sit, impatiently tapping my feet, waiting for her to finish eating so I can finish working.

*Oh, but she's waking up now, must run.*

DS:

I am the mother of grown, or almost grown sons. Ben, just turned twenty-one, has moved out, all the way to Vancouver. I have had to enlarge the interior of my mind, open up the western border that used to rest comfortably along Pembina Highway, the bus path Ben took from home to the University of Manitoba where he was doing a degree in music. I now take in the whole of the prairies and the Rocky Mountains, carving the route that connects me to Ben. My younger son, Zach, is seventeen, in his last year of high school, mostly self-sufficient, aware of the fact that he will usually find me in my study in front of a keyboard or a stack of papers. He knows the special way I pretend to listen to him, when I am really back inside the work I am trying to do. He forgives me the pretense, walks away, knowing, as well, that I will make room for a serious conversation before the night is out.

I have more time now, seemingly, but I am still pulled in directions that do not easily co-exist. They may appear to be different than before, as I enter, at fifty, the thirteenth year of full-time employment at the University of Winnipeg. I am not breast-feeding; I do not pick the boys up from after-school daycare. I don't spend half the night sewing Hallowe'en costumes and the other half consumed by the fact that both the costumes and the papers I've written with leftover time are dull and inadequate. But the conflicts, the conflictedness, remain the same.

The younger me would put the boys to bed as sternly as possible; the time between their bedtime and my morning class was crowded with things that had to get done. There was no room for a glass of water, a cough, a cry in the middle of the night. They sensed this and were extravagantly obedient and reliable. They could feel, perhaps, that I was on the brink of tears, overwhelmed by the fear that my performances, so heavily tracked by the possibility that tenure would be denied, could fray, collapse. They let me be the one to wake in the night and soothe myself with coffee and cigarettes, nurse the running nose and sore throat. I wonder at their patience and their generosity, for like many women who find their way into

academia, first through stipend and sessional work, then, perhaps, through tenure tracks dangerously narrowminded, I am burdened both by doubt and desire. Doubts about how I have learned to survive in settings driven by competitive, hierarchical modes of analysis and conduct that I find appalling and destructive. And desire held constant by an understanding of and belief in the creative and life-giving possibility that post-secondary learning can encourage and sustain.

Desire and doubt kept the younger me awake at night, writing papers about subjects I could barely comprehend, defending theses composed under duress and in between contractions. Desire and doubt keep the older me awake at night as well, wondering about my own integrity, for I am employed by a system that is elitist and self-serving. It is a system that ranks my productivity by measures I cannot endorse; that promotes research that is often deliberately inaccessible and is valued because its focus is compatible with a university-bred publishing industry that is closed and egocentric; that asks me to teach and knows that by and large I have no training and less incentive to improve my practice for, in fact, it is my research that will determine whether or not I perish; that puts me on a variety of task forces whose work is usually undone or forgotten from one year to the next. It is a system whose capacity to interrogate itself is fitful and uneven and whose commitment to "excellence" is often at odds with the principles of equality and accessibility that I would attempt to uphold in every other aspect of my daily life.

DK:

*Okay, Erin's settled into what we affectionately refer to as the "buzzer-butt," a bouncer chair with a battery-operated vibrator in the seat to substitute for a human knee or arms. I'm not proud, but I need the time.*

One of the first conversations Deborah Schnitzer and I ever shared was about how we had each managed to finish our dissertations while pregnant. There are many different ways in which the personal and professional can clash, and a nearly infinite number of configurations of craziness. We realized as we talked, though, that our pregnancy-dissertation stories functioned as fine, concrete metaphors for the female academic's situation as a whole, and for the deeply divided nature of so many of our lives.

In my case, after several years of lowly stipendiary teaching and after trying to conceive for over two years, I began to suspect I was pregnant shortly after receiving notice of my first genuine sessional contract position. A condition of the position was that I finally complete my PhD, which had been stalled part way

through the dissertation for longer than I care to remember, and so I made a vow to finish the last chapter by the end of the following month. I also decided to start smoking again in order to write the blasted thing (former smokers will know what I mean by this – I know one person who started smoking for the first time just to get his written). But I knew I shouldn't smoke and be pregnant at the same time, so I put off taking the pregnancy test until I finished the writing. After all, if I knew for sure I was pregnant I would have to quit smoking again, and who knows if I'd be able to finish the dissertation without that adrenaline-pumping poison?

It is impossible, of course, to explain the warped, hormonally and spiritually imbalanced logic of this decision after the fact. The truly odd thing, though, is that somehow, in the throes of combined graduate student compulsiveness and professional narrow-mindedness, I actually convinced myself that this was the best thing for the baby. Who could dispute the benefits of being born to a mother who had finished her degrees and had a steady job? (Perhaps only someone who has taught on stipends for many years can understand how an eight-month contract could appear "steady.") So I smoked for the first six weeks of my first daughter's life.

DS:

I remember being in what I consider to have been the tenth or eleventh month of my second pregnancy. We were living in Fisher River, a reserve in Manitoba's Interlake region, and I was trying desperately to finish the third chapter of my dissertation before Zachary's birth. Its focus was on Expressionism in verbal and visual art, and the emotional violence that accompanied many of the texts I was examining often erased the centre of gravity my growing shape required to go on. A standing egg, I was – ovalled and assailable. That oddness, combined with the million cigarettes I smoked as I stumbled from one sentence to the next, so compromised Zachary's well-being that I marvel at his emergence to this day. I was in an orbit that makes no sense to any except pregnant women trying to finish their dissertations.

My water broke in the early morning. There was an hour-long trip to make to the hospital in Arborg. Instead, I wrapped myself up in a number of towels and sat down at the kitchen table where I had done all my writing in between breakfast, lunch, and dinner and proceeded to complete the last section of chapter three. I didn't drip terribly much; my elder son Ben was still sleeping upstairs. I figured time was on my side. What kind of time would that be is the question that I ask now. At thirty-three, with a second child

on the way and a degree to finish within the seven- or eight-year gestation allotted by the university's calendar for humans in doctoral programs, I felt I was lucky to have this early morning slate clear. I had so primed myself for the end of chapter three, I could not comprehend the physical, outside-the-womb beginning of child number two.

Mendel, my husband (I used that word for him then), found me some time later, wrapped up in my usual obsession along with the towels and tried to persuade me into the car. I would not be moved. My friend Dorothy Lydia arrived to look after Ben. She pried me away from the kitchen table by agreeing to two conditions. First, I could go upstairs and make up Ben's bed perfectly; second, I could pack up the unfinished parts of chapter three and take them with me in the green bag I had used to transport research back and forth along the two-hundred-kilometre ride from Fisher River to the University of Manitoba library. With both conditions honoured, I settled into our Volkswagen Rabbit, bundled on one side by the green bag and in front by the womb that had formed, according to my state, as much desk as child. I even allowed Mendel to help me into the hospital, but only after he had shouldered both bags: the Daddy one that contained playing cards and lotion (we'd attended the early '80s version of prenatal classes) and the one that held what I still considered the most pressing actuality, the unfinished labour of chapter three.

We found Arborg and the nurse who managed the single room where everything took place. There were a number of new mothers, smiling and stretched, cradling little people who'd just entered the galaxy, and there was me, my womb, the green bag, and Mendel. He explained to the nurse what the green bag meant; she promised that I could get right back to the work as soon as I'd delivered. She was very calm and somewhat convincing; she stowed the bag under the bed. And then, in what seemed an instant, I awoke to the fact that, indeed, I was going to deliver a baby. Which I did. Two mighty contractions – Zachary wasn't willing to put up with much more.

The green bag? I did not harbour it nearly as carefully on the way home. It hovered, taunted, cajoled. I saw it out of the corner of my eye, as Zachary grew up in my lap. I trembled in its wake when the phone rang and my supervisor wondered at the elusiveness of chapter three. My green bag birthed a dissertation, finally, two years later. Zachary had learned to walk. I was still stumbling about, lit by cigarettes, on edge, as oddly configured by forms of labour that do battle to this day.

DK:

*Erin's in the windup swing. I stop every few sentences to give it a whirl, keep typing with one hand while the other turns the crank. I am handling this all just fine, I think.*

The English Department where we both teach has a regular Friday lunch meeting at which individuals take turns discussing their current research and pedagogical interests. Being troublemakers at heart, Deborah and I decided to subvert the solitary and disciplinary boundaries of the meetings by "hosting" one of the events together, to open a dialogue on conflicts between the personal and the professional for women in the academy. We told our pregnancy-dissertation stories and then outlined a number of "syndromes" that can be traced in some way to this basic conflict between the personal and the professional: the imposter syndrome, the superwoman syndrome, the control freak syndrome, the sessional track syndrome, and so on.

Every woman in the room had similar stories to share: of sick children during exams, of ignorant comments from professors and professional advisors, of concealing the news of pregnancy from graduate chairs out of fear of being passed over for fellowships, of being "dismissed" professionally when news of pregnancy was known, of travelling with children to conferences. Even the department secretary shared her observations of the various extreme and obsessive–compulsive habits of academic women. We laughed, we groaned, we rolled our eyes knowingly in empathy, and, most of all, we enjoyed the release of having a forum to share these stories, to give them a "legitimate" hearing, to acknowledge the commonality of our experiences and our collective "madness."

Not surprisingly, the responses to our presentation from the male members of the department dramatized the differences in how men and women perceive and experience their academic lives.

We knew we were onto something.

*This morning the back of my neck broke out in a bright red rash. And the damn crank is stuck …*

DS:

I love telling my green bag birthing story, but I also feel its illegitimacy within the academy. My sense of its authenticity, of the very real and overwhelming reality of the competing forces I struggle to accommodate,

is countered by other voices that have firmly established themselves inside my head. These are the voices that remind me of the women who are less conflicted than I, more securely in place within the tracks that have been laid down to measure professional girth. These are the voices of men who also talk about birthing stories, who resent what they see as women claiming rights to pressures that these men argue they feel just as intensely as they plot their careers. These are the voices that suggest that women who define versions of the madness Debbie and I were bringing to life in our stories simply aren't tough enough, smart enough, ambitious enough, bold enough. We all have names for that "not enough" space that undermines our belief in ourselves and our experience.

Debbie and I thought we could find a way for women to advocate for the complexity of their lives as they struggle with/in the academy. We thought about what a collection of stories like this might look like, sound like.

DK:

*Erin's father is home, walking the floor with her so I can finish this up while she slowly builds up to a wail …*

Although several books have appeared in recent years analyzing the academy's relationship to its female members, all of them do so within the confines of various disciplinary discourses endorsed by the academy itself. While we don't deny the oppositional value of this "scholarly" discourse, we believe there is also a paradoxical way in which it is often complicitous with that which it seeks to critique. Something happens in the process of translating the hallway conversations, the stories exchanged over coffee and conference registrations, that removes some of the energy, the vitality, the emotion, the directness. What was missing and needed in the publishing scene, we realized, was a forum for women to speak in a more personal way about these matters. And while we don't dispute that even the "creative" genres are heavily coded and convention-laden, we believe that the varieties of English that distinguish this collection deepen and extend the implications barely suggested by a more unilingual scholarly discourse.

Early in our search for a publisher willing to take on this project, we received a response from the (male) editor of a major academic publishing house who, after seeing a sample selection of the pieces, told us they could not consider publishing it. The problem was, apparently, that the collection would not have a large

enough audience because its tone was "too centred on complaint." Really! This is one of those needling little comments that one tries to forget, but that sticks under the skin like a splinter, nagging and festering.

Think about it. Or try not to. You'll see what we mean.

DS:

We chose the word "madness" for this project deliberately and carefully, reviewing its history in relation to women who have tried to dream and create by entering halls hallowed by patriarchy, women who insisted on the integrity of their multidimensional lives in academies that rendered that multidimensionality illegible and libellous. We felt the emotional and intellectual range the term could accommodate. We understood how often women have named the slope upon which they find themselves in this way, and we appreciated the contraries such a term might embrace: the defiance of unreasonable expectations and policies and the dependency upon those expectations and policies for definition and approval; the indignation and the acquiescence, resistance and internalization.

\* \* \* \* \*

*Prince George, B.C., and Winnipeg, Manitoba, May 2002*

As we approach the end of our long journey to gather submissions, edit, find a publisher, and edit some more, we are grateful to the University of Calgary Press for bravely sharing our belief that a forum is indeed needed for these "private" conversations about "professional" concerns. Because life-writing genres cross and blur academic boundaries concerning what may be said and how it may be said, we believe that the use of nontraditional writing forms by our contributors significantly strengthens the political critique offered by this collection.

The writings gathered here represent the voices of women ranging from graduate students to support staff to retired professors, affiliated with colleges and universities all across Canada. The points of view presented are informed by a wide range of factors such as age, background, experience, status, ideology, and

field of study, but all suggest, in their various ways, that much change is still needed before universities and colleges become healthy places for women to work and play.

We note with interest the predominance of entries written by women associated with English and the humanities in our collection, which directly reflects the disciplinary distribution of the submissions we received. This in turn may be accounted for, we believe, by two factors. First, the predominance of women working in those fields means there was a larger pool of potential contributors to draw from. Second, because the humanities in general tends to value personal expression more highly than some science departments or professional schools, there may have been greater willingness by women in those fields to engage in nontraditional discourse about their academic experiences.

It would have been exciting to have even greater diversity in the fields represented, but because the collection is unique in Canada we are hopeful that its publication will create a new conversational space enabling and encouraging more women – from all fields – to voice their experiences in the future. Significantly, the points of view developed by our individual contributors are not discipline-specific in their content. Life-writing genres by their very nature transcend disciplinary boundaries and are accessible, appealing, and relevant to both academics across fields and non-academic readers.

We also note with interest the predominance of motherhood-related issues in the submissions we received (only a fraction of which we were able to publish), which we believe is a direct reflection of the magnitude of these issues in the lives of women in academia. It is no secret that women's tendency to carry the role of primary caregiver is a major factor in any discussion of women's working lives, both inside and outside the academy.

Our collection makes no pretense of being a comprehensive catalogue or exhaustive index of issues faced by women in the academy, and we acknowledge that there are many interesting issues that are not discussed in an extended way by the contributors here. However, we are pleased that such a broad range of issues is in fact represented, including the impact of sexual abuse, racism, ageism, and cultural difference, and we are confident that every reader will find something in the volume that strikes them powerfully and personally. We often talk about what a second volume would do and invite people to e-mail us with their ideas at debbie@lifescapecoaching.com or debbieschnitzer@mts.net.

We are grateful to our contributors for their insight, intelligence, humour, creativity, and courage in sharing their experiences and ideas with us – and you – here. And we are grateful to each other for the mutual support to see this project through to completion. As we each dealt with the complexities of our own

lives and the challenges of working by long distance over the telephone and e-mail, there were many times when one or the other of us was about to topple, when it just seemed too much work on top of work on top of work on top of work. Inevitably, the other would step forward to brace us, and each time we reread the women's words printed here, they gave us renewed energy and conviction to get this book into the hands of every woman and man in or entering the tower. These conversations are ones we need to share in. Our voices will reverberate.

# MOVEMENT ONE

# Kate Rogers

## The Reign of Ice

This morning my students arrived late and out of breath
after pushing strollers through the snow to daycare. We all sit bleary-eyed
boots shedding slush on the grey broadloom.
No sun penetrates the storm swirling its white wings
across the window. The students thaw their hands
around steaming mugs
huddle into their coats. I am hungry for their dreams
of palm trees spreading feathered tails to the wind, golden drifts of sand.
But instead they want to talk about the news, to decipher its code of images and
rapid unknown words.
Jama says, "Montreal no power, yes?"
Zoya says, "Very bad weather – it is rain of ice?"
*The rain of ice,* I think. And so we talk about disaster.

D-I-S-A-S-T-E-R I spell it on the board – *no power* – *20 below*. I conjure
the moans of dying cows, the snap of frozen trees, shattering like glass.
But then I assure their bleak faces that donations are building mountains
of blankets and that the symphony played Mozart for all those bundled
into a Montreal shelter. I print S-H-E-L-T-E-R
then M-A-P-L-E-S for the broken trees, and point to the centre of our flag.

Some words are new but not the vocabulary of experience.
Maria's nephew died in the earthquake of '91 – Mexico City.
Jama lost three toes to a mine in Somalia.
Zoya says, "Chernobyl still disaster. No one can live there.
We were in park with babies, my friend and I. Old man ran
to us and told about accident. I thought – we can't see this – can be true –
this rain of needles? But I took my baby home to sit in house. Next day,

government trucks stopped in street. Bottles of wine and vodka poured out.
'Drink, drink men told, you will be well.' So, I and my husband, even baby –
drank and drank!" Zoya's laugh catches in her throat like something
swallowed wrong.

I do not understand – assume the liquor was to calm them all. But Zoya says,
"No no – for health!" Natan across the aisle – who never speaks – nods his head
and grins. I cannot grasp alcohol prescribed as medicine. Radiation
treated as bacteria?
"Your b-b-baby," I stutter …
"Okay!" she says. "Now he is healthy boy. But my friend stayed in park."

Now, with the present continuous, they bend to notebooks. Outside, snowflakes
glint silver – their atoms changing on the window glass. *Rain of ice*, I think.
The path to the bus stop will be dangerous.

# E-mail from Méira Cook

Subject: Our and your collaborative efforts
Date:       Mon, 5 Apr 1999 23:46:30 – 0700 (PDT)
From:      M. Cook
To:                 D. Keahey, D. Schnitzer

Dear Debbies,

Thank you so much for your lovely supportive e-mail. It came at just the right time too, because I was feeling very isolated in terms of university life. It seems that everyone I broke the happy news to here at UBC reacted as if I'd just committed a major career blunder and promptly stopped perceiving me as having any claim to an intellectual life. It was astonishing and a little scary and I think I'm still getting over the aftershocks.

Anyway, that brings me to the second part which is a huge brava for your "Madwoman" project. I think you have begun an important and enriching project, and one that will speak directly to so many women in the academy. I was so happy to receive the mailing and have taken the liberty of handing it out to women who I think might make interesting contributions. For my part – as you know – I have been thinking about some of the constructions of the female academic for a while now. This latest incarnation of "woman professor with a big belly and no brains" has thrown me a little, I must confess. I would love to write about it but feel that it is a little too fresh and raw at the moment. I would dearly love to have this particular experience subside into the "emotion recollected in tranquillity" category but alas, that takes time. So, while I applaud your project heartily, I won't be able to make a material contribution – but be assured that I couldn't be more supportive in every other way.

Am glad to hear Robin is thriving and completely understand your decision not to daycare her. Think of how much you'd be missing out if you went against your instincts just to satisfy some external idea of what an academic is. Anyway, should end off now but send warmest to you all,

Méira

# Day Cares

## Sharon Russell

Ian is standing spread-eagled in the doorway. His face bright red, tears streaming down his cheeks, his thin, three-year-old body determined not to let me pass. "No mommy, no mommy, no mommy," he chants over and over as I make my way toward the door and scoop him up in my arms once more.

"I'm sorry," I plead, "I have to go." His arms cling tightly around my neck as he sobs into my chest. I try to distract him. "Is that Blue's Clues on TV?" I ask brightly.

But it's no use; he clings tighter, sobbing, "Don't go." I know that it will be easier for everyone if I just leave. I pass him to his daycare giver. I have to pry his hands from my neck. I give Sarah, his twin sister, who is now entrenched in Blue's Clues, a quick kiss and back out of the door.

"See you soon," I promise, careful not to get so close that he can grab hold again.

I walk swiftly back to the car, my heart breaking. I tell myself that he'll stop crying moments after I leave, and that he will, eventually, have fun. As I start the engine, I check the clock in the car, confirming that I've spent too much time trying, in vain, to console him. Now very late for my first class, I hurry out of the driveway and onto the street. As a dark cloud of guilt settles over the car, I wonder if it's all worth it. Am I a bad mother for wanting a fulfilling career? Am I being selfish? I tell myself that I deserve to be happy, and I remind myself that my husband, Dave, who spends less time with the kids than I do, never feels guilty.

The drive to the college is familiar now. I drive by rote, barely paying attention to where I'm going. My body performs the necessary actions – stopping at red lights, signaling turns, watching for other traffic – and my mind wanders, considering the situation, mulling over the decisions, again and again.

Going back to school was a difficult choice. I had been working part time since the twins were nine months old, but my work schedule was stable. There was consistency and continuity in our week, and my salary covered the costs of daycare. Now as a student, my schedule changes every three to four months: it's inconsistent – two hours one morning, three hours the next afternoon, all day the day after that – and then homework outside of classes. We juggle care-giving options to cover the costs. Ian and Sarah spend two full days in their regular daycare: one day I attend classes and one day I work to pay for the two days of daycare. One afternoon I pick Dave up early from his job and he takes the kids home. On another day a friend comes in to watch them without charge, and on the final day they go to a babysitter who offers part-day rates. Financially, the juggling helps, but it's difficult for Ian and Sarah. They get attached to one caregiver and don't want to go to another. They're never sure what they will be doing on any given day, and they don't understand why mommy can't play with them as much as she used to.

While working, I was good at keeping my lives separate. When I left the office, I rarely thought about work issues until I returned the next day or after the weekend. My home time was focussed on the kids and other activities. Schoolwork, on the other hand, is insidious. It creeps into every activity and haunts me at all hours, sometimes even while I sleep. At times, I've even resorted to leaving the kids in front of the TV – something I'd sworn I'd never do – so I can work on an assignment. I try to make it up. I schedule time to take them to a playgroup, or to the park, or – to my husband's chagrin – I let them sneak into bed with me at night so we can cuddle.

I'm approaching the college. I make the final turn into the parkade, take a ticket stub, and find a parking spot near the stairway. I grab my bag and head toward the classroom. Momentarily, I consider stopping at the cafeteria for some tea, but decide I'd better wait until the break – I'm already late. I sneak into the classroom and take a seat by the door. The instructor is talking about a forum meeting that will be held later in the afternoon. I can't go: I have to pick the kids up by 2:30. I miss many of these extra activities – workshops, forums, meetings – because they fall outside of the regular class schedule, and I usually don't have time or money to arrange babysitting. I worry that I'm missing out on important information and networking opportunities, and some days I resent that loss.

Finally a break – a long one – my next class doesn't start for another two hours. I decide to spend the time researching in the library. As I walk across the concourse, I see another woman with a young boy, perhaps her son. He's clutching her hand tightly, wide-eyed, watching the people swarm through the college. I wonder how Ian and Sarah are doing at their daycare. Did Ian calm down after I left? Will they hate me for leaving them there? I shake off the guilt and pull open the library doors. I settle myself in front of a computer and begin searching databases for relevant material for an upcoming report. I click the mouse and pages of words appear on the screen in front of me. I scan through them quickly, struggling to comprehend them in relation to my assignment. The time passes quickly and I realize I had better leave or I won't have time for lunch before class.

I meet up with some classmates in the cafeteria; we gripe about our assignments and the amount of time we spend on them. Most of the students in the class are women, and we compare how our lives have changed since going back to school. During these discussions, I often feel grateful, and somewhat guilty, that my husband has been so supportive and helpful around the house. We have always shared household chores and caring for the kids. When I was dissatisfied with my job and career, he was the one who encouraged me to go back to school. Even so, I can't help noticing how now, three months into the semester, the laundry is piling up, the dishes don't get washed on a regular basis, and the floors have not been vacuumed in weeks. Dave has been in a funk for the last month: moping in front of the television, snapping at Ian and Sarah, and complaining about the tension in his neck and back. He says it doesn't have anything to do with me, but I'm conscious of how these symptoms have escalated in direct proportion to how busy I have been with homework. I am also keenly aware of the pressure he is under now that I don't have an income.

Our break is almost over. We gather our belongings and walk back to the classroom. We are due to hand

in an assignment today. I finished it late last night and am not confident of its quality. The instructor reviewed the criteria for the assignment during the last class, but I missed the class because Ian had a cold and wasn't allowed to attend daycare. I got the notes from a classmate but still feel uncomfortable that I missed a critical comment that wasn't written down. Three year olds get a lot of colds. Every time I hear a sneeze, a sniffle, or a cough, I worry that the daycare won't allow them to attend and I'll miss another school day. I was less concerned about missing time when I was working. If I took a sick day, everything waited for me. I could reschedule meetings, postpone reports or work from home, if necessary, and it was relatively easy to catch up when I got back to work. School, on the other hand, keeps marching onward without me. I can't postpone a lecture, and if I miss important information about an assignment or a test, my GPA suffers.

The class is coming to an end. I hand in the assignment with resignation and relief: it's beyond my control now. This is my last class for the day. I return to the car and leave the parkade. Driving away from the college, my thoughts return to Ian and Sarah. I worry about the long-term effects of juggling daycare options while I'm in school. How many years will they spend in therapy to recover? I tell myself that it is better for them to have a mother who is happy than it is to have one who begrudgingly stays home with them. I also remind myself that the quality of the time we have together is better after I spend some time away from them doing things for myself. But I only half believe these things.

I arrive at their daycare and pull into the driveway feeling somewhat anxious. As I walk up the steps to the door, I hear the kids playing.

I hear someone barking, "Woof, woof, woof."

Then another tiny, booming voice commanding, "Sit!" More barking and then the voices break out in laughter and I hear some raucous jumping and running. I knock on the door. It swings open and the game stops.

"It's mommy!" they shout in unison and come running toward me. I squat down and they leap onto my lap, knocking me to the floor.

"We were being doggies," Sarah excitedly informs me.

"And I made a craft," Ian shouts with delight as he climbs on a chair to reach the construction paper card. Someone has traced his hand onto the front and he has coloured it with markers and glued stickers all over it. "Let's take it home and show daddy," he suggests. Their daycare provider assures me that he was only upset for five minutes after I left and that the rest of the day went smoothly.

"Did you have a good day?" I ask as I buckle them into their car seats.

"Yeah," sighs Sarah tilting her head and nodding. Ian considers the question with a serious look on his face. He furrows his brow, puckers his lips, and taps his cheek lightly with his index finger – his thinking pose.

"I didn't like having a nap," he states, and then, wrinkling his nose and curling his lips into a look of utter disgust, he announces, "I don't want to go anymore."

# C. Celeste Sulliman

## (M)othering in the Academy

Within the definition of masculine academe, my career path has not been traditional. After much encouragement from a rare female mentor in my undergraduate program, I completed my master's degree. I worked/taught as a sessional at a small university college, during which time I gave birth to my two sons. There was no maternity leave policy in place for full-timers, let alone part-timers. My research was sporadic; finding research time, a workspace, and funding was very difficult. Routinely officeless, I managed class preparation, grading, student meetings, and research in the university library or in my kitchen. Mary Daly and Mary Poppins sat side by side on my library shelf.

After a number of years working with limited term and part-time contracts, I successfully competed for and was awarded a tenure-track position. I made an informal commitment to the university administration and my department to complete my doctorate as soon as possible. Anxious, I began a doctoral program but interrupted my studies because my sons were just too young; I needed to give them time and attention and I was not able to work with them around.

I am now working on my doctorate at the University of Calgary, wavering between folding laundry, going for a hike with my sons, and working on this paper. I experience the constant dialectic between being a mother and an academic. My identity is wrapped up in both roles, yet each role demands so much of my energy and me.

The problem I describe affects deeply the lives of women in the university setting. For example, in exploring the career paths of women in the academy, Paula Kaplan notes that the academic clock was created without consideration for the fact that the life season in which faculty are usually required to work hardest to display their abilities is the very time when women are most likely to become mothers. Set to the male's life cycle, this clock makes it much easier for a man who has a female partner fulfilling traditional roles. How much easier my life would be if only I had a wife!

Like me, many women in academia begin their teaching careers as part-time or full-time sessionals. Many more stay in those positions their entire work life. While our numbers in academia are growing, women do not follow the "standard" career path of doctoral studies, entry status, tenure, and promotion. Combined with the impediments in hiring practices, many of us have experienced harassment, discrimination, injustice, and family constraints, variables which compel us to rethink our decisions to stay in the academy. While initially we may be fooled by what Jacqueline Stalker and Susan Prentice call the "illusion of inclusion," we increasingly recognize the need to establish and foster a culture that includes modified workloads and responsibilities, and an acceptance of women's realities.

Many academics consider the body of knowledge relating to women's lived experience "unscholarly." As a result, research on issues like motherhood, breast-feeding, and childcare, for example, are often underresearched and underfunded. My own application for funding for breast-feeding research was scrutinized at a university-level funding committee. The nearly all-male committee had difficulty seeing the value of the research on women's experiences of breast-feeding, calling it "un-intellectual" and "a waste of time."

There are a number of ways we might warm the academic climate to make the university a more hospitable place for women faculty and students. Adequate childcare, flexible career paths, longer tenure tracks, and job-sharing need to be part of the institution's way of life. I can no longer try to fit into a predominantly male culture. We need to redefine who the institution should serve. In order to humanize the system we need to feminize it.

When I was eight months pregnant with my second child, the dean of my school telephoned in August to offer me a teaching contract for the year. The person who was supposed to teach several communication courses had decided not to accept the term contract offered, and at the last minute, the dean contacted me. I pointed out to him that I was very near my delivery date (although that was painfully obvious) and that I would have to take some time off during the semester to give birth. After some negotiation, I agreed to a one-year contract. Three weeks into the semester I gave birth to my son via an emergency Caesarean section, which thwarted my plan to "squat, give birth and go back to the rice field," as my colleagues and I demeaningly joked I would do. Subsequently, I taught the course with the aid of a teaching assistant for six weeks, taking Bryan to school in a Snuggly and breast-feeding on demand. As part of my negotiation, I secured an office space on campus. A student would sit with Bryan in my office, which became a makeshift nursery, and he became part of the regular flow of my personal/professional day. Go to campus, nurse, teach class, rock the baby, nurse, meet with students, nurse, attend meetings, nurse, go home, grade papers, read to the boys … and so it went for several months.

My lived experience is full of attempts to narrow the gap that keeps the domestic mother "private" and the academic scholar "public." Some of the experiences are damaging and debilitating: snide remarks from a faculty member (male) who thought it was disruptive to have a baby attend a school meeting; another who thought it "brazen" (his word) that I would breast-feed at work; the cool response from several committee members when I did not agree to a Saturday morning meeting time. (I could go on.) Other experiences are encouraging and empowering. For example, when a pregnant colleague who was teaching part-time asked how I managed to juggle the baby, the nursing, the academic work, and the attitudes, I offered encouragement and support. Subsequently, she too returned to work shortly after her son was born, taking her baby with her.

Bringing my children to work with me is a political statement, an act of resistance. By advancing mothering experiences and qualities, by blurring the lines between what is permissible and unsuitable in the workplace, the situation becomes easier since I do not have to fragment my life, keeping significant portions of it hidden away from public view. While I still struggle with the dissenting commentary and

unfavourable impressions, I do not regret the choice. For me, the greatest reward is the intimate relationship with my children. As Hillary Land reminds us, "One cannot stop *being* a mother." You embody the experience.

## Works Cited and Consulted

Dunlop, R. "Written on the Body." *Redefining Motherhood: Changing Identities and Patterns*. Eds. Sharon Abbey and Andrea O'Reilly. Toronto: Second Story Press, c 1998, 103–24.

Everest, M. B. *Where the Word Breaks Off: Voice of the Mother/Writer/Academic*. PhD dissertation, University of Calgary, 1996.

Grumet, M. *Bittermilk: Women and Teaching*. Amherst, MA: University of Massachusetts Press, 1988.

Imray, L., and Middleton, A. "Public and Private: Marking the Boundaries." *The Public and the Private*. Ed. E. Gamarnikow. London: Heinemann, 1983. 12–27.

Kaplan, P. *Lifting a Ton of Feathers: A Women's Guide to Surviving in the Academic World*. Toronto: University of Toronto Press, 1993.

Land, H. "Girls Can't Be Professors, Mummy." *Balancing Acts: On Being a Mother*. Ed. K. Gieve. London: Vertigo Press, 1989. 73–93.

Martin, J. R. *Changing the Educational Landscape: Philosophy, Women, and Curriculum*. New York: Routledge, 1994.

Stalker, J., and Prentice, S. *The Illusion of Inclusion: Women in Post-secondary Education*. Halifax, NS: Fernwood, 1998.

# Mother as Prometheus

## Monika Lee

Here is a tale of a cycle on the wheel of fortune, of rise and fall in which the tragic flaw is a love of children, the hubris a desire to be the best possible mother. When I was an undergraduate at the University of Toronto, no one would have suspected I was a tragic hero. I was fuelled by a passion for studying poetry, especially the English Romantic poets: I won a Gold Medal, numerous awards, and a scholarship. Shelley's "Prometheus Unbound" was the focus of my master's thesis. I imagined myself as a female Prometheus stealing the gifts of language and fire from the gods. My interest in Prometheus proved prophetic of the years ahead in ways I could not have foretold. Prometheus gave the gifts of knowledge and language to beings considered undeserving of such attention, evoking the punishment of the gods of Mount Olympus. When I took these same gifts and gave them to my children rather than to the scholarly community, I enacted an analogous rebellion. Like Prometheus, I would suffer as a result of my apostasy and would never regret either the rebellion or the suffering.

Throughout the ascent on the wheel of fortune (through master's and doctoral programs), my achievements were recognized and praised with many more scholarships and honours, but these paled beside the excitement I experienced through literature and criticism, writing and teaching. After my wedding and the news of a post-doctoral fellowship at Cornell University, my first thought was "Great! Now I can have a baby." My stock was high on the academic market but was about to begin its descent. It is now hard to identify with that early stage of Promethean exuberance and invincibility. I remember my children and their milestones so much more clearly.

The happiest moment of my life was when Anna was born. At the same time, however, the conflict between my all-consuming desire to be with her and my passion for studying literature was also born.

## mother as prof

i dedicate myself to the preservation of our love,
even though I sit, pores clogged
with scraps of IBM and dust,
so adverse to the tactile brightness of your shine,
leaving me bereft of your fleshy stock.

once submerged in a reciprocity so vital to our being,
now propped and dangling on the knocked knees of
                                              culture,
straining for a dagger-hewn piece of action,
separating me … oh, aching … from wordless, infans …

understand that these are the wordy weeds
that form the garden of my psyche.
without them I am no more me
than are you you without thunky thighs
and seventeen solid and delectable pounds.

As Anna grew and our bond intensified, academia was certainly losing the competition for my energies. Then I landed a job interview at the University of Toronto. I brought my nursing baby to the campus (to the consternation of the department chair) and a pitiful performance on my part bought me more time. Ambivalence grew to the point that I held back crucial documents from a dossier sent to the University of Waterloo, including some strong letters from well-known scholars. At the interview I was more detached than at Toronto, and I almost found the slow and painful death of my ambition amusing to witness.

By the time little Natasha was born and McGill wanted to interview me, I politely declined the interview over the phone. I had chosen the rock on which I was bound, and I knew who had the power to unbind me.

## routine

today the morning light awoke my flesh
supple and boneless as a kitten's;
before noon shoulds and oughts had pulled it taut –
a soundless fiddle string.

> i waggle and flounder among crumpled lists
> and gaunt bits of paper,
> while Tasha, playing kitten on a rug,
> wonders why Mama, string-tight,
> won't let a catlike fiddler play music on her
> all day long.

Letting go of the past and its ambitions is disorienting and painful. Following what I conceive as my higher duty seems a noble enough calling for my heroic cast of mind. The sinister thing is the knowledge that, after a few years such as these, Mount Olympus is off limits. The gods of academia are very jealous of their territory, and defection is an unforgivable offense. At Brescia College, I teach one course each year. Once a member of the sessional ghetto, one is generally expected to stay in that ghetto. Around me are many others: talented, well-published, committed sessional professors, most of them mothers, often married to tenured faculty. Most people assume that we are second-rate.

I write poems, since poetry complements my chaotic and creative life as a mother in ways that scholarly prose does not.

### living room

> let those who choose to, run the world,
> while i fathom and breathe small rushes of joy.
>
> (in any case)
> poems cannot be written in a windowless computer room,
>
> yet verse flows plainly across an untidy shag
> threading its way through the
> tangled rocking horse mane
> and overtop the crumpled flannelette cows.
>
> garlic skins, bespeaking a creative presence,
> have fallen confetti-like in our midst,
> while the antique horse (bless him)
>
> has no use for oats,
> and the toy kitchen has no need for plumbing.

So Mount Olympus fades into the mist and the tenure-stream world with it, and I am liberated by my children into a new language and freedom. I have no regrets but many worries. We are bringing daughters into a world unforgiving of and unaccommodating to mothers. The care and nurture of small children is a contractually limited appointment too. When the contract ends, what will we … they … become?

# Monika B. Hilder
## This Three-Horned Bronco of a Life

### In the Darkness

Mad? Me?! Was that MAD as in Mothers Are Damned fools to also teach and write? Or was that Mothers Are Doomed to dabble, never swim in the waters of academe/publishing? Or Mothers Are Discouraged by so many blocks to their professional aspirations? Or just the plain and simple obvious that Mothers Are Doormats, too busy serving to achieve anything?

Mad? Me?! Do you mean to suggest that somewhere underneath this calm, friendly professional demeanour (add charming, inspirational, enthusiastic – I really do love the mothering–teaching–writing triad, don't you know?), that underneath all this seethes a raging madwoman? A woman whose song jars with and jangles against the sanguinely successful voices ringing from the ivory tower? Do I look, sound like a stark-raving Fury? Are you daring to imply I am the elliptical wheel that wobbles woefully alongside, and often far behind, the suave round ones? (Comparisons are odious; I only wish the battlefield did not consist of them.) Now if you're thinking I'm "hormonal," you've got this much right: if I weren't "hormonal," wondrous female, there's no way in any arena that I could ride this three-horned bronco.

Mad? Me?! You bet I'm mad – disappointed, frustrated, feeling guilty, and alternately fiercely angry that I am able to do so little with words while I engage in the whirligig of family details. I am not always so disgruntled, but sufficiently so to answer your question in the affirmative.

Around this point you might be hoping I'll turn out to be a comedian and that this act of writing will make you laugh. Perhaps it will. That is one of my sincere hopes. I laugh an awful lot myself. Make that awe-full as well. But this is no comedy act of my design – all right, I will allow for your suggestion that this smacks of the supremacy of divine irony. Just don't ask me to be thankful in the next breath; I might hyperventilate and what would anyone have gained? The dirty (or blessed) reality, of course, is that the energy I could have put into full-time teaching and/or writing, I am giving to my family.

Oh I had a "real" job once, a full-time teaching position with a continuing contract and full benefits, but after our second child was born, I gave it up. Today I teach part-time and am having a blast, but

without clear career prospects and weightier rewards. I am also a publishing writer – articles, fiction, poetry, drama – but to date I write far less than I want to. I hope this will improve as my children get older. I answer frustrations with details like this summer's royalty check, which paid for half a mountain bike. It's something, anyway. With three elementary school age children, the youngest just now having begun kindergarten, the bulk of my time and energy is still spent on mothering. To boot, I did and do this of my own volition, freely, no less, and hereby declare that I am still, for long stretches of any given day, sane.

Mad? Me?! When I was young I had the hubris to reject the position that a woman must choose between books (teaching and writing them) and babies. (Isn't it ironic that this either/or dilemma is presented by many camps: the misogynists, the kindliest patriarchs and matriarchs, the feminists?) I still reject this position. I still want it all: books and babies. But sometimes I feel crazy with the competing demands on my person. I grow furious with the helpless feeling that I am going too slowly along the journey of teaching and writing literature. In part I wrestle with jealousy and a sense of failure as I see others do what I have not yet done. It's hard to overhear those many voices preaching, "See, we told you it couldn't be done, so why are you trying? Are you different from anybody else?" As Ursula K. Le Guin insists, "This refusal to allow both creation and procreation to women is cruelly wasteful: not only has it impoverished our literature by banning the housewives, but it has caused unbearable personal pain and self-mutilation: Woolf, obeying the wise doctors who said she must not bear a child; Plath, who put glasses of milk by her kids' beds and then put her head in the oven" (809).

People whose simple arithmetic was superior to mine knew before they became parents what I am still learning. There's the celebrated writer who said something like this: "First I became an author (read, 'successfully famous'), then I had one child." Smug, huh? Then there's a teacher/writer who said that having his one child cost him one book, but he was willing to live with that. One child. One unwritten book. My brain buzzed with mathematical possibilities. With my three children, how many of my potential books were never born? Meanwhile my mathematical skills have since accelerated to recognize the concept of the exponential. Having a second child, then a third, I learned, did not mean I was simply adding another person, then one more. The truth is that this threefold combustion is frighteningly explosive. The noise, the mess, the constraints, the emotional battles, the monumental work (I know I'm leaving stuff out, but I have forgotten what it is) – these are all draining to the nth degree. Home is an exponential energy drain. In the office I joke, "Hey! I come to work to relax."

So I fume that mothering shouldn't be this hard. (Make that fathering too, but this is my story.) I used to think that the ominous decree unto the woman – "in sorrow thou shalt bring forth children" – meant the dastardly details of birthing. With peculiar brilliance a poet has penned birthing as a crucifixion. But this initial crucifixion is only the dramatic initiation to what follows. After I got through the dastardly birthing, thrice, I found that those hours of intermittent tribulation are nothing (nothing!) in comparison to the sword in your heart that accompanies raising the blessed buggers. My mothering life is a crucible. (Or was that my threefold choice? Three wanted children, add teaching and writing. My life is defined by triads within triads. Mea culpa, mea maxima culpa!) Pain characterizes too much of this fleeting lifespan I have in which to raise my beautiful beasts. I would die for them (birthing does prove that, for starters). The immediate fact, though, is that I am dying daily in just trying to live with them.

So my teaching/writing aspirations are daily crucified to the needs and nonsense of my dear ones three. "Oh where, oh where did all my words go?" cries this "mad" woman who looks like me. "When and how and with what am I supposed to smithy words when I am bombarded with missiles like 'I need a band-aid!' 'You're so mean!' 'It's your fault!' 'I won't!' 'I don't care!' 'NO!' 'Where is it?' 'Well maybe I AM?' 'Stop pestering me!' 'I have homework – I meant I wasn't going to do my homework yesterday!' 'NO-OOOOO!'"

Pain. Darkness. Death to dreams.

## In the Dawn's Widening Light

By now you might be wondering if I have anything but a morbid view of this triad life. Yesterday, energy expiring, jaded, I wasn't so sure myself. But with the dawn's light, the darkness of depletion and discouragement fled, I arise with restored strength and hope. I have this perniciously whimsical faith that somehow – though slipping most precariously, white-knuckled grip, dirt flying in my face – somehow I will ride out my span on this bucking beast, still in the saddle when the bell rings.

Last night one of my computer-adept daughters snooped into this draft and, upon reading the paragraph on nastier things they say, roundly declared, "We don't say those things!" I held my tongue. This morning I think, "Well dears, you do say them, ever too much lately, but these things too shall pass (when?)." At this moment I am not grinding my teeth and am rather enjoying myself. At this hour I am considering instead the inverse economy where giving up the "brilliant career" results in getting much wealth of another sort. So today I will celebrate these wondrous things my three miracles have gifted me with – and remember that this brightness does penetrate and permeate the darkness. The dawn's light, so faint at first, proves to be, in the words of poet Myrna Reid Grant, a "widening light" (7). The power of this widening light is such that the darkness of the journey has not yet overcome it.

My Miracles Three, what travelling mercies they have gifted me with. The tender gift of being needed by a helpless newborn. The cooing giggles of toddlers. Great smacking kisses and nigh rib-cracking bear hugs. Virtuoso stuffed animal sagas. Paintings that astound, some of which we have framed. Written stories that enchant (the teacher calls me up on Saturday night, no less, to read a story over the phone to me). Unbelievable blasts from the French horn the first time my child holds the thing (I still can't get the knack of it). Angelic voices soaring in song (right after that yelling – whoops, I said I was going to concentrate on the good stuff now). Laughter that bubbles through our rooms and garden like diamonds slipping through a cascading brook. Resilience that responds to the locked bathroom door, the one with nobody on the other side, with "No problem! I know how to open it, Mom!" Alertness and chutzpah as my child first shaves a strip off of a Popsicle stick and pries that into the lock, then accepts the bamboo barbecue skewer I hand her and fiddles with it until the lock pops open. Tada!

Then there's the homespun creativity that allows me to fashion the lamb birthday cake I had no idea I could make. (What? You want a train cake? A zebra? A lion?) I've learned about how black curled Twizzlers licorice change themselves into hooves, tail, ears and face, how coconut becomes wool, how jelly beans mean pizzazz – and how all this creates jubilation in the hearts of nine-year-olds. Now I

could have spent three hours writing instead – or marking papers. But I didn't want to write a story or teach the next class without first having made the cake. Partly because I believe having made the cake will make for a better story and better class discussion, but mainly because I think some birthday magic will mean infinitely more to my child than another publishable or lecturing achievement of her mother's. Joy shared and multiplied means more to me than single-minded career success. And it's this joyous celebration of the extraordinary ordinary that I bring right back into the classroom and onto the printed page.

Then there are stretchers like "Does heaven have a deep end?" The ever-ready "But WHY?" (And my university students think I challenge them with WHY questions.) Wisdom that announces, "A sad face is an upside down face. A happy face is an upright one." Cheer that declares, "You're beautiful!" Indignation that insists, "Why aren't they publishing your story? Those editors are crazy! Kids would love that story!" Those glorious hiatuses from busyness (career and otherwise) so that I can enter the magic of my child flying on the tire swing until she jiggles free the appley blossom snow to drift down over her: sweet petals waft through the warming afternoon breeze, opening chambers of the mind and heart, filling me with bright, white hope. And there is infinitely more that I cannot even articulate for myself. Oh yes, this three-horned bucking bronco offers a most wonderful ride!

You see, my triad life is, in my husband's phrase, "a composite calling." All the parts interconnect and are integral to the whole. Hence, life is so kaleidoscopic that I know no boredom. I am so involved in my children's lives – school field trips, skating on "days off," guitar-playing for Pioneer groups, et al. – that a lot of people who rub shoulders with me daily have no idea that I teach half-time at the university. I can fly off to give a paper in Michigan and still come home to nurse my youngest (that was tricky but we managed). As a bone-weary new mother the morning star shining in my window becomes an epiphany that shapes itself into a poem, "The Royal Harbinger." My research and teaching interests in the child-saviour theme in children's and fantasy literature and how that relates to spirituality, feminism, and right-brain intuition is born out of life before kids and, especially, is enriched by life with kids. And then the children do say the pithiest things that invariably blurt their way into lectures so that students are both cheered and further challenged by the text.

There is much that is marvelous about having one's serene adult world of intellectual and creative endeavour dynamited by children. Instead of living in pursuit of individual success and pleasure, I'm forced to fight for every wordscape I wish to fashion. I run this race with not a few hounds of hell on my tail, all yelling, "We'll get her! We'll get her! Whoops – shit, we missed! Never mind, keep after her! She's bound to run out of steam!" I must run with the wind. Walk on water more than once. Stretch as if I were elastic incarnate. Focus until the paper catches fire. All this makes for wordscapes worth painting.

The journey is rich – and then it gets richer. So much of what I am – and now think and teach and write – I could not do without having had children. (That doesn't mean somebody else couldn't do it; it simply means I couldn't do it.) I whine, but the truth is that I wouldn't trade this triad life for anything. To ride this three-horned beast for even a few seconds is an extraordinary privilege. In the words of Ursula Le Guin, "Babies eat books. But they spit out wads of them that can be taped back together;

and they are only babies for a couple of years, while writers live for decades; and it is terrible, but not very terrible" (812).

Mad? Me?! Yes, I'm MAD alright. I am all those things I spouted off in the darkness. But I am all these terrific things this new day's light reveals as well. And now what difference do I and all the mothers like me make?

I could not say that I have particularly influenced the shape of the institutions I have served, past and present. It is true, they are empathetic and have ensured that my timetabling does not run amok. Importantly, this makes the books (the teaching and the writing of them) and babies equation a possibility. The key thing here is the affirmation these institutions give the madwoman by providing her with a forum to speak. Just as key is the courage with which the madwoman brings her whole self into the classroom. (Yes, mothers can still think. Yes, mothers make some mark in the academy. And yes, the mothering experience even adds to the depth of analysis. All this is encouraging to students of both genders.) In a pleasant partnership of opportunity and mutual affirmation then, both the madwoman and her institution allow her "mad" gifts to flourish. This freedom of speech and the sense of her gifts-and-burdens making some difference matter so much.

And with this voice let me venture some better definitions for MAD. How about Mothers Are Determined? We've got the intestinal fortitude to do so much; we have no choice. Or Mothers Are Daring? We dare to tread where others cannot, will not. Or Mothers Are Dynamo? We are charged with energy; out of necessity we convert energy into current, we mere vessels convey tremendous power. Or Mothers Are Dreamers? We attempt "impossible" things and sometimes they work. May more of our dreams come true. And this one, borrowed from C. S. Lewis's title *The Voyage of the Dawntreader*, is my favourite: Mothers Are Dawntreaders. We are dawntreaders because as we live out our composite callings we are, without being boastful, charting new waters in ways many mothers of the past could not. These waters may not be better but they are ours. And these waters we chart, like all the waters of the past, are filled with sea monsters, frightening islands, unknown sea-people, and are subject to violent weather. But as we sail steadily toward the east, the darkness inevitably bows before the dawn. It must, it shall.

Mad? Me?! Yes, yes, a resounding yes! I'm riding this three-horned bronco of a life with all my might, dust-caked and with tears in my eyes. But you know what? Call it rodeo madness, but I don't think I really want to tame my bronco after all. Instead, I'll be happy to plunge her into the water until she treads white foam. She/I must become dawntreaders. (I wonder now, do her three horns mean triple the powers of a unicorn?)

## Works Cited

Grant, Myrna Reid. "First Light" *A Widening Light: Poems of the Incarnation*. Ed. Luci Shaw. Vancouver: Regent College Reprints, 1994, 7.

Le Guin, Ursula K. "The Hand That Rocks the Cradle Writes the Book." *The Art of Short Fiction*. Ed. Gary Geddes. Toronto: HarperCollins, 1993, 812.

# Jill Watson Graham

## Cogito ergo mum

This is not at all what I had intended to write. My first thought was to distance my-self from the discouragement and bitterness that have blighted my advancing years as a doctoral candidate in English. I told myself that the piece must be impersonal, not self-indulgent, and above all, not self-pitying, for I know very well that my experience – even where it might differ from yours or anyone else's – is quite unremarkable. But all lives, I think, have the makings of tragedy or comedy – or both. That is, if you can get past beginnings …

*In medias res,* life (my life, at any rate) is a problem play whose ubiquitous themes are time and money. The dearth of both. So this piece started off as a drama about six characters in search of a PhD. They had sought an author in vain. Most of them were women, several on the threshold of middle age, and several others over it. My character, who had two children and a shift-working husband, lived a long distance from the university. Whether hazarding long commutes to teach in less than collegial circumstances or spending off-family hours facing screens and books, she suffered immoderate bouts of isolation, which led to self-pity and madness and … well, you can imagine how grateful she was for asylum on these pages. But she had better remain offstage, in the wings, for this piece is meant to be impersonal.

The eldest character, a woman nearing fifty and keen to top up her still-warm MA, had recently left public school teaching to move east with her husband and two cats. She had never wanted children and had succeeded in never having any.

Another, more of an ingenue, vested with some teaching and publishing credits, came to this university because it had accepted her rather dashing leading man as well. They seemed like a dynamic couple (you didn't think of one without the other), full of fun and optimism.

A rather staid, businesslike male in the cast (think of him as a foil to the leading man, above) was an overseas student on leave from a faculty position that would be his for keeps if he completed his PhD in

three years. His wife and two children remained back home.

The last character was a mother who had also come here from overseas. Her ambition was to teach philosophy to teachers, but it was an ambition that could only be fulfilled abroad. Upon receiving a scholarship to further her studies here, the scholar–mother (with what reluctance, I leave to your imagination) deposited her daughter, just out of babyhood, with caring relatives until she could manage to bring the child over here.

Mercifully, the curtain dropped on my fragment of drama before the end of scene one. The trouble seemed to be in the plot. I believe if I'd used boy actors instead of women I might've solved the problem. But as it was, the plot wasn't working, because for the life of me I couldn't figure out which situations or actions were probable causes and which were (or should be) effects. There's always some element of causality in a play, or so I thought. Perhaps I could reason things out in an essay.

Next thing I knew, the piece had donned (out of habit, I suspect) a philosopher's robes, and in that guise got further than the first attempt had; it went some way, I think, to becoming a critique of certain Socratic values (if not methods) upon which the academy itself (or at least the idea of an academy, until corporate values took over) was founded. Here's how far it went in those robes, which are voluminous on my frame, yet confoundedly tight for a wanton mind:

> Plato made famous the Socratic idea that "a life without … examination is not worth living." Since the academy was instituted for precisely that purpose (to examine or inquire into life), one is hardly surprised to hear echoes of Socrates – or rather, echoes of the hearsay of Socrates – in a modern-day homologue such as this from a literary critic and feminist, who writes that "to be … is to be narrated." The assumption behind both pronouncements is that reflection is the better part of life. But where Socrates implies that reflection consists of thought and discussion, the literary critic goes further, implying that the examined life must be written. Allowing that recorded narratives are indubitable evidence of an existence that is or was, one can nevertheless ask whether, or how, such an assertion serves the cause of women's struggle for equality.
>
> Consider, first, a vital adjunct to the idea that the unexamined life is not worth living: according to Plato, "We shall continue closest to knowledge if we avoid as much as we can all contact and association with the body" (*Phaedo* 66E). Indeed, if we hope to set ourselves up as philosophers, we need to rid ourselves of bodily concerns altogether: "The desire to free the soul is found chiefly, or rather solely, in the true philosopher; in fact the philosopher's occupation consists precisely in the freeing and separation of soul from body" (*Phaedo* 67A).
>
> Suppose, then, that one is a woman – or more precisely, that one is a mother – as well as a philosopher or artist or some poor soul straining for freedom through the life of the mind. One embodies in oneself another equally venerable symbol – one which, unfortunately, signifies

the contrary of pure philosophy. This symbol – oneself – is the female body that bears life. And contrary to Socrates' precept, many people who have borne or bred the fruit of a womb assert that there is no cleft in the immature fruit's sentience: it seems all of a piece, though it is undeniably fragile. Since its growing season is short, its nourishment and habitat are critical. To thrive, it requires the attention of minds and attendance of bodies. There is no evidence that it needs to be narrated, though it appears to delight in both active and passive acts of narration.

Since a palpable tension exists between the philosophical values symbolized by the academy and those symbolized by maternity, a woman philosopher exists as a matrix of duelling symbols and is apt to feel unauthorized, burdened by a sense of dislocation. Scholar mothers, who differ from other working women primarily in that their existence is bound up with acts of narration, suffer inordinately from this time-honoured tension between the life of the mind and the life of the body. The rational course, for them, is clear – so clear, indeed, that it should be much easier for them than for anyone else to become "true philosophers," since they have so much to gain by renouncing the body and embracing the modern-day philosopher's creed that "to be is to be narrated."

As things now stand, however, the scholar–mother or would-be philosopher who gives credence to gossips who impute value to the life of the body is doomed to remain sawn in half, like the nubile assistant of some absent-minded magician or (at best) the muddling apprentice of a bearded sorcerer. Even a scholar gipsy would be at pains to straddle this antinomial (or is it anatomical?) abyss, and never mind the question of how scholar–mothers might juggle the temporal logistics….

As you can see, what started out as an impersonal disquisition soon morphed into a polemic, with the personal and biological insidiously creeping in through metaphor, the back door. So I abandoned those weighty philosopher's robes when the fragment threatened to flower into fantasy (a polemical fantasy), when last I resuscitated it, after midnight, a week ago. Tired as I was and full of delinquent thoughts, the only notion that came to mind as I read over what I had written was Endora – wonderful, scornful Endora, that mother–witch from the TV-scape of my childhood (remember "Bewitched?"). Out of nowhere she popped into my head – so typical of her! She was always neither here nor there. But when she appeared, she too was all of a piece, though decidedly not *intacta*. Where are you now, Endora, in the hour of our need? (Had I been able to fit her in, I would have titled the piece "Endora's Box.")

Always loath to abjure lewdness or poor puns, I banished the philosophical essay (and Endora as well), though I've reproduced the fragment above because I spent so much time (and babysitting budget) on it. Indeed, I took such pains with it – like my children do with the sinkable and unthinkable but doughty little ships they make out of egg cartons – that my heart breaks when I think of it departing without a reader's

blessing. Consign it to your wastebasket if you wish, gentle Reader (as I do those sodden flotillas), but I've wasted time narrating at the moon unless you exist too. Are you there, Reader? Or have you never been narrated?

Please don't think that because it was confusing, I turned my back on philosophy altogether. (In fact, I think I have found hope and sanity in Epicurus' fragments – in that school whose motto was "live unnoticed" and which began not in an academy but in a garden that welcomed women and slaves. It was there, perhaps, that a wise serpent and a curious woman got the idea that knowledge was a fruit you could eat…. But that's another story.) Still stuck on the idea of causality, or perhaps over-respectful of logic, I tried (the next day) a little exercise in reason, starting with the proposition quoted above: "To be is to be narrated." To remain as objective as possible and get as close to pure reason as I could using words rather than numbers or arcane symbols, since I'm terrible at math, all considerations of sex had to be excluded. Accordingly, I examined the proposition's validity as it applies to the case of a contemporary hermaphrodite philosopher. (Whom I wished very much to name Leslie.) Having committed myself to objectivity, I christened the subject "XY" instead, and here is his/her reasoning:

> To be, I must eat. To eat, I must work. To work, I must publish.
> To publish takes writing. Writing takes time. In time I must eat.
>
> Therefore I teach.
> I teach, therefore I can't write much.
> I teach, therefore I can't eat much.

Since the personal, biological, and contingent will surreptitiously gain admittance anyway, it seems a good idea to admit them at the front door. Luckily, confession is in vogue, so I need not be embarrassed to confess that yet another fragment languished on this very spot, heavy with concrete detail, not two days ago. It had been lifted from my diary, a decade's meagre scratches pitifully hoarded in a Hilroy. Honesty compels me to confess that I had dressed it up for this occasion, but editorial prudence suggested that I cut out the most telling portions of my memoir, so I've cut it down to this little set of pasties, and you'll have to take my word for it that they conceal what were once heaving, breathless descriptions of early days in grad school, when I was a youthful if not young mother and an indentured post-secondary pedagogue (T.A.). Come to think of it, the pasties on this page may be preferable to the full-throated memoir, for you don't want to see my naked thoughts at age *xx* (here's where arcane symbols become immensely helpful). A tad over-attired, the autobiographical effort went like this:

My life as an academic runs almost parallel to my first decade as a mother…. [etc., etc., etc.] …

[1989] … Now, with the achievement of a long-delayed B.A., my plans to write during the off-hours of a high-paying career seemed slightly compromised, for the black academic robes I wore while receiving that first degree concealed a womb apple-round with daughter.

[1993] … having left a decent-but-deadening government job, convinced that ever higher degrees of education were my passport to the good life, if not the examined life, I strode to the stage to accept my new credential, Master of Arts. What my lot would be as I braved the future, I couldn't guess, but underneath it all I had a suspicion that … well, under the gown, once again….

[1994]… and lo, in the second year of my doctoral quest my tribe increased: I brought forth a boy-child, apparently sent in Olympian spite of my intrauterine device, to say nothing of my intellectual ambitions. Thereafter came colic and fevers and all the infections that a son sucks up / From bogs, fens, flats…

Hang on, that's Caliban's life, not mine. But … I thought he … he doesn't *exist*, does he?

And yet he is narrated, or told; he counts. My mother (like so many before her) has never been narrated: she is untold. Does she not count? If I don't write (for lack of leisure) or am not written about, shall I not *be*? Perhaps not. Futurity will forget me, lacking something to remember me by. I've half a mind to tell futurity that it's the mothers (and fathers too, if they aren't writers), passing on their tacit values, who create futurity itself. I've half a mind to begin a poem: "Without me / can futurity be?" Oh, scrap the poem. Let's assume that every life has its knowledge and agree that knowledge is worth telling. But can we not also question the value of confession, when it's epidemic on TV, on the Web, in papers and magazines? Even a devotee of words whose fascination lies in people might come to prefer silence, might she not? Might feel that we of the information age have turned into talking heads, a Neoplatonist's nightmare; that we are awash in symbols, most of them trying to sell us something; that if *telling* is all that matters, we dwell in towers of Babel; that this way madness lies. So, begging your further indulgence, allow me to affirm my good fortune in having a mother who merely *is*. She is looking after my kids at this very minute. (I miss them.) Living without leisure and luxury, she survived the schisms of working a diploma into a modest pension while raising three children with the help of my dad. Thanks to that pension, she can help me. But, for the record, she believes that my years in grad school are "a chronicle of wasted time," as Shakespeare put it. Mum puts it rather more bluntly. She has observed (among other things) that the closer you get to knowledge, the more closely you have to live.

And so I begin to think that although it may be possible and perhaps useful, it is also hypocritical of me to try to defend my maternal heritage of unnarratedness with that brazen old shield: autobiography. Therefore I'll spare you the specifics of my particular trouble living the double life of a scholar and mother,

lest the temptation to make a hero out of this mortal coil gets the better of me. Besides, I'm not ready to distance myself from the present moment. The moment lived, unnarrated, is an anchor for a mind that's always been inclined to absent itself from its local habitation. Happily, furtively, or desperately, it may be, the mind roams, and for long hours in the day or night mine is a gipsy spectre probing the minds of dead poets. These seven years past, I've spent more time with Virginia Woolf than with my own mother. Where is the merit in that? It is easier by far to live in harmony with my books than with my mother. Might it not, then, be a good thing that I am insufficiently removed from life to select, out of all these years, the daintiest delights, the deepest sorrows, the most distinctive quality? How discriminate amongst all the minutiae of my days? And why?

Why write?

That is the question. Well, let's see. There are many good reasons to write, and all of them, if you think about it, involve compensation. One writes for money (perhaps to eat). For fame, which (being marketable) not only converts to fodder, but doubly feeds the fragile ego. For posterity's or the present's enlightenment, if the ego be headstrong or hounded. But there is one reason that surpasses the others, that is in a sense the *sum* of them all: one writes for consolation. For comfort when what is, is no more. And if it be true that consolation is a higher thing than compensation, then I ask: is consolation not the gift of loving parents; of sisters, brothers, children and friends, as well as the gift of profoundly moral philosophers? So I deduce that it is good to write, but just as good (if not better) to live.

The difficulty, of course, lies in trying to do both, especially if we are mothers. For it's true that crafted symbolizations outlast scarce words, silent looks, artless gestures, brief touches, and those seemingly endless rounds of meals and laundry – the "mindless" routines that, sadly, do end in time. But if representations endure beyond the dying moments that shape and inhabit a body, a life, is it not because they are only phantoms, as dead and unfeeling as we will be, in a very short time?

To be is much more, finally, than to be narrated. Oh, I grant that if I survive to a condition of greater ripeness and softer living, I might want to perform, even publish, my *examination*: my verdict on which thoughts among the desperate horde at the gates of my consciousness, all clamouring for release, ought to be set free – or rather, discharged into some other media besides gossip and friendly discourse, which is their day parole. *Prendre la parole*, by all means. Write, if you have time and inclination, by all and any means. But bear in mind (as in body) that freedom walks the streets as servitude; that the labour of writing is like a mother's in that its rewards, being uncertain, lie in the labour itself. And therefore do not disparage or deny the existence of the untold, the unnarrated, and the invisible: we are the Real. What the philosophers sought.

Still, you might well ask, especially if you are a feminist philosopher, "How, if not by writing, are we to know and honour our mothers?"

Once again let me do my impersonal best to reduce the dilemma to bloodless and abstract terms. What is more abstract than dollars and cents, which are not only attached, variably, to "value," but can translate themselves into almost any symbol you please? Indeed, so adeptly can I impersonate the impersonal scholar that I shall shortly repose (mum) in the cosy lap of authority and yet also be like a mother of old, deferring to other voices, since I'm tired again anyway (that's my constant refrain). Hush now, and hear.

Inside the academy (which in his day was private) we have Socrates, who spoke, but so far as I know, didn't write. See how, condemned to drink his philosophy, Socrates is having second thoughts about freeing the soul from its body, as if after all there might be some serendipitous relation between philosophy and physique. (To his credit, he didn't recant, but merely drank, and did it with such dignity that we have sensed the worth of his philosophy ever since.) He tells us in his famous last words – as rendered by Plato – that in teaching people to think more of their "mental and moral well-being" than of "practical advantages," he has performed what he considers "the greatest possible service." For this service, he insists that "some reward" is deserved:

> Well, what is appropriate for a poor man who is a public benefactor and who requires leisure for giving you moral encouragement? Nothing could be more appropriate for such a person than free maintenance at the State's expense. He deserves it much more than any victor in the races at Olympia…. These people give you the semblance of success, but I give you the reality; they do not need maintenance, but I do. So if I am to suggest an appropriate penalty which is strictly in accordance with justice, I suggest free maintenance by the state.
>
> – Socrates's "Apology." From Plato, *The Last Days of Socrates*

I cannot say exactly when the state (or its deputies in the academy) changed its former penalty for philosophical inquiry and teaching – a cup of hemlock – to its current penalty of $3,200 per three-credit course – the going rate for part-time / adjunct faculty, a majority of whom are women, at two universities where I've taught recently. The gain, over more than two millennia, seems a tad small, but indicates that the academy, if not society at large, now values writing over teaching. Since Socrates talked more than he wrote, he probably fared as well in fourth-century Athens as he would in the academy of today, where one's published *corpus* determines one's position. The consequence is that although women have for some time been welcomed into that respectable establishment, there are many among them who (if not down and out) certainly dwell "downstairs." Or, looked at another way, they are located neither inside nor outside of the academy.

Moving, then, to the outskirts of the academy (perhaps to a garden), we find an authority whose bountiful pen could easily usurp a daughter's affection but for those nondescripts, the "m/others" who will rest anon. Virginia Woolf in the last part of her career examined the causes of war between nations, classes, and sexes. The prevention of war, she determined, depends on social justice for all; and social justice, that abstract objective, can be achieved only when power (in its most abstract form, $) is diffused to the "society of outsiders." This society would "take its stand" on the condition, first, that its outsiders "bind themselves to earn their own livings," because (as Woolf demonstrates) intellectual freedom depends upon "economic independence." Second, "an outsider must make it her business to press for a living wage in all the professions now open to her sex" and, further, "must create new professions in which she can earn the right to an independent opinion." This means, in effect, "press[ing] for a money wage for the unpaid worker" – we might add the "underpaid" one as well – "in her own class." Most important of all, however, for Woolf, was to recognize reproductive work – the nurturing of young minds and bodies – as being of a value equal to (if not surpassing) that of any other human endeavour:

> But above all she must press for a wage to be paid by the State legally to the mothers of educated men. The importance of this to our common fight is immeasurable; for it is the most effective way in which we can ensure that the large and very honourable class of married women shall have a mind and a will of their own …. [I]f any condition were to be attached to the guinea it would be this: that you should provide a wage to be paid by the State to those whose profession is marriage and motherhood. [Italics added]
>
> – Virginia Woolf, *Three Guineas*

A scholar mother might – just might – be able to exist both here and there (like Endora), or within and without the academy, if the busy world would heed a "mad" woman who espoused silence in the deep, long before her time was ripe.

How uncanny, the power to be both here and there. Or to be without being narrated. That last thought breeds another in this indigent mind – the *dramatis personae* I so shortly shrifted at the beginning of what was to be a play! I had forgotten them in my philanderings. How dispose of them, and bring words to an end? … (Think, think, think. Without spilling ink.) Finally, an idea strikes: have them do a dumb show, of course! And if dialogue is unnecessary, it occurs to me that I can save further time and trouble by abandoning all pretense to causality. Leaving philosophy inviolate *dans la tour d'ivoire*, I borrow the plot, at last, from what really happened:

Four years into the program, when her thesis was well underway, the eldest player's husband left her for a younger woman. Unable to sustain herself and two cats on teaching stipends, she moved to Asia, where – *sans* PhD and *sans* cats but with plenty of money for honey and travel – she is teaching still.

The ingenue has part-time teaching and library work. She presses on with her thesis, which was interrupted for about a year when her dashing leading man … dashed. She believes she is now closer to knowledge than ever before, but describes her travails in the academy as "soul-draining."

The leading man's whereabouts are unknown: he left no writing (and fortunately, no children) behind.

That businesslike foil to the dashingly irresponsible lover – the staid foreign fellow whose teaching job was all secured but for the paperwork – made quick progress. Having despatched his degree in three years, he is now back where he started, but with tenure. Which is to say that while acquiring his credentials, he acquired a lover here and divorced his wife there. Finishing his paperwork and legalizing his paramour, he went back there, where the job was. His transplanted *amour*, disenchanted with there, came back here. And so he picked up again (more or less where he left off) with Wife number one, whom he remarried. (*Stage direction: Two bewildered children look on throughout the action.*)

My character (fifth of the six characters in search of who knows what) now steps from the wings to bring the play to an end. She is, as you knew all along, the narrator, but her narration consists of nothing but a simple fact.

*Dim spotlight on centre stage. A remote-looking figure, a woman, laboriously writes symbols on a blackboard: she is teaching philosophy to teachers seated in a ring of shadow. Light gradually fades to black.* Her daughter, age five, died of malaria. Over there.

# Deborah Keahey

## Nine Steps toward a Twelve-Step Program for Recovering Academics

"It's never too late to be who you might have been."
– George Eliot

I am fascinated by those moments in which we perceive something – sometimes after years of struggle and half-sight – with sufficient clarity that it *compels* us to action. Those epiphanies from which there is no return, only forward, even if we don't yet know the precise path that will take. The moments in which all our awareness and analysis suddenly gels into something more than just another angst-filled evening, when a door opens up inside us and we take a deep breath, hold it, and step through.

**Step 1: Recognize the excuses you're making for what they are – excuses – and stop making them.** *Excuse-making is one of the key symptoms of addiction. "Get" that the life you are leading is the result of decisions and choices you have made, and are still making.*

Like most of the university women I know, I have struggled intermittently (well, okay, more so than not) with my academic identity. Like most, I've spent many an hour (well, okay, year) rehashing all the unbearable things about my situation and all the brilliant reasons I couldn't do anything about it. "I need the money." "I've invested too much in it to leave now." "It's really not so bad." "If only I could change myself enough to fit in, everything would be fine." "It's what I'm good at." "My students need me." "Only 35 more years to retirement." And my personal favourite, "But where else would I find a job that offers this much flexibility and stimulation?"

**Step 2: Recognize that there are other ways to live (and make a living) with creativity and flexibility and integrity.** *It may require a big shift to see the options, but it's possible. Know that you have choices, even if you don't yet know what they are.*

Part of the difficulty lies in a kind of tower-tunnel vision promoted by the "meta" work we do inside the ivory walls. You know you've got this when "applied knowledge" starts to sound vaguely dirty. When self-consciousness becomes your supreme measure of value. When you begin to believe in a hierarchy of

discourses, with academic language representing a higher order, qualitatively better than that of the "common folk." Or when you find yourself unable to fathom getting a "real" job because you've just spent the last four years deconstructing and critiquing capitalism. Seriously! It can be a real challenge to exit the world of analysis, to give up "the" position as commentators on the human condition and resume life as the object of *someone else's* study.

**Step 3: Let go of the need to analyze and critique everything.** *The academy privileges right-brain logical thinking, which when overused can lead to a lot of unproductive stress and mental knots. Relearn how to function in free-flowing creative mode more, trusting your intuitions. See life as an opportunity to enjoy rather than a problem to solve, and find peace in that. You'll be better equipped to deal with the problems later.*

Part of the difficulty also lies in what for lack of a better term I'll call the "crossing over phenomenon." This is the way in which at first you can see all the negative, damaging aspects of the institution and vow to never replicate them, but by the time you're in a position to do something about them, you've lost the ability to see what the problem was in the first place. I don't mean there aren't many wonderful women working daily to make universities fairer, more hospitable places for women to spend their learning and working lives (because there are); it's just that too often the very environment of the work undermines the work being done. When the text and the context come at you from opposite frequencies they just cancel each other out.

**Step 4: Be human.** *You already are – why not admit it? The "superwoman" model has outlived whatever usefulness it once had. Let it go.*

How many times have we all heard some version of the comment "I know what you're going through because I've been there and you'll just have to put up with it – things will get better once you get through this stage!" The institution as a whole is sorely lacking in role models of women who've achieved success on *their own terms* within the academy. Who experience their career as a source of joy and pleasure, rather than being *consumed* by it. Who are excited by their work, not *obsessed* by it. Who are energetic, not *adrenaline addicts*. Sessional-track women without the lingering bitterness, despair, and resentment, or tenured women who made it through the hoops of advancement without becoming overwhelmed with stress, anger, and self-doubt. It is a sad commentary that tenure is seen by many women as sacrificing your life rather than enhancing it.

**Step 5: Put yourself at the top of your to-do list.** *Make self-care a priority. Get professional help for depression or self-esteem issues, if warranted. I've heard it said that female academics rank second only to psychiatrists in manifesting depressive symptoms. Understand that if you don't take care of yourself, you won't be able to help anyone else (even if you think you are – remember that context and text can cancel each other out). Be in it (your career, your life) for the long haul. Stop running on adrenaline. Think sustainable sources of energy.*

I came close to breaking free – or thought I was – with the birth of my first child (the child who had smoked with me for the first two weeks of her existence and who at four months gestation endured the jaw-clenching, mind-numbing stress of my PhD oral defence). One week before she was born I finally succumbed to the migraines and fatigue and let someone else take over teaching one (but only one) of my three classes. I was sure things would collapse without me. How could I leave my students? What would they do? And then my daughter was born and the world turned upside down. My students were grown-ups (relatively speaking); they could take care of themselves. It was this child who needed me, and wild horses (or even a wily department head) couldn't have dragged me back.

**Step 6: Admit and fully own the damage your behaviour causes.** *Both to yourself and others – family, children, students, pets. Another key sign of addiction is denying or rationalizing negative consequences. If you're not sure what harm you've done, ask others to tell you (and – this is key – make it safe for them to do so).*

When my daughter was three months old, I agreed to do a poetry reading at a local bookstore but hadn't written anything new for many months (imagine that), so I used the opportunity (well, okay, pressure) to begin a long prose-poem about her birth. In one section of the poem (let's call it "the postpartum professor"), the academic world intrudes, highly ironicized:

> preparing to go back to work, the next semester's teaching, i reread faulkner's *as i lay dying*, the bundren children carrying their mother's dead and decaying body to be buried. 'my mother is a fish,' her youngest son says. i imagine my students' faces, puzzled, bored, disgusted. research critical evasions:
>
> "Interpellating a universalized radical perspectivism and antimimetic abstractionism with a superficial historicizing of the family's plight as a modernist agrarian fable misjudges their repellant constitution by the dialectical history of the homogenization, commodification and monetization of personal relations in the nineteenth-century south …"
>
> suddenly a duct clogs in my right breast. confused engorgement sets in, then aching panic, fear my milk will begin to dry up.
>
> a mother has died. the stench of her slowly dissolving body wafts up from my book, fills my room and leaves me reeling. 'my mother is a fish,' her son says.
>
> a single white tear drops from my left side. (Keahey 79)

**Step 7: Develop or join a supportive community that understands and shares your addiction (or a similar version of it).** *People who share your desire for recovery and who inspire you to make changes.*

My own crystal light bulb moment, my catalytic "aha!," my door-opening-step-through epiphany came, if you will believe it, when I read "Professional Girth," the introductory essay that Deborah Schnitzer and I co-wrote for this collection. Not as we wrote it, mind you (no, that would have been too obvious), but

afterwards, as we re-edited it for submission to publishers. Suddenly it hit me: not only was my behaviour insane (which I had known for some time) but I *simply must stop it.* For the first time I saw my situation clearly for what it was – an *addiction*. I'm sure I must have thought of that before, but for whatever mysterious and wonderful combination of reasons, this time the truth of it penetrated my many layers of conditioning, defence, denial, fear, and evasion. The answer suddenly became clear – to simply quit – and so I did.

**Step 8: Commit to get out or proceed on your own terms.** *No more half-hearted, halfway measures. You may be able to recover from within, or you may not. Some people need to go outside to detox. Be honest about your needs, respect them, and meet them.*

Honest. I just quit. (Don't you love simple answers?) Not quit teaching, because I still teach. (Okay, so it's a bit more complicated.) But playing the games. Hinging myself on the institution's approval (or dis-). Working myself silly for the institution's values and standards and priorities, as though they are my own. Because they aren't. (Though years of training help to obscure that fact.) Buying the myth that there are no options and that this is as good as it gets. Because it isn't. And because even if we do have more than one life, by most accounts we only have one soul and nothing is worth selling it for. Even an "A." Even an eight-month contract. Even tenure.

**Step 9: Get that you are your own best judge.** *Always. This is the first rule of assertiveness training. Define your own values, standards, priorities, and measures of success, and orient your life and work around those. Please yourself first, and let pleasing others be a by-product of that rather than the primary goal. If you're really enjoying your life, it becomes a lot less important what other people think anyway. Have fun. Be yourself. Follow your deepest heart's desire … why not?*

Working on this collection gave me a wonderful gift: a reflection of myself so painfully stark and clear that I could no longer subsume, rationalize, or turn away from it. I have nothing against delusions if they're working for you, but when you're deluded about your delusions working for you, it's time to say "stop." So I've let go, moved both physically and psychically to the academy's outer fringes, and I spend some of my time there these days developing a twelve-step program for recovering academics like myself: women – either inside or outside the institution, at the centre or the periphery – who have had their epiphany (or some of the many glimmers on the way there) and are committed to finding a better way, *their* way. I wish you well.

## Works Cited

Keahey, Deborah. "first off, let me say that writing a poem is *not* like giving birth." *waking blood: poems.* Winnipeg: Turnstone Press, 2000, 79.

# MOVEMENT TWO

## Circling Women

**Note:** This poem is an excerpt from my 1996 dissertation, *Women and Graduate Adult Education: A Feminist Poststructuralist Story of Transformation*. Six women participated in a series of learning circles to explore their experiences in graduate adult education programs.

i

I am Tammy and the women in the circle are very much
like me or

like me looking for connection
uniting the disjointed

bits

of
our/the
lives
we create  to
live in community our voices, our beauty, our pain, our spirit.
We are here – affirming self/other into existence –
      have you
           heard us yet?

I am Tammy and the women in the circle are very much

not
like me
at all.

I am
not wife, not mother, not juggler, not …
　　　– not woman?

I cheat with luxury – guilt – of time

and space.

I can have a bath whenever I want. There's no one else to think
　　　about …

## ii

(buzzing and laughter)

*Okay. I think we're set up. Okay. I'll start.*

*I am Tammy and I'm sure I don't know much here*

　　　*being unemployed when I started*

*didn't even know what adult ed was*
　　　*an eye-opening discovering*
　　　　　*I can put together a program*

she passes the raku spirit woman

*I am PJ and I'm going to say ditto (she laughs) about the practical application of learning but/and
sometimes I don't remember what people say exactly but I remember how people are,*

*so anyhow,*

*there's all these strong emotions that come over me….*
*that's when there's significant learning for me, so anyhow, I can always learn from the positive
and the negative emotions, people*

she passes the raku spirit woman

*I am Nahanni and I have always felt, I think,*

(sigh)

*ripped off*
*that it was such a farce.*

*Lucky that serendipity weaved the missing threads….*

*once I had that, it seemed that everything else got a lot easier.*
*It took so long*

*the*

*affirmation and validation of the way I learn.*
*Finally.*

she passes the raku spirit woman

*I am Carley and ah*

(long pause)

*this learning roller coaster,*
*discomfort,*
*dissatisfaction,*
*rehashing at the coffee machine …*

(pause)

*coming home to adult ed, the excitement,*
*whole other wonderful library world,*
*word processor comfort,*
*watching others in action*

(pause)

*taking risks as a learner and facilitator – transformed*

she passes the raku spirit woman

*I am Helen and I need to know what the experts have written and how that compares with what I know.*

my knowledge does have some merit

*My master's was a secret indulgence, a freebie, because I could work on it at work.*

*no one else knew or cared*

*I'm curious, Tammy, from a research perspective, how are you going to present this data and tie it in?*

she passes the raku spirit woman

*I am Elizabeth and "let's see some of this adult ed stuff" but I saw nothing*

*even Brookfield really misses the boat*

*And I also wonder a lot about this gender thing in learning, you know, is men's learning as rich as the things we're bringing out?*

*This master's degree is taking me so darn long …*

*to finish …*

*Life has this way of interfering with our best-made plans.*

she passes the raku spirit woman

## iii

We are the women in the learning circle

creating our own knowledge base
*being validated and validating one another*, said Nahanni.

*And what if we'd had a man in this group tonight?*
*How would that have changed things?* asked Carley.

# Jennifer Kelly and Aruna Srivastava

## Dancing on the Lines: Mothering, Daughtering, Masking, and Mentoring in the Academy

Jennifer:

### June 2000:

I am tired. Tired like I never thought possible. I am confused. I am pretty ticked. I haven't been able to figure out "what" I am these days. Exhausted, trying to parent full-time (Anna, two and a half; Paul, nine months, both, of course, glorious), teach part-time, and oh yeah, revise a PhD thesis (so I can finally graduate) and be involved in community activism. (Oh, those toilets need a scrub.) Am I an idiot? a failed feminist? a parody of feminism? an object lesson?

Why didn't anyone tell me it would be like this? (Would I have listened?) I feel betrayed (but by whom? what?). More than any time in my life, motherhood in combination with my attempts at academic work have for me been an ugly and exhausting discovery of how much of patriarchy and the institution I have internalized without realizing it. I can't tell where the institution stops and I start. This is not how I planned it. Where's the handbook on how to do this?

### Winter 1997:

Three years into my PhD and I don't really have anything written on my thesis. My partner and I decide to start a family. I choose the time, thinking that my aging body is changing faster than the institution. It is a choice made from privilege. I naively think that a due date – a real, material deadline – will also spur on the completion of the thesis (ha ha ha).

I don't inform my advisor, Aruna, or anyone else of these plans. I get pregnant. I have an early miscarriage, followed by a healthy pregnancy. I request changes in my teaching schedule as a graduate teaching fellow, flip-flopping on when to teach the course according to what's been happening in my body, but I don't reveal to the department administrators the reasons for these changes.

Should I have? How and when should the pregnant graduate student body announce itself in academia? How is that body read?

"Was it planned?" I am asked of both the miscarried pregnancy and my pregnancy with Anna. What an intrusive question, but it rolls off tongues so easily. I am baffled as to how to respond, but I automatically say "yes," immediately regretting it.

Later, I wonder why some people are so surprised. Others, however (and however surprised they may have been), are genuinely happy for me, wish me well, and give me the confidence that it is possible to balance motherhood and academia. But the questions nag. What pieces of myself have I been hiding? What mask have I been wearing? What version of myself (or, perhaps, of someone else, of some image) have I been performing as a graduate student so that motherhood didn't enter the picture?

I wonder to what extent I have internalized this idea that I will not be perceived as a committed academic if I become pregnant. Where did it come from and is it real or imagined or both?

And why didn't I tell Aruna about my plans? It only dawns on me, now, in the writing of this, that she might have been hurt, or at least surprised, by my silence. (She was one of the "was it planned?" people.)

What masks do graduate students wear for/with our supervisors? It is so easy to imagine supervisors as embodying *The Institution,* as holding such power over our careers, that I think we perform for them too, cut parts of ourselves out to fit some vague but powerful image of academia.

Later, now, I wonder to what extent I have been constructed, systemically and by individuals across desks, as female graduate student therefore daughter (and, once pregnant, disobedient one at that) therefore not really adult/colleague and therefore you'd-better-be-grateful-for-everything-we've-done-for-you (Little Girl). But also, I wonder how much I have internalized and performed that role without really questioning it. I was, after all, also treated as an adult and colleague by several members of the department. Where are the lines between the institution and the individuals inhabiting it (however resistantly)?

Blurriness.

## Summer 1997:

Members of the department whom I haven't seen for a while look at me, my expanding body, in surprise. Why? Do I look hideous? Do I no longer fit my earlier image? Is a pregnant academic that rare?

Where are the pregnant bodies in academia? (Are there any?) Why are they invisible and then, when they do appear, hypervisible?

In all of our processes of "professionalization," there is little discussion of the truth that most of us will not end up as tenured professors. We don't hear about the other jobs we might have outside of academia, that we may be able to combine an intellectual life with our family life, or that we may choose to perform the important but unpaid labour of parenting after our many years of post-secondary education.

Choosing to become a mother while in graduate school, therefore, feels like an either/or proposition; for all of our awareness of academic feminism, this gloomy pressure prevails, suggesting that academics who choose to mother throw out our brains and education with the baby's bath water. But still, it is a professionally and economically risky choice to jump off the tenure track before one is even on it. No wonder people looked at me (my belly?) strangely.

August 1997:

I am visiting with a friend. She looks at me intensely, and with joy and awe, her voice turning into capital letters, says, "Jen, you're going to be a MOTHER!!!"

Even as we laugh, I feel the weight of patriarchy, of all that is contained in that single word – mother. My comfortable sole identity as "student" (and therefore as vaguely in the future "academic") begins to slip away, consumed by a myth of all-encompassing motherhood but also, I think, by a new sense of adulthood, responsibility, agency, that I hadn't felt before as "student."

I think that maybe, just maybe, pregnancy reshaped the masks I wore. Sure, my body announcing how my life was changing had something to do with how others responded to me, but I know too that I was responding to my own body (my entire life) changing too. I was more relaxed in those pre-parenting weeks – I knew, bodily, maybe for the first time in a long time, that there was more to me and my life than academia, and that it was okay to talk about that.

I've spent a lot of time looking at women faculty as older, wiser, and yes, maternal. I have looked for their affirmation, support, advice, and example.

Many graduate student conversations revolve around "the supervisor" and what she thinks of us, our work – the two become disturbingly inseparable. I chose Aruna as my supervisor because of her very visible commitment to anti-racist work and her willingness and ability to make the personal political, taking risks in the process. I think that at first I constructed her as singularly professor/supervisor, erasing (conveniently for me as an able-bodied white woman) her identity, her lived experiences, as a woman of colour and as a person with disabilities.

As my thesis and my work turned more to critical race theory and anti-racist teaching, I found myself feeling less comfortable at times with our student–supervisor relationship. I wrestled with how to balance my race privilege with her authority as supervisor. I worried, as many of us white liberal well-intentioned folks do, that I would unintentionally say or do something racist and hurtful, even as I was engaging in a project

to resist that. Aruna opens her home and her heart to her students; we come to think of her as a friend. I did (and do) look to her for personal and professional affirmation, approval, support, advice. And she is still, after all, my supervisor, with many a reference letter still to write for me. I wonder how she juggles it all – friendship, professional supervision, mentoring, and the messy and painful work of anti-racism.

Winter 1997:

With seven-week-old Anna in tow and still recovering from the C-section that brought her into the world, I commute two hundred kilometres each week to teach a course (central to my thesis work, I don't want to let it go). I bring Anna with me because I am committed to breast-feeding, and to do so feels somehow resistant. As part of my attempt to make power relations in the classroom and the institution visible, I announce to the class that I am a graduate student, a breast-feeding mom, that I have arranged for a babysitter on campus, and that, while I have tried to plan for feedings during the class break, we may be interrupted for a feeding. Participants in the course are fine with this, are curious about Anna, and several congratulate me later. The class is predominantly women. I feel better about this than I thought I would.

But I've never announced my breasts in class before. Sure, "they" have always been there with me, even when teaching, but I've never talked about them like that. I've always felt how powerful the gaze on the teaching (woman's) body can be, but this is a weird embodied disembodiment. My breasts are not really mine anymore – unrecognizable in size and belonging to Anna now (they seem to be the centre of her universe) – and yet they are made more visible (hopefully not literally) in the classroom. I have actively named them in a process of self-definition in the classroom, in this space of historical patriarchal authority.

There are no washrooms close by to take Anna for a feeding, and even if there were, they are crowded and chairless. One day, I nurse Anna in the classroom, as all the students have left for the break. They return before we are finished. When Anna is done, I stand with my back to the class to make sure that my breasts aren't hanging out for all to see and that I have managed to do up the buttons on my blouse correctly. I'm not feeling very authoritative.

> graduate student instructor + breast-feeding = *what* in the university classroom?

I don't think this is what Hélène Cixous had in mind.

Fall 1998:

I have been working fairly steadily on my thesis and have a chunk written. I ask Aruna if she thinks I have enough written to get pregnant again.

She laughs and says, "I'm not touching that one."

## December 26, 1998–Spring 1999:

I am pregnant with Paul, due date August 14, though I don't yet know it is "him." I had thought I'd be able to handle this pregnancy better because of experience. How profoundly stupid.

The indescribable fatigue and nausea that I had forgotten in the joy of Anna's presence return with a vengeance. While I have a full-time sitter so I can, in theory, finish my thesis, there are many days in which my major accomplishment is sitting at my desk without keeling over. I find I need time to clear my head from the joyous and exuberant busyness of our life with Anna before I can think about my thesis. I nap a lot. I watch a disgusting amount of moronic television. I cry at a Waltons rerun.

I have few truly productive hours each day, and I feel that familiar (student? women's? liberal middle-class?) guilt about that.

## May 1999:

Aruna has set my defence date for July 13. I have been living my own Field of Dreams dissertation fantasy ("If we set a defence date, the words will come"), and I have a panic attack about whether or not I can finish writing in time. Aruna calmly advises me that I can do what I want. She has taken a huge leap of faith in preparing to defend a project that is unfinished.

## July 8, 1999:

I meet with Aruna to prepare for "the defence." She carefully and critically takes me through the process, indicating how the institution (dys)functions in this particular instance, and how to survive it, and even excel in it.

Her words that stick in my mind are "Perform confidence."

Though this is an absolutely accurate assessment of what I need to do to do well in the defence, they are also sickly ironic, I think at the time. Here we have a competitive, individualistic, patriarchal system designed to strip away self-confidence, and a particular instance designed, *by definition*, to make a student feel defensive in the face of a committee that in very real terms *represents* the institution.

And I have to pretend that I am confident?

That I love my project (even when I don't)?

That I am not, quite literally, a student (daughter?) actively and openly seeking the approval of my supervisory committee and examining committee – as academics, as feminists (as academic mothers?)?

That despite a project that calls for self-reflexive anti-racist critical practice, a practice that to my mind

must expose our doubts and confusions, that critiques our investments in power and authority, I must be confident, authoritative, certain?

I drive the two hundred kilometres home, feeling increasingly angry.

After all of this work, I wonder, is merely surviving the best I can hope for?

I am not, after all, frustrated with Aruna for so carefully articulating what so often seems indescribable, the palpable yet indescribable ways that power functions in the academy, particularly in that moment of the defence. But I am so tired of fighting what seems an immense yet invisible thing called "the system."

## July 13, 1999:

The DEFENCE. It's hard to perform academic confidence when your pregnant belly is so big that you can barely reach the table and your diaphragm is so squished you have trouble breathing. I am literally "taking up space" in the room, but I don't think this is what Aruna meant.

But she has prepared me well. I perform as required. Admittedly, I feel some real confidence as the process continues. I breathe a huge sigh of relief at the end of two hours, believing I have done well (challenging questions aside).

Aruna comes to tell me that the committee has "provisionally" passed my thesis – that further revisions are required. In a stupor I thank the examining committee (though I'm not feeling any gratitude). Aruna shuts the door. We sit down.

My mask falls off with a crash. I burst into tears. I have never worked so hard before, and I have rarely worked hard with less than strong results. My exhausted body articulates what my mind cannot yet comprehend; it screams silently to the institution walls, "No, I cannot give you any more. You have taken enough."

I wail, pretty much uncontrollably. I'm not really used to what feels like, in this moment, a public failure (why THAT word?). Aruna too is upset. Yet she manages at once to support me and give the examiners their fair due, negotiating again the maze of academia, criticizing systems not individuals, telling me what, of course, I don't want to hear (and later accept) – that some of the criticisms of my work are indeed accurate. She stresses how the system has constructed me as mother, as supposed "good" student (daughter?), and therefore how this outcome has been a product of all of these dynamics.

Aruna stands beside my chair and gently puts her arm around my shoulder. I lean into her and cry some more, comforted. All of my masks are off.

August 16, 1999:

Paul is a few days overdue and I get a phone call from Red Crow Community College to teach a fall university-credit English course. Belly out to there, back aching, desperately wanting to sit down for what is only a five-minute phone call, I find myself saying "yes".... I'm not sure why, exactly – forty-one-week stupor, perhaps.

It is only months later, exhausted still, that I realize I said "yes" because the request for my teaching was an affirmation of my intellect that somehow the defence process, even though I had passed, had not provided. I came to regret the decision to teach, not only because of the exhaustion and stress it entailed but because once again I had succumbed – to a need for affirmation that (even at the time) I recognized as patriarchally and institutionally produced and yet that I can't seem to shake, despite my years of feminist theorizing. And yes, as a white woman being asked to return to teach Aboriginal students, it was a troubling reproduction of dynamics of white liberal racism – ah, I am a "good white woman" after all, see?

October 1999:

Here I am again with a several-week-old baby, this time Paul, on the floor beside the computer, hoping he's content enough with a mirror and some dangling toys for me to get some "work" done. I am thankful for an uninterrupted hour. Mothering has made me time efficient, and I look back longingly and disparagingly to my days of time-wasting graduate student freedom.

It is disturbingly telling that I unconsciously refer to my academic work as "work" and don't use that word very often for the labour of parenting.

I apply for a post-doctoral fellowship and shortly afterwards experience a career crisis – that resounding pressure from nowhere and everywhere at once that I'd better start applying for jobs NOW or else I will be forever doomed (to what?), and that my years of graduate school will somehow be wasted. I have been feeling stress because there aren't enough hours, minutes, in the day, it seems, to give all I want to my children. And then there's that other work hovering – dissertation revisions, a deadline for this article … the list seems endless.

I realize how, even as I have theorized and critiqued this, I too have unconsciously internalized the devaluation of my daily labour as a mother. I have been deeming my teaching, my dissertation, *the* academic job, as the "work" that matters – not only because I love it passionately (for all the good reasons), but because somewhere along the line I have learned and been told (by patriarchy, capitalism, and yes, even by the do-it-all feminism of the '80s and '90s) that looking after a twenty-two-month-old and a two-month-old isn't *really* work, even as my tired body (and exuberant heart) tells me it bloody well is, and it certainly isn't "intellectual" work.

December 1999:

A brief telephone conversation with one of my examiners leaves me baffled, infuriated, crying in the university library. Clearly unhappy with my originally submitted thesis, she tries, genuinely, to affirm my intellectual potential by saying, "I want you to do justice to yourself." I am at once affirmed and divided. She has always deeply respected my work, approached it so rigorously and critically that I have at times been afraid to show her works in progress. She has supported me, my pregnancies; she has been steadfast in her support of my struggles with whiteness, racism, anti-racism; she has delighted in news of Anna and Paul. And yet this comment somehow strikes at the heart of all I have internalized about myself, the institution, this separation of intellect from body, of one facet of self from the rest, this dangling carrot of the ideal of individualism and perfection.

All my raging mind can think is "what self" is she talking about? Surely, the exhausted postpartum woman who has, after all, managed to successfully defend a PhD while pregnant and with a two-year-old at home should be happy, I think – should feel a sense of accomplishment. This messy person is not the student Aruna has supervised, but the person Aruna has mentored, not in becoming the professional (professionalized) academic, but in becoming (not there yet!) a full someone claiming her entire self, warts and all, as not only a process of feminist sense-making and sanity-saving, but as pedagogically and critically and institutionally, and in terms of life in general, important.

I am no longer angry at the comment. Even as I raged at the time, Aruna, with her uncanny ability to recognize how power functions, how binaries reassert themselves, pointed out that my construction of the examiner was unfair. (But it was very comfortable for me.) Now, I am starting to realize how conflicted the location of academic feminism is after all: an impossible possibility? a possible impossibility? In raising my expectations of my academic "mothers," I am only playing into the hand of patriarchy once again.

Months later, in a moment of out-of-body self-observation, I am befuddled to see myself telling one of "my students" something about how her assignment "wasn't her best work," "I know you can do better ...." Argh.

Aruna:

February–March 2000:

It has taken me all this time to return to this paper, reading and rereading Jen's words, her process, her anger and frustration, the insane demands of this profession and of the profession of motherhood. I am not too far into my career to forget the importance of the "supervisor" and to know how unfair I was, in retrospect,

to my mentors, how unfair I am to myself and, sometimes, the graduate students who choose to work with me in trying to negotiate "the system." I have just gone through another defence, this time of a black male student who has, like Jen, been treated both fairly and unfairly by our department, by white Canadian culture at large, and whose experiences of racism bring another dimension to the relationship and experience of being a grad student and to our relationship as supervisor and supervisee: there, the role in a satisfying binary….

Both experiences were gruelling for me personally, in different ways. Remembering a conversation with a colleague just after Jennifer's defence, I am forcefully reminded yet again of how deeply the process of the defence (and of writing the dissertation) are inflected with what my colleague called a "psychology of failure." More senior than I, and just as desperate not to replicate this process, this colleague says she feels as if she should refuse to work on examination committees anymore. This seemed like a logical answer at the time, more so after the second examination. (And in between, another student has completed his candidacy examination in fine style. The committee is very happy with his "performance." Afterwards, he weeps in consternation at the process of oral examination; not given to self-recrimination, this man has had an awful time at an exam that we all thought went swimmingly. )

After three of these events, I still cannot sort out what goes wrong, what I could do better – if anything – and, more crucial for me, whether my students are being ill-served by my supervision: more accurately, by the fact that I, Aruna, am their supervisor. Rethinking this and rereading Jen's recollections and theorizations above, I find myself still chafing at the implications and constructions of that role: My Supervisor. I have been angry when Jennifer doesn't call me by name but by role (What does my supervisor think? Where is Aruna? her friend? even her mentor? the woman of colour?). It makes me angry and yet I don't say anything about it, don't take it on as I would another false construction. It is false, but isn't; it is a necessary fiction, I know.

I think back to my most important mentor and friend, a woman who modelled for me what a supervisor or an academic mentor (a woman in academia) could be, as opposed to what she couldn't or shouldn't be. And I remember her deep hurt – I was then surprised that she could feel hurt – that her students, her friends, some of us her supervisees, would or could not share our real trials and tribulations with her, would not let her into our lives when those lives seemed on a collision course with the academy. At the time, I thought her protestations seemed forced: does she really care about all of us?, we wondered in a not-so-rare moment of us-think. Of course she did. Like me, she was acutely aware that there were power relations at work; she taught me that these relations were always shifting, never static, even for "A Supervisor." I have forgotten those lessons now being one, however, am tempted by that binary of us versus them just as I wish they, the students who are not students for long in the scheme of things, would not be so tempted by it.

Sounds like me against the world, doesn't it? At the vulnerable time of defences, it can feel that way: differently for me, securely tenured, comfortable as the narrative would have it, but fighting three times

around a sense of paranoia that my work in anti-racism has taught me is not so paranoid really: are my students (mine, she says) being punished, disciplined for my perceived shortcomings as a supervisor – my laxity, over-supportiveness, lack of rigour, encouragement of creativity (these are the stories I hear about myself)? Why do I feel as if big brother and big sister are watching over me as well? At what point do I share these concerns with students – where is that peculiar point of negotiation between institutional silence (which I represent), a silence intended to be protective, and institutional silence that in its protectiveness fails to protect the student who must know, if she is to survive contentedly, the politics and personalities at work? Is it appropriate to share my own fears and anxieties? These are the questions I ask and, to the last, my response is "of course it is." Where the negotiation and the finesse come into play is in interrogating myself about my motivations: there is only a political and ethical difference, in the end, between revealing academic processes – the politics of which we are all acutely aware, especially if we are racialized, sexualized by the academy – and complying with them, engaging students in the inevitable dishonest process of picking sides, allying ourselves with particular personalities and with political, curricular, and other agendas. Certainly, we all do this to some extent: professionalization in the end is professionalization into the seedier aspects of academic life, but I like to think that there is a difference between asking students to look at that seediness squarely and confront it, and inveigling them into inhabiting it. Surely, I used to think, feminism has taught us that: just as surely, in many cases, it has not, just as an awareness of racism or ableism is no guarantee that those of us experiencing it will not succumb to the seedy.

What peculiar dynamic is it that makes me feel responsible for lack of perfection? Especially when I am convinced that the dissertation process is a process of professionalization in the narrowest sense of the word. It is the one place perhaps where we don't encourage risk or creativity, true intellectual activity, but despite ourselves wish our students to meet a status quo requirement: can you do this exercise as well as and within the same parameters as everyone else, and by committee? Can you contribute "uniquely" and "originally" to the field in a (sometimes) mind-numbingly unoriginal and conformist form? I remember trying to explain this to Jen, about mid-thesis. Truth or not?, I thought, when she asked if her thesis was good. Try to explain supportively, if you can, in the worst moment of thesis-writing (the middle) that you feel that the dissertation form encourages mediocrity, covering your ass, five chapters intro and conclusion, a particularly conceived apparatus: scholarship often outside of intellectual interest. Try to explain to Jen that no thesis you have ever read (aside from those that kick against the pricks and get through miraculously anyway) is exciting, original work. Try to explain that technically, it isn't even necessary for the work to be intellectually excellent, well-written. Try to explain that to someone like Jen who has a great investment in perfection, like so many academic women: do it better than the rest or not at all. And so I tell her it is fine (which it is), damning I expect with faint praise because to me it is important that even at this stage the machinery of the academy be revealed.

And, yes, I tell her that the performance of confidence is the thing. That however she feels, she must perform as if she is sure of herself in that oral examination. And she performs brilliantly in her defence. In my inexperience, naïveté, unawareness of the political undercurrents of decision-making, I am taken aback by the committee's lack of enthusiasm for her project, their (to my reading) lack of awareness of the intellectual and personal risks Jennifer has taken in her project, or the scholarship that has indeed gone into that work. Imperfect, yes, but more than passable, especially with a good defence. She passes, but the "substantive" revisions she is asked for I know will (temporarily) feel devastating: an attack on herself, atrociously badly timed (Paul is due any day). Even I cannot muster up the good will to congratulate her for what is the most important accomplishment after all: passing the dissertation and defence. My mistake costs her dearly, demonstrates my sensitivity to nuances that I should not have shown such sensitivity to, models something I should not have, even as I am devastated as well; not by the result itself, so much as the way it is arrived at, by my not fighting hard enough (what? for a child as a parent would? I reject that model; it is insidious) for something I believe to be true, even if it is equally true that the dissertation could use extra work.

The next time this happens I am ready and heartily congratulate the "candidate" for passing, revisions or not, as I should have Jennifer. I expect too that I was much more invested in her feelings than I was in his, that I was responding not only as A Supervisor but also as a multitude of other things. I wonder in the usual silence around these things whether I am the only supervisor who has students get through with a "pass, but …" and I wonder if others feel as overseen and untrusted to make sure the revisions are done satisfactorily.

I haven't discussed Jennifer's motherhood, the overt presence of the pregnant body in that examination room, our ongoing discomfort in academia with the visible traces of maternity, of embodiment of any kind. I have seen first- (second-?) hand women I know undergo the scrutiny – almost always silent – of male and female academics: how does the pregnant woman, the woman with the stroller, challenge us? Even with the incursion and establishment of feminism in the academy (and certainly in our department), how precarious is her position: she threatens that feminist presence just as much as she threatens the patriarchal underpinnings that have always elided maternity (and paternity) in the academy.

That was another unspoken in the defence: a committee comprised entirely of feminists. How were we to respond to the urgency of the timing and still remain "good" feminists? Did we disembody Jen in our desire not to make excuses for the visible potentiality of Paul in that room? Even in our discussions about the amount of time the revisions might take, I am suspicious that we assumed that having two children to take care of afforded Jennifer a luxury that others might not have: time "off" to do the work right (and, of course, that's just what Supermom did, hand in a work not just revised to meet our demands but revised so well that she put us, I think, to shame: this should have been post-doctoral work).

The underside of this, of course, is that it lets us off the hook entirely: taking the life of the student into account can be the humane thing to do, can rationalize our decisions, but can also be the most insidious

process ever. So we do not discuss it carefully, as one element among many to consider, even though the thesis itself carried and tried to thematize the anxiety of motherhood, of the maternal, pregnant body: perhaps too subtly, "theoretically," but it was there and demanded, I think, a more careful reading.

And this is where, especially given the most recent defence I attended, my nagging inner voice gets the better of me. At what point can we/do we/should we talk about privilege: economic, class, race, gender, sexual orientation? The rules say we should not, but the rules are founded on systems of privilege already. A large amount of projection (especially among women, I would argue) occurs in this process of deciding who will become one of us and who will not – and yet we are not especially vigilant about our own investments, our own shifting places in academic hierarchy. (In this "us" I include graduate students, for the academy models this selective amnesia in its professionalizing practices, and once we allow ourselves to talk of race, of disability, of gender as a factor, we shift far too quickly into a discourse of blame and victimization, asserting that to bring these factors into consideration, to be considerate in other words, is to capitulate to the worst forms of excuse-making. Yet again, we buy into the notion of objectivity, equal playing fields, and the like).

With Jen, we disembody her, and she then fights for and against this disembodiment herself. Like me, but with a difference (my fight for embodiment has never had to include the vicissitudes of pregnancy and motherhood but is about invisibility instead – although I remind myself that I have not had children specifically because of this disability), Jennifer is in many ways the perfect daughter of the academy: just compliant enough, academic enough, comfortable enough within its confines that she will be disciplined just enough to teach her a lesson or two. A white middle-class woman with enough economic privilege not to make any of us feel too uneasy in the ivory tower. The mythical (and actual) "excellent" student who "we" know will go far … The corollary, perhaps being, as she pants her way through the last of her hoops, that we should then push her just that much further. I truly wonder what it must be like to wander our halls, peopled with as many women as men these days, pregnant or breast-feeding or diaper-changing. It humanizes, for sure, and I hope has done as much as theoretical musings have to condition Jen's approach to teaching. Perhaps that vulnerability is one way of keeping the teaching self honest, approachable, facing the students, even as she buttons up her blouse away from them.

And certainly, that particular facet of Jennifer has done me far more good than "supervising" ten perfect dissertations: in holding Anna and Paul close to me, in watching them hunger and cry and wet themselves and smile and laugh in the halls of academe, in smelling their baby smell and hugging them close to me (the real benefit of working to maintain friendships through the shifting sands of power), the cynicism and fear and (sometimes) despair about the humanity of our profession leaves me. I will never forget Anna's delight in stepping into a muddy puddle the day the final thesis was (first!) handed in, her atavistic pleasure in that dirty water and her ice cream cone.

Jennifer has completed a process that she should be proud of for herself. She has negotiated the peculiar vicissitudes of being a graduate student with dignity, has started to recognize both the falsity and the power of the binaries (student/teacher; supervisor/supervisee; mother/academic) she inhabits, and has chosen to remain within, negotiating. She is a fine mother to two children whom she has shared with me and with others here, and, as important, she has embarked on what will feel like a perilous path of activism-in-academe. She has done most of this all by herself.

Jennifer:

March 2000:

The revision process is unspeakably painful. It takes a tremendous amount of will to return to a project I am so tired of, to set aside the frustration at still being at this ^@%#%@%% desk almost a year later than I had planned. The vague process of pleasing the institution in the defence has become, quite literally, a process of reconciling some very different perspectives of my project in what feels like "pleasing" the individual examiners (even as their critiques are accurate, helpful, and supportive), though not Aruna, who has maintained throughout that the project is mine to write and revise as I wish. Here, I feel more academically daughterly than at any other time in the process, and I chafe some more. Aruna reminds me constantly that this is merely an academic exercise to be completed; if you feel bogged, she advises, do only the minimum. I've never been good at that, particularly when I really do care about my work. It takes a long time to absorb and sift through the critiques, to find confidence in my project and the determination to make it my own, and, oh yeah, to stay awake and to think in complete sentences. This juggling act is the hardest thing I have ever done.

I didn't schedule a winter of illness into my daytimer. Anna throws up on me for a week (Paul for a few days). Anna is hospitalized, dehydrated from a wicked flu and with a violent allergic reaction to penicillin. Then I get sick. It is a month before my thesis revisions are due, I'm still teaching, and this is clearly a stress-related illness; my (female) doctor looks me in the eye, tells me I'm too young to have this illness, asks who is looking after my children, threatens to hospitalize me if I don't rest. I nap in between working on my thesis and preparing to teach, knowing that recovery will only come with the end of this @^^#^^# thesis. (It would, of course, be so easy to blame my partner; he's a convenient target in all of this [another insidious binary emerges], but I have, being a good daughter of patriarchy, performed, consciously or not, the "super" roles to their logical conclusions. The circles under his eyes have their story too.)

I am angry at myself (another symptom) for not planning better, doing better, for not being able to get

up at five every morning before Anna and Paul so I can do my "academic" work, and for not realizing in advance what I was doing to myself in taking on motherhood, teaching, thesis-revising, and community work. I should have known, I mutter.

The phrase "postpartum depression" hovers about. I decide to rename this condition for what it is: chronic patriarchy.

\* \* \* \* \*

A month later, I am receiving kudos for my revised thesis and advice on publishing it as a book. Relief and confidence merge. I notice how I am feeling like an "insider" in academia now, because of the forthcoming piece of paper, and how disturbing and insidious this is. I notice how quickly I am letting the pain and struggle of the last eight months fade into memory, into the it-wasn't-so-bad-after-all mode that is part of my cycle of being.

I vow to remember.

\* \* \* \* \*

Recently, the CAUT bulletin published a piece called "Why I Didn't Write the Article I Was Asked to Write," by Elena Hanna. In it, Hanna takes an ironic tone and explains that she hesitated to write about the issue of career and family for women academics because "I was afraid to tell the world I thought women academics, particularly those in science, were unfairly burdened with the double shift of total dedication to career and total dedication to family" (2). She writes of her fears of the backlash and denials she would receive in citing research showing the problems academic mothers face, and she concludes by saying she was afraid she was "mired in the past, in the way things used to be, and that young academic women would resent what I had to say" (3). While the irony of the piece is inescapable, foregrounding the very burden on academic mothers/women in terms of family commitment, I found myself angry at Hanna, like a daughter angry at a mother for not telling her truth, for not providing me with the evidence that the insanities of my position are not all of my own doing. I want someone to show me how to do this. I don't know of any other women doing what I have done (borne two children while completing their PhD), and it's easy to think that if I'm having trouble coping it's my own stupid fault. It is so frighteningly tempting to dump all of the academic work to be a full-time mother and I know I need time to think this through.

Aruna:

April 2000:

I read in the *Globe and Mail*'s "Lives Lived" column that my PhD supervisor, Maqbool Aziz, has died. I am surprised by my own grief. Ours was a purely academic relationship, or so I thought, and we had stayed in touch only sporadically since I left McMaster. I was angry that the powers-that-be had not informed me of Aziz's death (almost a month earlier), that I had not been able to attend his memorial service, say my goodbyes with everyone else who cared for him. I clearly expected, after all is said and done, that someone in that academy should have known and cared enough about this relationship to let former graduate students know of his sudden death, and I remain angry about that. What is more instructive, however, is that that relationship had such a profound effect on me: Aziz was not like a father or a parent, but I suppose he was the closest I might get to the academic version of one, and I owe him a debt of gratitude that I can now not repay. He supported me through the very lonely process of dissertation-writing, broke rules he should not have at a particularly problematic defence (my first face-to-face experience in the academy with racism), and did not waver from his perception of his role as my guide and mentor, even through the very seedy politics of that final grad school moment: he did not succumb to them. He also was an intellectual mentor in the truest sense, but never ostentatiously so I don't know, in fact, if I have ever fully appreciated that. I was fortunate, of course to have an academic "mother" – a feminist mentor as well. Perhaps I have been fortunate to seek out and establish connections with people who are willing to mentor me as I struggle through the complex process of mentoring others (often through this act of "supervision"). Aziz was, as my father was to many students, a guru, a mentor/supervisor who modelled for me ethical ways of progressing through the academy, even as he (and I) limited our relationship carefully, hoping that it would not get messy, as Jennifer's and mine has: a real-world kind of messiness for which I am grateful and for which I have worked hard to find ways to negotiate.

But, official memories aside, I recognize that even that traditional relationship did get messy. Aziz taught me as nobody ever had before the problematics of being racialized in the academy. He was the perfect example of the man of colour, colonially educated, and perpetually because of racism; complex, but always reduced by others, including graduate students, to a symbol of what was traditional (and many of us thought reprehensible) about our discipline. Only in the act of working through, at his behest (command, actually), my own investments in and lack of knowledge about my history as a South Asian woman did I learn more about myself, about a repressed history of South Asianness, of femaleness, and of racialization. This act of research (about which I was quite resentful initially) revolutionized my work and my being in profound ways that even my earlier hearty embrace of feminism had not. Traditional he might have been, but motivated for reasons I think few people wanted to recognize – that he was a dark man from a no longer extant country

who had been profoundly displaced by partition, one of the most capricious and harmful events in British colonial history, and who embodied that displacement and taught it. His name was Maqbool; many called him Mac, a good pronounceable name. This is a long eulogy of sorts, the only one that I am able to give to someone who taught me that academia has its rules, rules that are capricious and always mitigated by privilege and power. And at our weekly supper meeting in his home during my final months of writing that dissertation, he introduced me to an astonishing variety of mustards and chutneys, fed me karela, talked of gardening, of India and Pakistan and Henry James, warned me against expecting too much of that thesis work – it is just a hurdle to jump; don't worry too much about your jumping style – and kept an awful lot of secrets as well.

## May 2000:

As I reflect on all I've written, I realize that I have not written what I set out to. I recently heard a talk about the reality of the glass ceiling for women academics today. I have heard talk of it as a slippery "moving target": now you see it, now you don't. I believe that the process of professionalizing graduate students is in good part a process of teaching them to acquiesce to a feeling of both powerlessness and entitlement, the former already a reality for many women inside and outside of the academy, for people of colour, for people with disabilities, for gays and lesbians, for the working class. It is the sense of entitlement that academic processes afford that is as dangerous, and it is a danger that very few of us avoid once our work, our being, has been academically sanctioned. Both entitlement and powerlessness contribute to the situation Jennifer describes leading up to her dissertation defence, and they are possibly laid bare only in the situation of this defence: when we, the professors, perform and take very seriously our role as super-visors, overseers of our profession, without the necessary rigorous self-reflexivity and humanity that might ensure that we do not contribute to or model a psychology of failure, most often in the name of replicating, or reacting in some way to What Was Done to Us. If nothing else, I hope that I have been able to provide in small part what my academic mentors provided me: encouragement to differ as much as I wanted and needed to from them and their (personal and academic) paths and a sense of my own worth as an embodied intellectual. I still return to them – in memory and in person – often.

## Jennifer:

### April 2000:

I think some more about Aruna's description of the student/supervisor binary as a "necessary fiction." In talking about this paper she refers to the desire of students to occupy this binary unthinkingly, and I have been wondering why we do so, so readily. Part of it is the individualism of the institution and the disturbing comfort the subject position of student affords. As we students typically focus on how the institution infantilizes us (and this is true also), we are also in a position that can afford us the ability to claim all success as our own (the individualism of the institution, the refusal to recognize formally the influence of the supervisor in intellectual growth or the development of "original" research), and to blame failures or problems on supervisors or the institution at large, even as they might be our own. It allows us, as Aruna points out, to erase our privileges.

I have been struggling throughout our relationship and in the near-year of thinking about writing this paper, to understand and articulate how I have constructed Aruna, and therefore myself, through this relationship of supervisor/student. It is not accidental, I think, but an effect of this necessary fiction (unnecessary truth?) that there are certain aspects of my role in the maintenance of the binary that are just now becoming visible for me, now that I'm on that mythical "other side," on the inside of the PhD club.

I withheld from Aruna a great deal of my life of the past few years. And it's tremendously difficult for me to sort out how and where the reasons are about my personality/personal baggage and how and where they are about institutional structures and systemic inequalities and power relations. A common refrain among many of Aruna's supervisees is that we are afraid to show her our work in progress, the unspoken narrative being that we want to please her; we don't want to disappoint her, don't want her to see us trip over our conservative politics; not only because of her role as supervisor but also because of our profound respect and awe for her work. But there's another construction, one already named by Aruna: the assumption that our supervisor can't possibly care about us that much, like us that much, or that such concern has to be based strictly on our academic performance or political acumen.

For me, much of the unspoken in our relationship has to do with my privileges as a white, able-bodied woman and my ability to mask (deny? repress?) my own conflicts and emotions and doubts, saying "I'm fine" a lot when I'm not, but also assuming I will be somewhere down the road. Often I don't talk about the conflict or problem at hand because I recognize, particularly when it comes to institutional matters, that the "problem" is a construction (i.e., the institution's production of students whose identity and self-esteem are attached to academic performance) even as I'm succumbing to the power of those constructions. It's a tiring place to live, in perpetual tug-of-war. I think a lot about mice on wheels trapped in see-through plastic spheres.

More importantly, though, race does complicate the student–supervisor relationship in so many ways; I have begun to wonder how my withholding from Aruna, as friend *and* supervisor, even as she continued to be open with me, sharing much of her academic and personal life with me, was my unconscious enactment of white and able-bodied privilege as well as a reconstitution of the institutionally produced student–supervisor binary. I often withheld saying what was going on personally with me because I thought it wouldn't be polite (where did that come from?) nor appropriate, as a woman privileged by race and good health, to complain (I didn't think of it as sharing with a friend) about the ups and downs of my life. Somewhere lurking still was the/my ideas about how a graduate student is supposed to perform for her supervisor. As Aruna talked openly of her experiences of racism in the academy, as she shared some of her ongoing experiences as a diabetic and epileptic, as a woman in the world, I listened, but what I didn't always hear, couldn't hear, were not only the gestures of trust and friendship but her active resistance to the falseness of the binaries, the embodiment of her politics. I never wanted to construct her as the caretaker of the guilt-ridden white woman working through her racism (recognizing that the student's thirst for the supervisor's recognition, just as my baggage about my likeability, is also systemically produced and wrapped up in our relationship). But I do know that at times, when I withheld my struggles from Aruna (usually in thoughts like "I shouldn't dump on her"), I was performing (unconsciously, thinking I was just being polite) a version of middle-class liberal whiteness (or a version of graduate student, or both?) – by not sharing with her, I was not only performing the stereotypical suffer-in-silence role that patriarchy is so fond of (as is the institution – don't complain, be grateful we let you into the program), but maybe I was also reproducing that dynamic in which minority peoples perform their pain for us, as if our silence equals respect and change.

## May 2000:

I am having trouble seeing if I have changed anything at all, or merely succumbed – to patriarchy, racism, the institution, my baggage, fatigue. I write this even as I know this response is just another effect of it all.

I have moments when I think that the seemingly perpetual micro-material realities of parenthood will drive me crazy. (There's *more* gunge? O, gee, more laundry and dishes. I did a PhD for *this?*) I sometimes feel like I am the only mother in the world with a PhD in post-colonial theory. (I am definitely the only one in my southern Alberta town of 3,500 people).

How weird am I? (And is this feeling just another symptom of chronic patriarchy?)

Then I have these other incredible privileged moments (unsolicited hugs, winning smiles, new baby and toddler skills accomplished) that make the labour all worthwhile. I know, too, that I will miss these days. And there are moments when I recognize that my academic life does have a positive influence on how I parent (Anna's insistence, for example, that it's a snow*person*, not automatically a snow*man*: a minor victory, perhaps).

I would like to think that I can have an academic life and be a mother. I would like to think that the micro-materialities of motherhood have sharpened and nuanced my theoretical perspectives. I would like to think that motherhood will bring a groundedness to the work I do.

I would like to think that I will be able to resist the institutional pressures to disembody myself, to somehow (impossibly) separate myself from Anna and Paul, to wear masks, to do the daughter-dance on lines rather than kick at them and erase them.

While it will feel like madness most of the time, I know that continuing will be an act of sanity.

# Tanis MacDonald

## A Valediction: of the Booke

January teaches the sun
an unruly chill; I must read
forty books before April.
My poetry professor swore
an oath against love last fall,
but now has been dropped
into it like a rock in oil.
My professor sports a chunky
gold ring and a mouthful of
peaceful teeth, takes more breaks,
tells more jokes. The smart girl
in the Donne seminar unwinds
her thick rope of hair,
a sensual shock that stretches
to her waist, or pools like syrup
across my desk. On dark library
afternoons, she studies
with her lover, his spill
of hair as long as hers, two dark
heads rapt with text and each other,
Siamese twins joined at the temple.
Solitude is for other people.

The professor wears a new shirt and a watch that runs slow.
We argue about Donne's metaphysics,
his ordered crush of language,
disparate feet of a compass
pointing to love and grief.
The professor scribbles
A's on a stack of unread papers,
fiddles with a pencil and watches
icicles on the eaves lengthen
to spears. A long brown hair
lies across my desk. I wind it
clockwise around my pen ten times
before it breaks. Ten more weeks
of winter. Ten weeks until
the far-flung foot of my compass
draws an absolute arc,
before icicles melt to fill
every available vessel,
even the cup I carry to class,
a curve of liquid nudging
the rim, easy to spill.

# Nisha Karumanchery-Luik and Helen Ramirez

## Teaching for Legitimacy;
### or, Tea-ching from the Margins

### Beginning

Over endless pots of tea, we have had many conversations like these where we struggle to work out our ethical and material needs with an institution that on one hand offers both promise of intellectual freedom and membership, and on the other subjects us to marginal status. We are two women who through long and engaging discussions are trying to resolve the intricacies of our relationship to the university. Through these conversations, we have sought to clarify how our race, our age, our material conditions, and our gender have provided interesting and sometimes painful illuminations on the external world's perception of our legitimacy as scholars. As you imagine our tea conversations, see us as a woman of colour and a white woman who have found ourselves profoundly in accord with this dilemma as we seek full-time employment and ponder what it is we must do to find acceptance among colleagues and students alike as legitimate scholars and teachers.

We found each other partly serendipitously and partly through need, as part-time instructors while teaching the same Women's Studies course at the same university. As our courses proceeded and our sense of alienation within the institution increased, we sought out one another regularly to find support so we might work out the meaning of our shared frustrations. So, we did what women have done for decades: we met in our homes, where we plotted new directions and strategies to what seem like old problems. Over tea and the disruptions of children and animals, we delved into ideas and explored with critical attention the causes or themes of our frustrations. What follows are our voices, seeking ways into academia that acknowledge our right to be both scholars and teachers without losing those values that frame our feminist consciousness.

And so we begin this present conversation by establishing how voices are lost and recovered persistently in ever new configurations of meaning.

## Losing the Fear: Legitimacy of Voice

**Nisha:** Finding my voice has been a long, arduous process. I have only recently been able to deconstruct and understand my voicelessness in the past. Examining my experiences of silence, especially my silence in grad school, I begin to see how the power dynamics and politics of academia and how various forms of oppression – for me primarily based on race and gender – have worked in my life and how they have influenced me profoundly.

**Helen:** My experience, Nisha, is similar. My voice has only become stronger since graduating. I feel freer to speak, act, and move without sensing the full weight of judgment or inadequacy one often feels as a student – and yet … is teaching all that different?

**Nisha:** No, teaching also presents us with this dilemma. And recently I've discovered that I really enjoy teaching, which is miraculous since less than eight years ago I was terrified of public speaking. However, teaching at the university level can be a challenge for other reasons. You have your authority questioned and sometimes undermined. Being a woman is certainly part of it, but other aspects of my identity also come into play. Being a relatively young-looking South Asian woman – I'm in my mid-thirties – sometimes my students don't know what to expect or make of me – that is, of course, until I open my mouth and my strong, clear, "unaccented" voice sounds from my seemingly small mouth.

**Helen:** Your point about accented voices is immensely important. It's clear how stereotypes act to obliterate the value of voices that sound different to the ears of those in the majority.

**Nisha:** So, my race, my gender, and my age have all, directly and indirectly, impacted on my experiences teaching and working in the university setting. Often it's subtle. Sometimes it's not so subtle. Sometimes it's a student who feels the need to challenge or question everything, from lecture topics to why the final exam is worth thirty per cent instead of twenty per cent. I try to be "nice" and "approachable," but at the same time I don't want them to think I'm a pushover or mistake my pleasantness as being a weakness, which leaves me in a double bind. I want to be open to students' needs, but I don't want to be taken advantage of because they perceive me as being accommodating. The mainstream stereotypes about South Asian women suggest that we are weak, quiet, accommodating, and submissive, characteristics that I usually don't embody. And of course, these stereotypes are based on myth and not the reality of our lives. Although we may have many

experiences in common, there is tremendous diversity among South Asian women and any stereotypes that try to define us using one or another quality are suspect. As the instructor, I can't afford to be stereotyped in those ways. I guess I do exert energy so that I'm not seen as weak or overly accommodating. Certainly in my classes, where it's appropriate, I try to get the class to examine and discuss diversity and stereotypes. I guess it's all part of the process of learning and unlearning.

**Helen:** My worry is mainly that students, instructors, institutions are all so reluctant to change and are therefore poor at what you call "the process of learning and unlearning."

**Nisha:** If that's true, then how much energy should I be expending to break those stereotypes in order to be heard and taken up as a legitimate scholar? And what happens if I don't or can't? What kinds of fallout must I anticipate? I was once told by a well-meaning colleague that I'm lucky I don't have an accent and that students would respond to me differently if I did. What exactly does this mean and why? My knowledge and my ability to teach would be the same with or without an Indian accent. Often professors with British or French accents are treated with respect. Indeed, in the larger society, these accents are valued and considered attractive. Why are Indian accents or Chinese or African accents perceived differently and often scrutinized by students and others in academia? Why are these accents not valued? It does come down to value systems and systems of oppression. We have to ask who holds power in these situations and who has the authority to speak.

**Helen:** Do students have any understanding that they're being racist?

**Nisha:** It's complex and seems to depend on the situation and the specific students. For instance, while I was a teaching assistant I worked with two different professors who taught the same course. One was an older white male and the other a young woman of colour. They gave similar assignments and essay topics in their classes, but it was striking how differently the students treated and responded to the two professors. The students accepted the assignments from the male professor without question, but challenged, argued, and complained about similar assignments when they were presented by the young woman of colour. They also complained about things like "she stood in the same place for the whole lecture"! As if that has anything to do with anything. They even complained about her "accent"! It's interesting to see who is perceived as having authority in the university setting and who isn't, and what this authority is based on. I've learned hard lessons from those experiences.

**Helen:** So, what about your experiences now as the instructor?

**Nisha:** Right. In my classes, I have to work to make sure students take me seriously. I once taught a course entitled "Women in Cross-Cultural Perspectives," and I had one student who kept questioning why we

had to examine race in a Women's Studies class. She implied that I included race because as a woman of colour, race must be important to me. She didn't recognize that everyone has a race and that race, ethnicity, sexual orientation, and class differences are crucial in understanding gender relations and women's diverse experiences. Another time, I had a student who, in the last two weeks of class, threatened to go to the dean with complaints because she felt the readings for my course were too difficult – readings that most of the fifty-nine other students found interesting, valuable, and thought-provoking. She actually never spoke to me directly about it; she rallied a couple of her friends and made the threats to several other Women's Studies profs in the department; I was told about it later. Coincidently, the student had just received a mark that she was not very pleased with for an essay. She stormed into my office after class, very angry that she "didn't even get the class average," and demanded that I raise her mark. When I tried to explain why she got that mark and why it wouldn't be fair to just raise her mark, she stormed out.

I wonder if the experience would have been different if I were not a woman of colour. I wonder if she would have approached the situation in the same way if I had been an older white male professor, or some combination of these; I think she probably would not have. Other times, when I teach Women's Studies courses, some students have a difficult time accepting that a woman of colour could possibly teach feminisms, as if being a person of colour disqualifies me from expertise in that area. I guess it stems from a belief that feminism is or was about white women's lives and experiences – and, really, early North American feminisms were, but they're not any more. And so seeing a person of colour teaching the class, they may think: what could she possibly know about a white women's movement or what could she know about my experience as a white student, since she's so different?

**Helen:** You know, as I'm listening to you and trying to imagine having to deal with race on top of all the kinds of judgments I face as a woman in the academy, I wonder how women of colour learn to brace themselves – although perhaps this never comes for some women – against overt and more nuanced hits that come from so many directions. It makes me very angry; it's true for women generally, but even more so for women of colour. How can all these blocks or closed doors be anticipated? It's a battleground but often covered with a veneer of solicitude. As it is, I often feel vulnerable in class and fight internally not to allow those insecurities that arise from being observed to take hold of me or to writ them large on my face and my body.

**Nisha:** I know what you mean about those insecurities, Helen. It's something that many of us face as new instructors. Sometimes it is just our own fears and self-doubt, but other times it's how we're perceived by others.

**Helen:** I once had a student tell me at the end of a term that when she and her fellow students first heard the tone of my voice, which apparently is relatively soft, they doubted my legitimacy as a feminist! Incredibly, in this case, I was being condemned because my voice, not its meaning, failed to measure up to some preformed image of what a real feminist is.

**Nisha:** I know! One student told me that when she first saw me, she couldn't believe I was a feminist because I wore makeup!

**Helen:** I suppose it's important to see the humour in this sort of thing. Still I can't help but think it also speaks to a more profound issue. Why must some voices be given more credence – ahhh power I do know the answer – than others? This all reminds me of my PhD defence. My external-internal examiner had made it quite clear to the department head that he despised feminist theory and my use of it to analyze women's activism in Latin America, but because the department head was anxious to follow through on my defence, he convinced this antagonistic opponent to remain on the committee. I knew none of this until the day of the event itself. When it came his turn to evaluate my work he simply went page by page and questioned my use of commas – nothing more, nothing less. At the end, I felt brutalized by this individual and dismissed as a scholar of worth, even though I had passed with glowing accolades from the other members. For a long time, I could only hear the voice of this one individual as though his criticism was more valid than the others. So what does all this mean? I believe it means that as women we know that our voices, even at their most benign, can be dismissed as unworthy. As feminists, who are also very human, the result is yet another shot at our well-being, our sense of ourselves as valid thinkers and scholars.

**Nisha:** I've also felt brutalized as a graduate student. And I swore to myself that if and when I am ever in such a position of power, I want to be a student-positive professor, and not let the power and politics turn me into someone harsh and threatening.

**Helen:** When I think of this, I'm reminded of the work we do. We know, for instance, that the real power of oppression exists in its ability to seep into our very beings, like me hearing only the voice of this examiner as the sole valid representative of my work. Right now, part of my commitment to what I see as a process of understanding how to be a feminist is to learn how to say "no" to the internalization of oppression.

**Nisha:** (Big sigh). So Helen, with all of these things we have to confront, how do we deal with it? It seems all the experiences are connected, like pieces of a whole. We've struggled with legitimacy and voice as students, and we're now struggling with similar issues as teachers and scholars: when we try to get our ideas published, or when we apply for full-time work, or even in the part-time teaching we're doing now.

**Helen:** Somehow I believe these are issues that speak to a deeper problem than just the two of us. What does it mean to sacrifice our energy and our meagre security to an institution that fundamentally discounts our worth? These issues speak not simply to us, but to women everywhere who are struggling to eke out an existence against major roadblocks found in every direction we turn.

## Part-Time Status in a Full-Time World

**Nisha:** And it's frustrating to do this part-time/sessional teaching. No matter how excellent our teaching skills and how fabulous our student evaluations, it doesn't necessarily amount to much. There's no job security.

**Helen:** There's no doubt about that. The truth is it's a buyer's market. We are tossed aside as soon as a new marketable product comes on board, which leaves us jobless.

**Nisha:** Right. There are very few full-time or tenure-track positions in Women's Studies. And it feels like we need to have strong links to the "Old-er Boys Network" in order to get into other departments. Maybe this is not the case, but it sure feels that way sometimes. I know in my classes, when students feel comfortable enough, they often comment on how "different" I look/ I am from the typical university professors they are used to – read: older, white, male. And of course, there are those who see the differences and make their own conclusions about my teaching ability and possible knowledge in whatever area, based on appearances – here are those stereotypes working again.

**Helen:** And Nisha, that's the whole problem with working in Women's Studies. Not only do we look different *inside* the department, being part-timers, but also in the broader university context for our association with a marginalized discipline. It undercuts our authority to speak as though we have "real knowledge." Perhaps this is why Women's Studies is always threatened with extinction. My experience with departments like Women's Studies is that more and more they find themselves forced to make themselves more palatable to the consumer, shying away from using terms like "feminist" …

**Nisha:** … or even wanting to change "Women's Studies" to "gender studies" for similar reasons.

**Helen:** While I understand the quandary, since much of their very existence depends on enrolment, I see this as a kind of slow death for Women's Studies that rids it of its ethical and political base. How can we continue to teach about women's struggles with a clear moral conscience when we've joined the very system that actually demeans "outsiders"?

**Nisha:** Maybe then it's important to identify ourselves as part-time instructors specifically in the area of Women's Studies. When we talk about being marginalized as part-time instructors in the larger university setting, what's also important is identifying our positioning in Women's Studies as being further marginalized in the academy. And this feeling of marginality is all too familiar to me: female, woman of colour, looking younger – a negative in the university teaching context, sessional lecturer, teaching in Women's Studies – they all intersect and in the university setting serve to push me, and you, and many others like us to the margins. Since schooling and education systems reproduce inequalities found in the larger society, it should come as no surprise when we see these inequalities reflected in university structures and practices. The university is the site for the production of knowledge, but one has to ask: whose ideas are taken up as knowledge? And that's another lengthy discussion. What concerns me is that I've heard of brilliant women who have their PhDs, who have published extensively, but who have only been able to find part-time teaching contracts, for eight, nine, ten years after they graduate! How many of us can afford to live on part-time teaching pay for ten years?

**Helen:** The truth is that these days the university survives because of sessionals. Rather than open positions and provide benefits and some appearance of job security, the option is to give as many one-course teaching jobs to as many people as possible. This allows them the power to withdraw these jobs at any time as well. The result is that we dedicate all our waking hours to that one course, often because we are committed and anxious to prove our worth, but also because we are persistently asked to teach courses for the first time! What also makes me angry is a discussion I heard among tenured feminist academics claiming that we sessionals lack dedication to both the job and the students. I only know instructors who have gone out of their way for their students! and all this for a living that neither allows time to search for other work nor provides a living that allows us to pay our bills. We are patronized in our own department under rhetoric that invites us in only partly as colleagues so that the veneer of emancipation is maintained.

**Nisha:** I feel a lot of angst around the struggle to find full-time work.

**Helen:** And … there's an urgency as well, isn't there?

**Nisha:** Yes. I wonder how many of us would have pursued different career paths had we known at the time that after twelve years of university education, and having acquired three degrees, we still could face – and many of us do face – unemployment, huge student loan debts, underemployment, and poverty? For those of us teaching part-time, we all know how overworked and underpaid we are. Working as part-time instructors puts us in a very dubious position. We're always having to apply and reapply for jobs that get cancelled, get changed, or whatever else. We get hired to teach a course, we work really hard to put it together, and if

the contract is not renewed the next year – as it often isn't – we lose all that work. All that time and energy put into developing the curriculum, and planning the course seems lost. As part-time instructors we have no ownership of our work. There's no sense of permanency, belonging, or continuity. Yet I understand that universities could not function without the services of their part-time teaching staff. Imagine all the courses that simply wouldn't get offered if we were not available – bargaining leverage? Or are there just too many of us needing to work that someone else would happily fill the positions that we decline on principle?

**Helen:** I can't agree more. I don't know if I would have pursued such a rough road knowing that I would finish with no job in sight and a debt load through the roof! I support my two kids on these sessional positions and am more often than not filled with anxiety about how I'm going to meet next month's bills, or more accurately put food on the table. This weekend I was just sick with worry. This long space between teaching jobs and searching out other contract work and being subject to the vicissitudes of that claimed my sanity. I had to consider quite literally a multitude of strategies for figuring out how to feed my family, not just in August but right now! I worry about the message I'm sending my children that education is no guarantee of security. I realize this is true of any job, but to have studied for so long and to find myself grasping and grateful at the crumbs that are thrown my way – I think sometimes a dark hole would be preferable.

**Nisha:** For me teaching part-time manifests into underemployment and dependence. As a recent PhD who has only been able to find part-time work, I am absolutely dependent on my partner financially. Indeed, I would not be able to teach part-time if I had to pay for rent and groceries and all the other expenses that go along with living. So I struggle with this because financial independence is not only something I value and believe in, but women's independence is something I teach about in my Women's Studies classrooms. You know … "women should get educated and acquire skills so that we have options, and so that we are not dependent financially on husbands/partners/parents to support us." Teaching part-time fosters financial dependence. Am I not then forced to compromise and live contradictory to my beliefs and values in order to teach part-time?

**Helen:** I dream – are we allowed this still? – of a time when I can say, "Yeah, I struggled, but my life was meaningful." This period in our lives, however, seems to lack what I crave – meaning – because of its wretched proximity to rejection and illegitimacy as a scholar and thinker, and its haunting threat of poverty. I want my students to know that I have seen dark holes: I can, on some level, understand their struggle, but because of its connection to the academy, the place many of them still value or have yet to deconstruct, I feel reluctant to expose much of this side of my life. It feels too vulnerable – it's like losing yet another notch of my legitimacy. How can I ever guarantee how it might be interpreted by students? So tell me, if we're such a

strong but unorganized bargaining power as part-time faculty, why haven't we done something? Why aren't full-time faculty willing to give up some of their security and demand more egalitarian practices? And why haven't I?

**Nisha:** Helen, your point about the lack of meaning is an interesting one as well. I also feel this lack of meaning sometimes, a feeling of insignificance related to the work I'm doing. Much of this thinking happens right after I've successfully finished teaching a course, only to find that they've cancelled it for next year. Feelings of despondency also surface when I receive a rejection letter from some journal or in response to an application for a full-time job. At those moments, the excellent feedback from the students, the learning that took place in the classroom, the lives influenced and changed have no meaning. All that work for what? What I'm left with are feelings of rejection, insecurity, and self-doubt. I try to gain strength from my "accomplishments," and perhaps I need to take the higher road and say, "Well, it's all worth it because I'm making a contribution toward positive social change, and I am making a difference." But sometimes I just need more.

**Helen:** Is it possible that the only satisfying space for intellectual discovery and action is in communities outside the artifice of the academy? Should we be searching more actively for places in which we can build a new kind of community with greater and more egalitarian freedoms without compromising the ethical and intellectual vigour we remain committed to?

**Nisha:** Kind of like what we're doing here over tea, which is so much better and more balanced than dealing with the academy.

**Helen:** Yes. It allows us even more freedom to push our thinking further and find support – or even criticism – not based on the maintenance of demeaning power. I would rather think with you and others. This way I feel not only supported but challenged and strengthened to confront those overwhelming obstacles. In such a community isolation and vulnerability disappear.

## The Politics and the Personal

**Nisha:** Academia is so fraught with politics. Sometimes it feels as though it's not how successful we are as teachers, or how promising and exciting our research work is; it's got more to do with who we know and who we schmooze up to. It was that way when applying for grants and scholarships, and it feels like it's that way now, when applying for work.

The whole reference letter process is so political. Who writes the letter? What do they say about you? How long is it? Is it glowing? Do they send it once you've asked them? How do their personalities and

schedules and workloads impact on the letter? And are the contents based on merit or something else? What if they just don't care … or worse, what if they don't want you to succeed?! Okay, Helen, now, I'm definitely ranting!

**Helen:** We *should* be ranting, we should be shouting, we should be saying something about the injustice of a system aimed at evaluating us through categories that don't open up spaces for new forms of knowledge but limit real creative thinking – the type of thinking that also demands change – and herein lies the problem! And yet how to do so without having doors slammed in our faces! Working on the inside, the institution wants to know if our work will earn it a higher profile – that is, supposedly superior students and therefore funding. This reminds me of bell hooks saying her students at Princeton were no brighter than her students in Harlem – it was simply a question of who had hope, and the kids at Princeton knew they were going to succeed whereas the ones in Harlem understood the depth of those walls blocking their way at every step! I think about this a lot. I think about do I want to produce work that will open doors or do I want to produce work that remains rooted in the demand that we be allowed to think rigorously and within a realm of freedom? What type of world do we live in where we make meaningful work more and more difficult to attain? A world where women more regularly than men must rely on contract and part-time positions. As the market shrinks, even this will be taken away from us as men too look for work among part time and contract positions.

I feel as though all our ideals, our beliefs in a caring society, are being pushed further to the sidelines as the constraints of government funding disallow considerate attention to the difficulties of those struggling to survive. As I did my PhD and now as I endeavour to put together paid work, my struggle becomes even more difficult. We tire, we feel as though we are being bombarded from every direction, constantly doing damage control, never having time or energy for making more substantive changes – really not even having the energy to think and implement a plan for such change. I worry about what will happen when there is no more energy.

**Nisha:** This gets back to the idea of community. I get much of the needed energy outside the academy, from like-minded friends who understand the issues and the politics and what's at stake.

**Helen:** We may still be living a kind of contradiction – you know, these strong principles we hold that seem to jut against the aims of the institution, but because we have this support from individuals outside the academy, I feel we're better equipped to confront the ostracism we find in the institution. But I can't help wondering: do we stay outside the institution's door knocking to be let in because of ego? There must be more to it than simply this. We must believe in what we're doing and ultimately be getting some satisfaction from this relationship. So what could it be? Why do we stay?

**Nisha:** Why do I stay? It's important to me that I teach anti-racism and use feminist theorizing to expose and examine oppressive structures. I feel that working in these areas and teaching about these issues is something I have to contribute. And in order to teach these topics, I required my PhD. That's really the main reason I decided to pursue doctoral studies. Also, this work can be immensely rewarding in that working for equality and justice allows me to earn a living that is meaningful to me. Plus I feel connected to a larger movement. Feminism is nothing short of a revolution, and I know how profoundly my life has been impacted by it! Hearing students say "This knowledge is changing my life or has changed the way I think about or experience oppression" is rewarding. So I continue.

**Helen:** Nisha, there isn't anything you've said that I'm not in complete accord with. Yes, teaching is important although immensely challenging for me, which gives it a bit of an ambiguous cast as I struggle to learn more about how to be an effective teacher. I love good conversations with students. And shouldn't the university be the place where this exchange of ideas is valued? What I'm seeking to do in the classroom is draw more on what I learn in my life outside of the academy, hopefully to make feminist theory more applicable to the lives of students. I find myself withdrawing from that arena of competition where my c.v. is tossed in with hundreds of others, all equally deserving a position. I need something that will feed my family and keep me connected to students.

Soon, though, I will be perceived as "old material" and put out to pasture as new instructors just finishing their PhDs enter the job market. Mostly, though, I wonder: in the whole scheme of change, am I really making a difference anywhere? Have I added something new, something of value? I doubt it. Maybe it's better to think of myself as simply a foot warrior, although I shudder at using such language. Our predecessors fundamentally altered social theory and our understanding of rights as a society. I don't want to forget. Nor do I believe we should ever relinquish our vigilance.

**Nisha:** Maybe this is why our conversations are so important – we're keeping watch.

And so we continue our discussions over tea, grateful for our friendship and the opportunity to talk about our shared struggles and insecurities. Our tea ritual has become not only a safe space and time to talk over anxieties and doubts as part of our self-care, but also a time to be supportive of each other and share strategies, laughter, and growth.

With September around the corner, we brace ourselves for the cycle to begin anew and hope we have the kind of energy required to continue on this path. We are hopeful that this process of talking and thinking through, and now sharing these words with others in the same predicament, might result in improving the conditions of our lives in relation to the work we do in the academy, individually and collectively.

# Juggling on a High Wire

## *Fiona Joy Green*

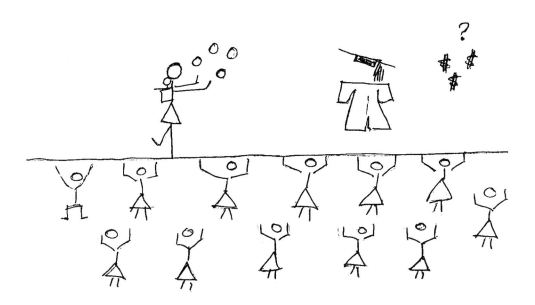

# Women in Difficult Spaces
# Daisy Beharry

August 1, 1994. BWIA Boeing 747, Flight 604, is parked alongside the departure lounge at the Piarco International airport. It is a typical morning for that time of the year – clear skies, clean air, 27°C. An invitation to the beach.

On the treed route that links cities and towns to small coastal villages, cars whoosh by, the sun glinting off their bumpers as they hurry east to find the best spot on the shoreline. Sticky human bodies anticipate frolicking in the waves. In two hours the heat will be so intense that a watery mirage will shimmer above the road surface.

I will not be on this road again for a long time. I am leaving this, my favourite drive, the warm sunshine, the ease of living, and a good job to go and live in Canada. The decision has been slow and deliberate. My husband and I have discussed migration at length. As wife and mother, the weight of the decision rests on me. Do I want my children to grow up in a foreign land? Am I prepared for the struggle to make ends meet while supporting and encouraging everyone else in the family?

It seemed that I was the one who was engineering the future of other people, yet secretly I myself felt professionally diminished. I feared that I would not continue as a teacher right away. It would be a long wait before a newly landed immigrant could find employment in a profession such as teaching. Besides, the main concern at first would be to learn our new environment. Vague as it was, though, a nagging idea that I might continue my studies in Canada stayed with me. I could not see myself as totally divorced from a school environment.

Even with the realization that I was giving up some of my independence, I convinced myself that I had no choice but to migrate. Crime was on the increase in Trinidad. Every day there were reports of breaking, entering, and killing. Several members of a family could be killed at one time. Murderers made away with jewellery, money, television sets, stereo equipment, and anything else that suited their fancy. When our own home became a target, we thought that it was time to move.

Little did we know that in fleeing from crime in one country, we were running headlong into the despair and loneliness that await immigrants in another. None of the many friends and relatives with whom we had discussed migration had even once mentioned feelings of isolation and depression. So, in our ignorance, we packed up and left the people we knew and the surroundings in which we had played marbles and fished, had been educated and gained jobs.

Eventually the day of departure arrived. There was no turning back. In the final analysis, I had made a decision that would determine the lives of three other people. At that moment, it seemed to me that women are always trapped in situations where they are liable to feel guilty. I was taking these people away from their relatives, away from the familiar and the comfortable.

I felt my thoughts growing larger and larger: how long would it take us to find a place? What jobs would we get? How long would our money last? What were the minimum things we needed to set up house? I felt my brain would pop. While there was no thrill, no real tingle of excitement about coming to Canada, I never expected this overwhelming anxiety. Where was the detached rationality that I had exercised in my decision to migrate?

Even while imagining a life of bare survival, I felt that women demonstrate a unique foresight and pragmatism when they think that their families might be at risk. So for me, there would be no turning back – at least, not yet. I would give our new condition a good fight.

Finally, we reached Toronto. At the Lester B. Pearson Airport, my family was taken to another room for an interview by immigration officials because we were landed immigrants. There we were questioned about where we were going to live, how much money we were bringing into the country, and – Welcome to Canada! the immigration lady added, "English instruction is available in Kitchener. Check with the Multicultural Centre." My husband and I puzzled over this remark but we had no explanation. Several thoughts raced through my mind. I wondered if we had checked the wrong box for language on the immigration forms. That seemed unlikely. Or was it assumed that all people of colour could not speak English? Or were all newcomers to the country, whether English-speaking or not, required to learn Canadian English? Whatever it was, I was dealt my first sharp blow in this country. I felt as though I was left without a language, or at best, that my language was not recognized.

It was not until much later that I realized that although we were in an English-speaking country, we could be in certain areas, like the sausage stalls at a farmers' market or in the vicinity of Westmount and Victoria, where not a word of English was heard.

Language differences show up acutely in the Kitchener area in almost every situation. For those whose first language is not English, it must be pleasing to communicate in some measure in English

when they need assistance in offices and stores. Conversely, for those, like me, who have spoken English all their lives, it is perplexing to find themselves not understood.

On the myriad immigration forms we had filled out, my husband and I had checked our language as English. We were to be proven wrong in Canada. We were made to repeat ourselves in public places. We realized that people did not listen to words; they listened for an accent. Or rather they listened for Canadian. Any English that did not sound like Canadian speech was an accent; therefore, the Canadian language had no accent. If my logic is right, then Canadian is deemed the standard for good English.

I remember a conversation that I had with an originally Trinidadian woman who had lived in Canada for many years. It was during coffee break at Kmart where she was a regular employee and I was working, stacking shelves for six weeks. With us were two white women who asked me about my background. (I've had to do this numerous times in this country, and it never feels like a conversation but like an interview.) While I was speaking, my home-country friend remarked, "You have an accent."

"Yes, I do have an accent. A Trinidadian accent," I replied. "And you have an accent too. Canadian."

"No, I don't have an accent. I speak like a Canadian." to which the two white women agreed. Thus, I was enlightened to the Canadian fact that "accent" is a derogatory term.

But language is complex and is signalled by many things other than speech. Again, it was at Kmart, when I was shopping for curtains for the townhouse we rented two weeks after we arrived. In the household linen department, a woman was standing at a table, neatly folding curtains and putting them back into their bags. As I approached her, the woman raised her eyes, glanced at me and my family, and bustled away. Many people equate colour of skin and hair with not-English or even worse, with languagelessness. Five weeks later, I was to work with this woman, fitting on hooks, filling shelves, and firing price-tags from a black gun. She was one of the women at the coffee break.

That was my first job in Canada, and my only one for many months to come. While juggling around shampoo and body lotion, or cookies and chips, I forced my mind to reach into the future. Could I do this job for the rest of my life? Would I get an extension at the end of the six weeks? I spent many solitary hours at the store. I was not required to think; I had to use only my hands. Therefore, I had my mind to myself. I started several novels; I played a game of synonyms and antonyms; I wished I had to memorize the vocabulary of a foreign language for a quiz. Again the thought of taking university courses entered my head; I even imagined doing a master's degree in English, but I was already losing confidence in my language and myself. Nothing could take away an underlying hopelessness. Would I find a job that I

could enjoy, so that I would be able to contribute to the society in which I lived, as I had taught the young people at home to do? My mind was a tangle of depression. How many nail clippers to hang on a hook. Had we done the right thing to come to this foreign land? The only salve to my bruised consciousness was my husband's encouragement at the end of the day that despite our minimum wages, things were not too bad and they could only get better. More than anything else, my family was with me.

Since my time was not extended at Kmart, I was left at loose ends again. I stayed at home for several months with my son. My thoughts swung back and forth like a pendulum. I would remember the theories about how rewarding it was for mother and child to be at home together. At the same time, I was stirred by a desire to have an additional purpose in life. I wanted to continue as a professional. It was just my luck that 1994 to 1995 marked a virtual standstill in hiring teachers in Ontario. Although my qualifications were approved by the Ontario Ministry of Education even while I was in Trinidad, it would now be impossible for me to get a teaching job.

Our first winter brought fever and colds for everyone, leaving me no time to do or think of anything else but to get us all better. After the days of snow passed, I became restless again. I wanted to go back to university. Having done many literature courses in my first degree, I now wanted to do something different but related. For the six months that I had been in Canada, I had heard languages and accents – that bad word again – that I could not easily identify. I was intrigued by the variety that one could hear on any afternoon in the mall. I knew it – I was going to study linguistics.

I had another reason for wanting to go back to school. Since I wanted to teach, I thought I should try to understand the education system through practice, and what better way to do that than as a student. I applied as a post-degree student at the University of Waterloo and was accepted to take Introduction to Linguistics in the spring of 1995.

I looked forward to studying in Canada. Yet I had several misgivings. I was sure to be the oldest – no, the only aged student in an undergraduate course. How did professors feel about having extremely mature students in class? There was sure to be embarrassment on both sides. And there was. The conversation about accents while I was working at Kmart trailed my mind throughout my studies at the university. I was reluctant to speak in class for fear that the instructor and the students would not understand me. It was always interesting to watch the reaction of the class whenever I made my small contributions. They were all very polite. Students who could not understand me looked intently away so that I wouldn't feel bad; others bent their heads, concentrating hard to make out what I was saying, and there was the instructor who stared fixedly, sometimes with creased forehead, so as not to miss a single word of my little speech.

The uneasiness that I felt about my accent could not equal the pain and guilt that filled me as I sat

in that linguistics class. I had always wondered how women with young children coped with studies. It must take a real hardening of will to stay in a class, knowing that your child might be crying for you. How do we reconcile a desire for self-development and our obligation to our families? Here I was in the centre of such a conflict. I longed for intellectual stimulation but I rendered my son vulnerable in order to satisfy that need. I had left him with a babysitter. He was in a strange house with strange people.

As soon as I knew that I would be going to school, I started calling the daycare providers advertised in the newspapers. That, too, was a revealing experience. I remember calling a number and getting a heavily accented (that bad word again) voluminous response. I can't say I knew every word the woman was saying, but I put together what I made out and came up with what could have been her answer. All through the conversation, I was thinking, "I'm sure she's having the same problem with me." Canadian voices, on the other hand, were usually hesitant. I noticed how some of them haltingly gave information after I explained my situation. Others politely slid out of the conversation and some were noncommittal. But all were courteous.

Eventually I contacted a young mother who was willing to have my son as a playmate for her little girl. I was a bit surprised and doubtful after my previous experience. Bravely, I asked, "Are you sure you'll be okay with an immigrant child?" She quickly replied, "Oh, that's not a problem." That was a horrible question for me to ask. It was politically incorrect – but what was I to do? I wanted to make sure that everyone involved was comfortable, and I couldn't ask my three-year-old.

As children usually do, my son adjusted well. I rushed off on the bus with him two mornings a week to be on time for my 8:30 lecture. I pelted out of the classroom at 10:00 to be able to catch the first of the two buses on the route to pick him up. My heart broke each time to see how eagerly he came to me when I returned, how he hurriedly dressed himself and helped me to look out for the bus.

Yet these difficulties did not detract from my interest in linguistics, so I signed up for a course called Linguistics and Literature for the fall term. In the meantime, a new institute, the Waterloo Centre for Applied Linguistics, was scheduled to open in late September to train candidates who wanted to teach English as a Second Language. Here was my chance to be a teacher.

I learned about the physical difficulty foreign language speakers might have in enunciating English words. I heard about numerous different cultural norms and brushed up on my teaching skills. I became sensitive to the tremendous adjustment that non-English speakers must make to fit into an English-speaking society. I was English-speaking and I was finding it difficult enough to live in Canada with my language.

Here I was, busy learning all sorts of new and exciting things. Sounds like I was getting really smart. But at what cost? I was sacrificing my family again. When I was not studying at home, I was attending classes. Every Saturday morning for almost two years while I trained as an ESL teacher, I left my home at 8:45 a.m. and did not see my family again until 5:15 p.m. and I did not have a job and courses cost money. I continued taking courses at the university and training for ESL teaching. When I gained my ESL certificate, I got two part-time jobs in Continuing Education: one teaching ESL, the other teaching Grade Eleven English. I could have stopped studying then, and I tried without success to get more classes to increase my income.

My decision to apply to graduate school came after much deliberation. The reality of my situation was that I needed a job to help support my family. My little part-time jobs were by no means a healthy contribution to the household budget. But there was this underlying, insistent feeling that I was not ready to give up studying. I felt that I was suffering from a huge information gap; the several post-degree undergraduate courses I had taken had whetted my academic appetite but had left me in limbo.

There was a life to live, time to spend with my family, and the need to have some buying power – and there was the inner something that had to be satisfied. Ambition, intellectual poise, status symbol? It was none of those things. Naming the feeling defies me even now. At the time, when we could ill-afford the money, doing a master's degree felt like an extravagance. I tried to justify it by saying it was something I had always wanted to do and that people must satisfy some of their vagaries to add excitement to their lives. On the practical side, I reasoned that I would find a better job when I qualified.

Then there was my newness to the country. So many bridges to cross; so many frontiers to penetrate. Migration to Canada was a vast frontier; each achievement in the new country was one step further into unfamiliar territory. Each form that I filled out, whether for social insurance, health, library, or job, asked me to proclaim my identity, thus confirming my otherness. I knew I was different but I did not make it a burden; I acted like a normal human being – I think.

I started the master's program in English – Language and Professional Writing in September 1998 at the University of Waterloo. Early in the program I realized that otherness was a big issue. Intellectuals had theorized about it: psychologists had tried to analyze the behaviour of those who felt "other," historians knew the circumstances that made people feel like this, professors wrote of the performativity of "others" who occupied a particular sociopolitical space in the culture, and sociolinguists observed that certain discursive patterns were unique to groups of "others."

Overwhelming as all of this may seem, little bits and pieces of it made perfect sense to me. I had been experiencing my own difference, and now here was an academic analysis of it. At times, usually when I

was alone, wrapped in the silence of my room, I would be exhilarated by the mere idea that people could write in such a formal, erudite style on an experience that was so real and commonplace for large sections of the society. Ironically, the majority of these intellectuals who wrote about problems of identity were not themselves "different" in any way. They were born here, into mainstream culture. They did not have to learn how to become Canadian. These writers had the authority of knowledge and social class, the etiquette of Canadian culture, and the security of a closed community. No identity crisis could exist in their real world.

Central to the question of identity was the burning issue of the place of women in society. We addressed this problem in every course. We hurt for the female writers of the sixteenth century, we were impassioned by the struggle of early feminists for recognition and respect, and we were grateful to present-day women activists whose voices sometimes resonate in employment procedures and opportunities for education and general advancement. I think that all the women in the program appreciated that whatever agency we now enjoy has been obtained through pain and contestation.

At times, however, I felt we were bordering on a frightening denial of men. I thought about how the descendants of colonized peoples still blame the former colonizers and their descendants. In a similar way, I wondered: were we putting our male contemporaries on a guilt trip without carefully looking at how they might be more our friends than their predecessors were to our great-grandmothers? This was just one of the myriad questions that filled my mind during this program. Many of the theories that we studied touched on my own quest for identity both as an immigrant and as a woman.

Universities are a young scene. Students are young and most professors are youthful. Sometimes I felt out of place with all of my forty-plus years descending upon me with a weight of tiredness. At other times I would look for another aging face in class. There were a few and interestingly, they were women. This made me feel good, not because we were partners in maturity, but because we were all women. We felt the same inner embarrassment at the start of the program and went through periods of doubt. But these other women were free, their children having already left home. I was caught in between. Every minute became precious to me in a way I never could have anticipated. I expected to be busy with studies, family, and a small part-time job, but not to the point of counting minutes with none to spare. Sleep became an absolute necessity, and any excess sleep enjoyed was immediately regretted. My young friends on campus had remarked, "You have a lot of courage. And you must be incredibly organized to have a job, look after a family, and do a master's." Courage – yes; organized – I don't think so.

My sons were bounced around the most. Jobs and classes were fixed, but soccer practice, library visits, and piano lessons had to be juggled. Besides, I was the memory bank for the family: grocery lists, dental appointments, parents' meetings. My mind was a whirlwind. I watched the fall leaves scatter in their golden and russet splendour, and I thought how like them were my thoughts, only my thoughts scattered in chaos and stress.

My life was becoming unfamiliar to me. Before now, I had prepared a fresh dinner every day. Now I cooked on Saturday for the entire week. When, at mealtime, no one made any adverse comment about microwaved food, I felt I had cheated them. Guilt seeped in from every direction. When my sons asked if we could go to the movies and I said "I'll see," I really meant "no." I could not give up two hours of reading theory to watch a movie. As my priorities changed, fear became a reality. Could my family be slipping away from me? It didn't seem so. My husband discussed, typed, and edited dutifully. My children helped with household chores and stayed away when I was writing papers, never forgetting to remind me of deadlines. Yet none of that helped to erase my sense of selfishness. Locked in my room with Lacan and Derrida on the one hand and Althusser and Butler on the other, I thought of how my family would have liked just to have me around. Isolation spurred my doubts: what was the use of this mass of academic information in real life? Couldn't I make a better effort at balancing studies and family?

When my son got ill during the first few days of snow, I was jolted back into reality. There was no way I could give fair attention to literary theory for my final exam when I had to check him for body temperature and stuffy nose throughout the night. My mind was a virtual maelstrom like the sweeping snow outside. Anxiety over the final exam in a required course and concern over a sick child made me feel as though every nerve in my being was stretched to its limit. I was constantly expending myself. I felt as though I was being emptied from deep inside – mental energy, emotional support, physical work around the house. But women, it has to be, have a special survival apparatus. So when spring came around, I valiantly signed up for two courses, my limit as a part-time student. This time, however, I would try to be fair to my family. I would not deprive them of their outings. We came to a happy compromise: we would take long day trips so that I could catch up on my reading while enjoying the lush summer scenery of southern Ontario, and they would still have their fun.

Resilience? Stubbornness? I don't know what to call it. But as if I was not distraught enough, I took on a study of *Wide Sargasso Sea* for my major project. Whether it is the madwoman in the attic or in the academy, the symbol of women in difficult spaces will continue to haunt me for a long time.

# Winter Afternoon at School

## JOAN PILLIPOW

I am looking for paper bones
Fine slivers of flint hidden deep in stone
I want to draw them out, and turn them over in the light

In the library I peer down squinting where e.e.
and C. Rossetti chat amicably from the lowest places
Over acrid dusty pages in the spaces

I think I can just see them over a cup of tea
Gesturing politely

Reading over the greenhouse
I watch pigeons bask on the slanted glass
Until dusk comes, a Van Gogh Blue sky

There is so much beauty
All around me

Tired shells of the working world ride the bus
A drift of whisky wafts over us
and babies wrapped like sandwiches

Bob in unison to the motion of the bus
Dreamily, towards the vanishing point
We gaze at the ghost of the day in the window

# "Untitled"

# APARITA BHANDARI

It is perhaps just as well that my mother did not get her wish to name me Akanksha. It would have been the proverbial cosmic joke. Even though I like the name, I now think it rather providential. It would have rendered me in a somewhat passive light. Akanksha: to hope, or to have hope. Instead, my parents, or rather (ironically enough) my father, named me Aparita, which roughly translated means "unconquerable." I love telling people that, even though there are many times when I feel that I am in a situation that is quite contrary to my name.

What is her problem, you ask? Well it is not phenomenal, but it is aggravating enough to take a toll on my life, forcing me every now and again to wonder whether I am on the right track. It seems so foolish: I am almost twenty-three, finishing up my master's, and fairly good at what I do (there's no other reason why I would be here), and I still question, albeit only occasionally, whether I have made a monumental mistake in pursuing the life at the "academe." One would think that by this time I would know exactly what I am doing (well, I do…) and in which I direction I am headed (I know that too …), but unfortunately it seems to me that somewhere along the way I lost that resilience that used to mark my every action. Why? I do not know, or perhaps I do not want to know.

I suppose it all started when I chose literature as my salvation. For an Indian girl who was relatively good in her studies and whose cousins all pursued the sciences (well, most of them), choosing literature was the equivalent of letting the death-knell sound. My father, in some ways, has still not been able to reconcile with the fact that the kid who once said that her favourite subject was mathematics (it was, after English), did not go on to be an engineer, or a doctor, or even a lawyer, but chose to pursue English?! Not only did I commit the major mistake of choosing the humanities, but after three years of being an undergraduate I decided that I liked this field enough to dedicate even more time to it. I wanted to pursue the life of an academic. It would not have been so bad had I chosen the sciences; an academic in literature is not what my father wanted me to be. The funniest thing is that

after all these years, he still hopes that one of these days I am going to change my mind. As a result, every now and again I am bombarded with the *big* question, "So what are you going to do?"

Then there are other factors of being a South Asian girl of a certain age. (Perhaps this question plagues my non-South Asian colleagues also, I do not know.) I have to find a *suitable boy*, not just any suitable boy, but one with whom I can have a viable (not) die-able relationship. The fact that I am twenty-two and soon will cross the line that is generally considered the "proper age to get married" is of great concern for my parents. People probably see me *not* as a young, bright, sociable girl but as a girl who is pursuing a field that does not have many good career opportunities, who is nice to talk to but cannot seem to find someone for herself. Whenever I go out to gatherings with my parents, I am asked the same question, "So what do you do?" and on hearing the response, the gates of conversations are generally closed. Only rarely do I find someone who can talk to me on matters other than weather.

If I am not enough of a social failure through my pursuit of what is politely called the "liberal arts," my stance as a woman who asks questions, especially from a post-colonial perspective, creates more problems. There are certain things that are taken for granted in our society; men do enjoy a certain privilege that women do not, and this phenomenon is not limited to just my culture. This hegemony might not be that obvious, but it exists in many covert ways, and I find it especially noticeable (in its many forms) in my culture and its configurations, which allow, almost condone, a world view largely based on the gross inequality between sexes.

While studying post-colonial literature, one studies the configuration of the native in the master's texts: how the colonizers invoked a particular ideology to validate their presence and superiority to the native, and how the native writes back to re-establish a lost identity, reclaiming language and agency. In the backdrop of such a (usually patriarchal) narrative, one also studies the usually silent woman, doubly displaced and without agency. Without even meaning to, I often find myself giving a feminist perspective to most of the texts. Even when I try to search for something other than women's issues, I find myself coming back to the same theme: the marginalization of women. Actually it is a fairly inescapable theme, in the background of the male-centred narrative and the foreground of the female-centred narrative. My own experiences – being brought up in a society that was patriarchal (no matter how subtle it was, and still is), having to rebel against male authority in the smallest of issues – makes it even harder for me to abandon the question of the female space, or the lack thereof.

With such a perspective I often find myself at odds with the way my society works, especially the older generation. The general lip service to the question of equality of the sexes is done in a particularly loud voice. However, there are little things that strike me as odd, even when I find myself

getting used to them. I have often noticed at social dos the almost immediate division of men and women; they seem to naturally occupy two sides of the room with a line that seems to demarcate the split. When I remarked about this the first time, I was looked at with a beatifically tolerant gaze for a moment, and the matter was laughed off. Then, of course, there is the convenient way in which I and others of my ilk (for whom marriage is not such a priority) are labelled as "those feminists," a malaise (ostensibly) commonly found among young career-oriented women, especially those who have a background that calls for such an outlook, i.e., literature, psychology, law, etc. "Oh, she is a feminist" seems to explain a lot of things to people, with connotations that escape me.

I find this stereotyping grossly ironical. Had these people known me a few years ago, they might well have been justified in defining me as such a character. Admittedly, I was never a male-bashing, bra-burning feminist, but I had always been a mediocre one, railing enough about the way patriarchal discourse worked in the text and the way it was taught. However, I can trace my downward trajectory from strongly contesting the case for Antigone's decision to do her duty by burying her brother, thus opposing Creon's dictum, in my first-year undergraduate class to the more subdued look at whether Beatrice really manages to "outwit" the male ethos of Messina in my first year master's class in Delhi. Recently, especially after my foray into the field of post-colonial literature with a somewhat feminist stance and (perhaps) also due to my situation in my society outside my intellectual pursuit, I find myself becoming less and less of the feminist that I once was.

Let me explain. When I first ventured into the hallowed halls of English literature I had the guidance of a professor of English literature who, besides being my friend's mother, was a strong advocate of the "female cause." Needless to say, I was at her house frequently, browsing her bookshelves, sipping warm cups of tea, discussing issues with a decidedly feminist agenda, and exploring the deeper nuances of texts. Antigone was the first text that she broached, and under her tutelage I could relate strongly to this character who defied patriarchy. I had found a kindred spirit, being at the rebellious stage of life myself. But as time passed, I found myself conforming more and more to various strictures that set dos and don'ts, and I grew accustomed to the existence of rules. I even came to wonder (in my essay in my master's class) whether Beatrice really does have any semblance to a proto-feminist when she is (finally) silenced by a kiss at the end of the play. At that point, my mentor ironically pointed out to me that often you have to fit yourself into a certain frame, which then allows a little more room for you to manoeuver your own position.

This is not to say that I have abandoned feminism in its entirety, but I find myself questioning whether it is really viable as an in-your-face concept. Despite there being greater awareness and understanding of the role of women today, in my daily life and in the literature from my own field

I often mark an acceptance, perhaps resigned, of the hierarchy of the male over the female. It puts me in a very paradoxical quandary: where do I stand on this issue? I know that even though we talk of women's rights, they are, more often than not, ignored. I also know that we seem to find a way out to manage the situation, perhaps not with an outright rebellion but by subtle manoeuvrings. I have come to believe that men and women are not alike, and the sooner we accept it, the better. No matter how much of a hue and cry we raise, at the end of the day we do have to do the larger share of the work in a family and bear the brunt well. Of course, men should help, and if they do it is great. Yet I have often seen situations where this does not happen: the caveman philosophy that "the man earns while the woman cooks" still persists. This does not make the women in these situations any less powerful or less liberated in my opinion.

I do not want to demean the status of a woman as the lesser of the two in any way, and this is where I run into my quandary because I seem to be at odds with a lot of my more feminist (often non-South Asian) colleagues, especially in our "academic discussions." I do not condone the relegation of women to the subservient sex, but this (perhaps Machiavellian?) approach of mine to work with the patriarchy is rarely taken seriously by them. I cannot blame them, for there is a problem with my own formulation. It requires a kind of appreciation and respect by men, and is supposed to culminate in a helping-out concept, a concept that is by and large ignored by most of them. My stance is also aimed at a specific group of women, feminists who try to approach the South Asian perspective through a necessarily Western outlook that just does not work. Patriarchy cannot be dismissed, but it can be opposed. While I think an outright rebellion is often futile because you run into a wall, I think that there are several chinks in the wall that can be used to climb it. It requires recognition of the way in which patriarchy works, and this is where I use my feminist knowledge.

I used to fight my battles in my essays; that is where I learned how patriarchy operated and tried to formulate how one should resist it. Unfortunately, things are never that simple: they often look good theoretically but it is very hard to put them into practice. I often find myself living a paradox: while I champion the "woman's issue" in my study, I live the life of the female figure in the grand narrative. It is very hard to escape patriarchy when your life is shaped around it. I studied in a gender-specific class (English literature is a woman's domain in India), a class that is never really taken seriously except by the passionate few who are in it. Seen more as a potential didn't-get-in-anywhere-else class, or a potential marriage-market-candidate class, or "ohmygosh she is going to become a Lecturer" (teaching, according to some, is not the greatest job), there are few things that you could do that are worse. Even today, as I stand on the threshold of finishing my master's degree, the fact that I am a student of English who cannot get a job as easily as someone who studies computer science, that

I am a girl who is expected to "settle down" sooner rather than later, makes me cringe every time my parents want to have a discussion with me about the way in which my life is headed.

Just being a girl and realizing the pitfalls of being one (and believe me, they outweigh the strengths by far) initially made me want to rebel against everything, but after a while the screaming matches and the headaches that accompanied the rebellion taught me the futility of it all. Things will not change for a long long while, and until then you have to get used to it. However, literature did give me the power to realize that change is inevitable, eventually, and this has given me the strength to think that one day I can change this situation of mine. I suppose I would have found out all of these things even if I had not studied them, but I think that being able to assert that there is a problem is something that my journey into the academe has taught me. My mother thinks, at times, that I have studied too much, that I theorize too much. I, on the other hand, am grateful that literature has given me the opportunity to do just that, so that even if I find myself pursuing some other field in the not-so-distant future, I will still have that knowledge with me. It will be a memory that I do not intend losing. Yet there are other times when I wonder. Will I really be able to conquer all, or should I just hope? Aparita or Akanksha? Maybe my father was not that far off, but then neither was my mother.

# Denise M. Blais

## plain M.A. in blues (for S.C.)

yesterday …
gray rain streaming through city skies
satori percussion on the windows
fingertips tapping on keys:
the weather's the music
these pages, only their footnotes

and today …
Montreal's July heat rolling down my skin
a body stripped bare before her *Starwriter* machine
pounding out some sort of introduction to
institutionalized musings
over love, death, and performance art
(not necessarily in that order)
and I'm thinking
of just how crazy this all is
– "if you're not in pain and suffering, then
it's not for real, not serious" – and
of how twisted I feel
watching myself
become a mistress in dire straits
wrestling with words they'll call an M.A. thesis
sweating, cursing humidity and confinement
when I'd rather be
writing poetry, or walking down the Main
or, more than anything else right now,

steeping l the company
of you, prairie-lake sand, and beer
(most certainly in that order)

(Montreal, 8 July 1991 – 23 October 1999)

# MOVEMENT THREE

# Ruth Danofsky

## Commencement

On completing
graduate work
a friend hails me
as *launched*
as I spin out
into orbit
of tenuous employment
marginal status
and fierce self-loathing
where too soon
purged
of lingering hope
I float loose
unmoored
clung to by flotsam
and other bits
of academic debris

# An Academic Defence

# *Ranjini Mendis*

The day after my course work was completed for my master's degree in the English department, my husband declared that I was insane. "The consensus of opinion among responsible people," he said, "is that you are mentally ill. I'm going to offer you three choices. You can get medically treated here in Calgary, or go to your parents in Ceylon – I'll get the Reverend of my church to see that you are taken to a psychiatrist – or go to Boston for a rest cure. If you don't, we will have no choice but to get a legal separation."

Having pronounced thus, he departed to a religious retreat for a weekend of prayer and meditation, leaving me with our three-year-old daughter and a critical decision to make.

\* \* \* \* \*

We were relatively new immigrants from Ceylon (now Sri Lanka). We had been married just a few months when I had been urged by my husband and his father to resign from my English instructor's permanent job at the University of Ceylon to accompany him to Boston for a two-year engineering training program.

To my dismay, at the end of the two years my husband and his father (who was in Ceylon) decided that we shouldn't return home, and I became useful for us to gain entry into Canada: my admission to McGill University paved the way, and my husband's father, a high official in Ceylon at that time, arranged a job for his son with an engineering company in Montreal.

Three months into my master's degree at McGill's English department, my husband was transferred to Calgary, and I had no choice but to tell my supervisor, Bharati Mukherjee, that I needed to withdraw in order to accompany my husband to Calgary. I ignored her unmistakable look that spoke volumes to me about a new immigrant woman from the East throwing away a valuable opportunity for a good education.

Next, my father-in-law advised my husband to impregnate me, regardless of my wish to continue with my studies for the moment. They needed a child for property and lineage, and a son was hoped for. Nine months later, I gave birth to a little girl, and my in-laws in Ceylon became intensely agitated by the advent of our daughter. My husband's sister began visiting my parents and pleading with them to accept her boy-child as their very own, trying to convert my already Christian parents to be "born again," while my father-in-law began to move in mysterious ways to discredit me and my family.

* * * * *

Q:  When did your husband start calling you mad?

A:  The first mention of a mental illness on my part by my husband was in 1979, when he called me "a lunatic of a wife." Before that he had mentioned that schizophrenia occurs up to thirty-five years of age.

Q:  What precipitated this?

A:  His father wrote a letter to his work place saying that I should be watched carefully because I display "imaginary grievances."

* * * * *

In the meantime, I managed to persuade my husband to let me get back to my English studies, and since this seemed to him and his parents a better alternative than my settling into independent employment, he gave me his blessing. I felt "home" again, back in the academic world, determinedly juggling child rearing, home, and a strange marriage in an alien world. His parents, meanwhile, were pulling strings to get us back to Ceylon and to put a stop to all this "degree work."

"All these books!" my mother-in-law exclaimed when she and my father-in-law stopped over on one of their world trips. "What's the use of so many books? You should do a little social work, play the piano, make your husband happy...."

"You should put aside these English literature books and read the Bible," my sister-in-law, frenetically declaring "I Found It" in the true style of Christian crusaders, advised me in a letter.

"Why are you studying the literature of a foreign power? We got rid of those buggers (the British) decades ago from Ceylon, so now you are kissing ass with them?" asked one of his friends.

My academic interests pushed me further and further from the Sinhala national culture, and my husband, though an educated man and no stranger to English, displayed stubborn resistance to Western popular/secular culture. He sought comfort from daily living in the familiar security blanket of the Church, becoming addicted to it, even more so after our child was born and I resumed my English literature studies. Swayed strongly by charismatic fervour and an intense desire to save my errant soul, he could not fathom my emerging confidence in speaking and thinking for myself. It was all I could do to get my term papers written while caring for our little daughter, with his persistent voice of salvation all the more intense when I had an assignment due.

"He touched me, OOOO He touched meee...." he would sing in heartfelt tones while I was trying hard to concentrate on "Astrophel and Stella," and he would play radio sermons on righteous living before and after my classes, to and from the university. Straight from Donne's Elegy 15 I would be whisked by my husband to a Pentecostal gathering where the pastor would urge me to raise my arms and speak to God, while

a circle of devotees would weep and chant monotonous prayers all around me, our three-year-old daughter still in her university daycare clothes, waiting to go home.

And it came to pass that there grew in me an inordinate attachment to everyone and all that was connected to the English Academy. The courtesy with which I was treated at the university fed me, the familiarity of a culture curiously reminiscent of the English missionary education in Ceylon provided refuge from the ever-increasing pull of my husband and his family to give up my foreign ways of thinking. My sense of self, which was fast disappearing, revived momentarily in class or when a professor or fellow students would greet me by name, with respect, in the corridors of Calgary Hall – "Ranjini" – and I would faintly remember the academic identity I had had in the University of Ceylon, before succumbing to the pressures of my marriage.

Toward the end of my course work, it was clear that I was moving away from the restrictions of the Sri Lankan culture, and my husband and his family became apoplectic.

\* \* \* \* \*

Q:   When exactly did your husband pronounce you mentally ill?
A:   It was the day after my course work ended. I wanted to go home because my father had suffered a second heart attack and I hadn't seen them for six years. My husband had written to his father about my wish to go home and his father sent us a letter saying that that wasn't a good idea. When I insisted that I should be allowed to go and see my father, he made this pronouncement.

\* \* \* \* \*

My trip to Boston was of no use: the Ceylonese professors of English with whom I stayed declared me hopelessly sane, and my husband was most dissatisfied with this outcome, saying I had tricked them. He sent me to Ceylon, next, in the hope of getting me cured of this malady he was determined I had.

The sojourn in Ceylon was not at all easy. My parents had been informed by my husband's father that I was arriving mad as a hatter, and he told them to get me medically treated immediately. My parents saw that I was in the middle of a nightmare of abuse and suffered in their helplessness. Humble people that they were, they were no match for my in-laws who sent people daily to observe and question me. I remember my mother standing in the living room with a look of overwhelming sorrow while the Methodist minister who was my husband's "ambassador" cross-examined me, taking down notes in a little black book. Daily, his people would come and clang our metal gate, and dumbly my parents would let them in, the manners and respect inculcated through Christianity no match for marital authority.

And I realized that as a woman I had no resources or voice in my native land.

\* \* \* \* \*

I was to have returned to Canada in time for the beginning of the fall semester, but I was commanded by my husband not to come back; not just yet. In a letter delivered by his father, he wrote, "After much thought, I came to the painful conclusion that it is totally inadvisable for you to return to Calgary as planned. Please await my arrival in Ceylon. I'm investigating the feasibility of coming earlier than planned. Regret you have to put off studies until January and suggest you inform your professor accordingly…."

I was caught in a trap. I wrote to the English department, turning down my research grant and informing them that most probably I would not be able to resume my studies because of the circumstances. To my amazement, my supervisor and the head of department were supportive of me and encouraged me to come back to my master's program when I could see my way. In the ensuing period, I was to hold on, like a drowning rat, to their acceptance of me as a person in my own right.

In order to support myself and my daughter and to prove that I was in my right mind, I taught an intensive course in English at the University of Ceylon. In the evenings, I continued to be grilled and questioned by my husband's ambassadors, or I would have to trudge to his Reverend's manse in Colombo to face more questioning, returning home at dusk in crowded buses, exhausted and desperate for survival, settling down at night to mark essays for the next day.

A few days before the expiry date of my return ticket, my husband arrived in Ceylon. He arrived at our gates in his father's new car and ordered my parents to sit in their own living room and not to speak. I saw my father, who was recovering from a heart attack, hobbling into that room with the aid of a cane and looking stupefied as my mother stood meekly by, silent and defeated.

"You will recall," my husband spoke in his best English, "that I sent a dictated message through my father on September 14 this year…. It has now become patently clear that all efforts at a reconciliation have failed and I have come to the painful conclusion, and I am saying this with a very, very heavy heart, that it is not possible for you to return to Canada. In the event of your acting against my wishes, that is if you decide to go to Canada without my consent, I regret I cannot support you. I have already cancelled all the arrangements in Canada. Very briefly, there will be no car and no funds for your use. To sum up, if you do decide to go, you would be completely on your own, and you and you alone would be held responsible for all consequences. Incidentally, I want to make it quite clear that I take full responsibility for this action."

He stood up, got into his father's car, smiled and waved at us standing there frozen in shock, and sped away.

\* \* \* \* \*

Despite his warning, within the next two days I arranged for a security guard to be with my daughter and me at the airport, packed my bags in the dead of night so I could go undetected, and left for the airport, hiding in a van. From the glass-enclosed transit lounge, I watched my sister-in-law come tearing into the airport with a letter. The security guard reluctantly allowed me to hold out my hand for the letter; it contained

the same familiar threats: "If you perchance proceed to Canada against my wishes and better judgment on an extremely serious situation, you will be slamming the door of reconciliation in my face. In this event, I have already told you last Sunday that I will not provide you any financial assistance of any kind in Canada and I will consider very seriously the possibility of a judicial separation including taking the custody of the child."

As prophesied by my husband, he withheld the car, stereo, and bank accounts, but my child and I stayed in the house and tried to resume our daily routine in Calgary at the university and daycare.

\* \* \* \* \*

My husband returned to Canada from Ceylon, intensely agitated. Three months later, I left the house and my marriage, with our daughter and a suitcase half-full of library books. My supervisor gave me her blessing and wished me well the morning I informed her that I was finally leaving, and provided me with the names of a doctor, a lawyer, and a master's student in counselling who would befriend me through the worst times to come.

My daughter and I stayed with fellow grad students in their wonderfully remote farmhouse for the first while, and later at an English professor's house while she and her family were away on holiday, all the while filing for a divorce and trying to get some reading done for my thesis. "No, we don't go on picnics," I heard my little daughter tell the social worker who had come to observe my parenting; "My mom is writing a Teesis."

\* \* \* \* \*

Scene: Court of Queen's Bench, December of the final year of my M.A.

"Your Lordship," my husband bowed low to the judge. Very low. "I cannot and will not call anyone 'My Lord' or 'Your Worship.' My Lord is my Father in heaven and I cannot, in all conscience, call you 'My Lord.'"

The elderly (male) judge woke up and stared at the thin, tall, intense, bespectacled man on the witness stand. "All right. Let's get on with it," he growled, and so the drama began.

My husband contested the divorce on grounds that I was insane and did not know what I was doing. He contested the child custody as well, with grave reservations as to my fitness as a mother, since he was certain I was off my head.

My witnesses were from the university, since the Sri Lankan friends chose to befriend my husband and his family. First on the stand was Wendy. Pregnant and almost full term, she appeared the image of gentle motherhood, with soft voice and blue maternity dress with little white flowers. Then came the English professor

at whose house my daughter and I had stayed during my time of travail. Standing fearlessly in the witness stand, she explained her specialization, British Romantic literature, PhD from Toronto. Her confidence in me as a mother and friend made my husband's lawyer fidget. The judge swivelled in his chair and stared. He was having a good day.

I hobbled onto the witness stand on crutches; I had slipped and fallen in the snow, fracturing my ankle, much to my chagrin.

My husband's lawyer began to question me.

Q:    I understand you are a student?
A:    Yes.
Q:    What is your area of study?
A:    I'm working on my master's thesis in English literature.
Q:    Do you drink alcoholic beverages to excess?
A:    I have taken a drink at parties, but no, I don't drink as a habit.
Q:    Your husband says you watch bad TV programs. Is that so? What are these programs?
A:    Soap operas, *As the World Turns*, in Boston, long ago. [If I had known about blue movies, I could have made this much more interesting.]
Q:    Now about your sex life.

Visions of the Kama Sutra flashed before my eyes. I swallowed my desire to have fun with this, and remained sedate.

Q:    Your husband says that once you even called him "Jesus Christ." Is that so?
A:    He misunderstood my tone.
Q:    Is it true that you wanted to buy a book instead of borrowing it from a library?
A:    Yes; my father-in-law told us that I shouldn't walk alone on the streets in Boston, so I couldn't go to the library. And he told us not to step out after seven o'clock in the evenings. Dangerous.
Q:    Have you ever torn a religious book in two? [This torn book has been exhibited by my husband to various members of the university community as proof of my insanity.]
Q:    You have gone away from God, your husband says. Is that true?
A:    I don't think so, but I can't weep and talk in tongues like he does.
Q:    What is your master's thesis on?
A:    Renaissance music and poetry, in particular the Fayrfax manuscript, which is one of the three musical manuscripts of the time of Henry VIII.
Q:    Have you gone away from your Sri Lankan friends?
A:    I have had no time for socializing.

My husband then triumphantly produced a prescription written for me by his family psychiatrist in Ceylon, on whom I had never set eyes. (This doctor, incidentally, has since then denied ever giving any

such prescription.) The judge refused this bit of treasure, and my husband disappointedly put it back in his pocket.

His lawyer spoke.

"Here is an analysis written by your husband's minister in the Methodist Church in Ceylon. He says that your studies have become a central concern in your marriage. I quote, 'The career has become important to her. If it is because she feels God wants her to use her talents better and be better equipped to serve other people, then it is a good reason. If it is, on the other hand, to assert her independence or show the world she is capable of a higher degree, to assert her greatness, then that's not a good enough reason. She must work out her own feelings about her career, clarify her motives, and reassure him.' How would you defend yourself on this, Mrs. Mendis?" [I wish I had had the language I needed then.]

\* \* \* \* \*

My husband now spoke with authority: "My wife seems to have undergone a gradual development of paranoid pathology from 'early manifestations' – I'm quoting here – to 'acute paranoid turmoil,' and during the last year or so – I'm quoting again – displayed certain symptoms of 'paranoid crystallization' … 'Centrality,' 'delusions,' and 'fear of loss of autonomy.' I'm quoting from this book."

"LET ME REMIND YOU," the judge boomed, "THAT WE ARE HERE TO GRANT a DECREE, NOT a DEGREE."

Q:  Your wife has a degree in music, and her thesis is on music and literature, is it not? Now, why would you keep the stereo away from her?

A:  It's only I who knows how to connect it – this is a complicated system, and my wife is a person, I'm sorry to say this, but she can't even change a bulb. And this is like my baby, my own personal thing. It's like my second child.

Q:  All right. Now, after your wife began her studies, did you ever consider separating from her?

A:  Good point. I respect the sanctity of marriage, and I have taken oaths here. I have before man and God taken my vows of marriage, for better, for worse, for richer, for poorer, in sickness and in health, and I believe she is sick, to put it very bluntly.

Q:  If a psychiatrist were to do a complete assessment of your wife and was hypothetically to certify her as being sane and fully competent, would you not then be prepared to give up your view that she is insane?

A:  I will reconsider, because I have to be one hundred per cent convinced that in fact she hasn't even fooled the psychiatrist.

Q:  And if you felt she hadn't fooled a psychiatrist, would your opinion change?

A:  I'm a very fair person, fair as fair can be. I think, given a fair chance, a psychiatrist will be able to evaluate what the real cause of the problem is, and if she's willing to get herself treated, you know, I think we can return to our normal family life, and that's the end of the story.

* * * * *

At the end of the trial, I was granted the divorce and the custody of our daughter. The lawyer billed me $10,000, which included the fees for all the calls of my persistent husband. This was the next insurmountable problem, since I was on student loans and barely getting by, what with daycare fees, rent, food bills….

* * * * *

Two months later, I was in court again, this time with Dr. Tony Petti, Renaissance scholar, who offered to speak on my behalf to the Clerk of the Court.

"Well, umm, Mr. Pettigrew," the clerk began, and I stifled a giggle at the error. "What would you like to say about this bill?"

Dr. Petti waxed eloquent in his best British accent, quoting Latin phrases, which made the clerk wince and adjust his glasses.

"Let me tell you," he said. "This lawyer has charged this poor student every time he thought of polishing his toenails. Further, I do declare, that if this woman is lying on any count, I shall go out into that corridor, and HANG MYSELF!"

The clerk gulped and resumed his business in a monotone and with a look of misery. Dr. Petti was in his element, being of a dramatic disposition.

My bill was reduced fifty per cent.

Dr. Petti died of a heart attack not long after.

* * * * *

The thesis got written, finally, and I have outlasted the battles of insanity charges and court cases. My former husband, a professional engineer, was called to the bar in Alberta on getting his law degree after the divorce. He is now trying to establish a new church, and, I hear, is a youth and marital counsellor.

# SUSAN BRALEY Immoderate Musings

In the novel *Jane Eyre*, Charlotte Brontë (1816–1855) creates the character Bertha, a woman who has been deemed by her husband to be mad and thus is incarcerated in the attic of his estate. She escapes, sets the upper floors on fire, and leaps to her death rather than be rescued.

Denise Levertov (1923– ) frequently examines the *fe-male* strug-gle for self-definition in her poetry.

Ginia pedals heavy-hearted against the resisting slope of the campus hill (the lovingly used car is languishing in the shop again) her left shoulder blade pressed down by the weight of her book bag – a hundred half-inspired papers from her first-year Forms of Fiction class and a summons to an appeal hearing ... For Curtis LeDoubt, last semester's F was really Ginia's failure: she could not move beyond her feminist biases, you see, to recognize why Brontë's Bertha got what she deserved.

*Something **Hangs** in back of me,*
Levertov's lines drift back to her from a now-distant class,
*I can't see it, can't move it.*

*I know it's black,*
*a hump on my back.*

*It's heavy ....*

*What's in it? ....*

*... Could all that weight*

*Be the power of flight?*
*Look inward: see me*

*With embryo wings, one*
*Feathered in soot, the other*

*blazing ciliations of ember, pale*
*flare-pinions ....*

She takes a deep, settling breath
– she can't guarantee blazing inspirations in all her lectures
but no one else in Curtis LeDoubt's class has taken exception.

Alighting outside the Liberal Arts Hall, she catches a glimpse of Al;
twenty years her senior, he teaches medieval and Renaissance lit;
he is peering at her as she leans to lock her front wheel,
although now, when she stands straight, he calls to her lightly,
"Oh hi!"
As she walks to the doorway where he stands, her body flinches,
registering his soundless grazing on breasts and waist and legs –
fodder, no doubt, for some general consumption in the faculty men's
room.

In much of her poetry, Sylvia Plath (1932–1963) indicts patriarchy for its misogyny; here, in "Lady Lazarus," she animates the *ravaged* woman as voracious and vengeful.

*Beware*
*Beware*
(Sylvia throws her the words as Ginia leaves Al behind on the stairs).

*Out of the ash*
*I rise with my red hair*
*And I eat men like air.*

In the departmental office, she finds only essays in the mail,
and Joel, hired with her two summers ago, trolling for an audience;
"Look at this – my article's been accepted!" he bursts forth.
He thrusts the letter into her hands and, over her shoulder, reads
its contents aloud. "I see no reason that I shouldn't get the Atwood
grad course now!"
Mouthing expected praises, Ginia feels herself dissolving.

In the novel *To the Lighthouse*, Virginia Woolf (1882–1941) creates Mrs. Ramsay, Victorian matriarch, who ministers selflessly to her histrionic *husband*; she plays her role to perfection – and ultimately to her own extinction.

*all her strength flaring up to be drunk and quenched*
*by the beak of brass, the arid scimitar of the male,*
*which smote mercilessly, again and again ....*
*[until] there was scarcely a shell of herself left for her*
*to know herself by ....*

She flees to her own office to gather books for class;
in her mind, Mrs. Ramsay evanesces, replaced
by a bland but expectant cursor blinking on an empty screen –
how can I weave those wayward paragraphs into a conclusion ....
"Try rereading your opening," offers Veronica, her office mate,
accustomed herself to thinking out loud. "I found your argument really
focused there, and don't let Joel's success
intimidate you – your work is at least as good!"

*perhaps I am not worthy ...*
*Of work like this: perhaps a woman's soul*
*Aspires, and not creates; yet we aspire*
*And yet I'll try out your perhapses, sir*
*And if I fail ... why, burn me up my straw*
*Like other false works – I'll not ask for grace;*
*Your scorn is better....*

Buoyed up by new resolve, she engages her class with verve.
She lays Shields' *Swann* to rest and introduces Atwood's *Grace*,
these women authors her lighthouse, the students her shifting seas.

Elizabeth Barrett Browning (1806–1861), in her poem *Aurora Leigh*, challenges the nineteenth-century notion that women do not have the capacity to compose creatively. The "Joels" of Browning's world may have chosen not to notice that her numerous publications prove this assumption false.

But when the essays are returned, all excitement is lost;
All ideas shrivelled to a percentage, and Ginia to Maternitas. "Would you explain where I went wrong?" "I don't understand."
"I was never good in English – would you proofread mine from now on?"

The Angel in the Classroom begins to hover, as she often has before:
*"intensely sympathetic ... Immensely charming ... utterly un-selfish ..."*
"The Writing Clinic is in Room 101," Ginia announces firmly;
then, lacking an ink-pot, she eyes the Angel and minimizes her!

At the afternoon meeting to discuss final exams,
Chair Mel Landry presides with flair,
offering eye contact and affirmation to all the men who are there; "Great paper, Dr. Lucci – Dr. Lewis, let's hear about your proposal; Ginia, you don't mind taking notes, do you. The secretary can't be here."
Dr. Lewis – Joel – recites Veronica's words exactly,
"borrowed" from yesterday's musings over coffee.
"You know," says Veronica clearly, "I suggested that very idea just recently."
"Any other discussion?" asks Landry. "Dr. Lucci?"

In her 1929 address "Professions for Women," Virginia Woolf's young *female* writer *struggles* to neutralize in her mind the ever-present Victorian (and male) ideal for women – the compliant and coy Angel in the House. Even when the writer flings her *ink-pot* at the Angel and chokes her, the *phantom* presence is not banished *entirely*.

Ginia storms down the hall with Veronica, although neither of them expresses disbelief.
Instead she hears Simone's voice from her book bag – shouting in sympathetic indignation:

*The most mediocre of males feels himself a demi-god as compared to women ... ; he believes "the most brilliant among [women] ... reflects more or less luminously ideas that come from **us**...."*

In her book *the Second Sex*, Simone de Beauvoir (1908–1986) exposes the centuries-old myth that woman is Other, the deviant and substandard version of the substantial and *essential* One, man.

*Decline to be Other ... refuse to be party to the deal!*

Ginia and Veronica end up in the Women's Studies lounge,
finding others who have sought out the same asylum –
yes, a room of their own – never mind the derogatory jeers:
"A haven for hysterics ... a coven of commiserating...."
Here unbridled laughter is healing, and madcap rage sublime,
A rollicking tarantella freeing body, soul and mind.

*They put me in the Closet –*
*Because they liked me "still" –*

*Still! Could themselves have peeped –*
*And seen my Brain – go round –*
*They might as wise have lodged a Bird*

*Himself has but to will*
*And easy as a Star*
*Abolish his Captivity –*
*And laugh – No more have I –*

Ginia, back on her bicycle in the twilight, releases its brake at the top of the hill;
she raises her arms – full-fledged wings,
resisting the wind as she flies;
the sun is a blazing ember behind her,
and her sisters inhabit the skies.

Emily Dickinson (1830–1886) defied Victorian *expectations* of women by deliberately choosing to devote herself to an aesthetic *vocation* rather than to a domestic life; her twenty-year self-exile in her room was for her freedom, as she describes here in Poem 631.

# (avoid) kicking sacred cows
# DENISE M. BLAIS

*Let me speak of this* … FEAR
Fear in the face of AUTHORITY.
Fear remembering FEAR …

Fear trembling inside, as words stick in my throat …
FEAR locked under my tongue.
FEAR welding my mouth shut, as I watch
the unspoken consensus forming
   forming    forming
between the words and the pregnant pauses,
circulating around the room, whizzing past me,
pushing me   further      outside the circle …

FEAR   rising out of my gut and oozing through pores,
dripping down my sides as my sweaty palms fumble
in pockets, seeking an anchor …
   while the masters and mistresses sit around the table,
mastering their trust of mistrust,
nodding their consent and approval …
   while Bob and Joan spin (out) around the table,
serving up their anger and hate with mashed potatoes,
dishing out abuse and vegetables as entrées in the plates
of their "six million dollar" children …

FEAR as an unexpected, unwanted question …
FEAR brushed off by evasion and ambiguity, by a
simultaneous Yes and No answer. FEAR as paradox.
FEAR splitting into a double-take, a tug of war … between
guilt's conformity and silence, and,
sputtering words of defiance and dissent.

Fear in the face of some real DANGER present … and
FEAR reaching back to MOMENTS past … and

living the confusion of them both, shaking with fear:
under the scrutiny of professor and students
   while performing on stage, shaking with terror …
before that ghostly night figure of Mother
   while explaining why I've come home so late …

The words spill out …
just before Mother's hand comes crashing down, thrashing them,
   splitting their atoms, then colliding with the side of my head
just before Professor's half-silent command to pull the plug, to
   stop the moving video images, comes ringing out over
my frenzied mind in its uncensored flurry ….

FEAR in the face of authority figures who make me
the sole witness
to this psychic bashing, re-enacted
over and over … again …

FEAR in the back seat of the red station wagon …
coming home from summer holidays, creeping towards the city and
creeping towards the start of a new school year,
crying to myself …
thinking I'll never make it through Grade 4 …
thinking of the horror awaiting me … the one who couldn't
get her multiplication tables straight …
   thinking… I'm dead for sure.

(Montreal, 5 April 1990 – 5 May 1999)

# Slow Advances:
# The Academy's Response
# to Sexual Assault

# MARY ELLEN DONNAN

My life has been profoundly altered by sexual assaults I experienced more than a decade ago, as an undergraduate university student. While not everyone who is sexually assaulted struggles with symptoms of post-traumatic stress years later, I know that I am not the only one who does. In writing this paper I am breaking a resilient taboo that has created a resounding silence around the issue and experience of sexual assault at the academy. As a victim, I have felt the need to protect myself with silence to prevent anyone from using the knowledge of my pain against me. Even on campuses with some protective and supportive programs in place, in my experience, there is a lack of dialogue about sexual assault and its impacts outside of the one recovery program that is offered. Although sexual violence such as I have experienced injures female students with terrible frequency, these impacts are still little-discussed, poorly understood by most, and responded to institutionally in ways that put all of the responsibility on the victim. The incidents related below are accounts of my own experiences. Text in italics records my unspoken thoughts at the time of the incident, in a method Carolyn Ellis (1992) calls "internal ethnography."

\* \* \* \* \*

Even though feminists have recognized that exerting rational control over all aspects of our experience is unhealthy, and I am well-versed in such theories, I am still not accustomed to losing control of my emotions in a supervisory committee meeting. There were only four of us – my supervisor, two advisors and myself – but each of those three committee members were very active in their respective fields, and I was conscious throughout the meeting of their status as well-established scholars and of their busy schedules. I had been

reading about my topic for months and was keen to impress them with the depth and breadth of my knowledge. I did keep my crying completely silent, but it eventually became obvious to everyone present because it prevented me from being able to talk. Nobody said it was not okay, but the sudden attempts to be nice by complimenting my general abilities revealed my supervisor's discomfort, and my own shame was huge. I had managed to hold off the tears until the last ten minutes of a meeting that was more than ninety minutes long, but it finally got to me. It was not being "sent back to the drawing board" after months of research on my dissertation topic that made me cry; it was something else, but at the time I could not figure it out. Let me take you back through it.

I am nervous but well prepared as the meeting starts. I have a tendency to over-prepare to insulate against my shaky self-esteem.[1] I am aware of taking up the time of three high-ranking scholars for this meeting. To be sure of making good use of the time and of being well prepared, I discussed the agenda with my supervisor and then another committee member a week before. I like to have my ideas challenged, but my experiences have left me with residual tendencies toward an exaggerated sense of powerlessness in some confrontational situations, so I want a fair chance to prepare.

The start of the meeting is delayed – my supervisor keeps us all waiting for at least five minutes. Upon her arrival at the meeting table, she takes the role of chairperson away from me. I think about protesting, but then decide *it is one less responsibility for me and we have prior agreement on the agenda anyway.* I shift from constructive nervousness to a palm-sweaty, breath-grabbing fear in the first minutes of the meeting. One committee member is from another department, and my supervisor suggests that during the two minutes it will take for her to explain the expectations to this non-departmental member, I might want to prepare descriptions of both my comprehensive and thesis areas. I have been working on my thesis topic for months, so it's not difficult to describe the area. *That is fine.* I have not thought about my comprehensive area for a year and a half. *I really can't remember. None of this was on the agreed-upon agenda.* My reaction is instantaneous and I do not experience it as a choice. A dozen protests die silently in my throat while I am unable to make them into sentences. Panic wrestles calm for supremacy as my vision blurs from accumulating tears. *Fight that, fight that! Do not let them see your uncertainty and self-doubt. Just get through this bit and you should be back on the planned agenda that you are ready for.* My chest feels constricted, my breathing light and rapid.

As the other committee members discuss the program requirements, I am drawing a total blank. *Now try to remember: how can your comprehensive area be summarized in proper sociological terms? I would have written something up for myself if only I had known.* I feel absolutely completely powerless to protest. *Surely it is a small expectation that I should be able to talk of both these things.* I expect wrath if I refuse to try and ridicule if I say I cannot remember. *If I tell them I have chronic memory problems, they will always be expecting my incompetence and every thing will be made more difficult for me. Just get through this; then maybe we can do what this meeting was supposed to be for.* Internally, I continue to rationally argue against my own reaction, but the emotions of fear, shame, and helplessness are overwhelmingly powerful. They block out most of my abilities for intellectual thinking.

The simple change of an agenda has become the worst trigger that I have experienced all year so I spend the first meeting with my whole supervisory committee unable to understand or express what is happening. It took almost four weeks to co-ordinate everyone's schedules and make that meeting possible, and it ends after an hour and a half because my efforts to choke back a tidal wave of emotions have rendered me almost mute.

* * * * *

My tears continue throughout that evening, and it takes me a few hours the next day to get up the motivation to do anything or go anywhere. Then it is mostly about "saving face," demonstrating by my appearance on campus that I am okay and getting on with things. I can maintain superficial emotional control for a few hours, but in truth I am unable to get anything into perspective. Over the next few days, I do all the right things: talk with my counsellor, ease off on my work expectations, try to pay attention to my nutrition, plan some recreational activities with friends. Still I am constantly fighting depression. I have a lack of will to continue. I keep throwing up within a few hours of eating, and exhaustion begins taking its toll. I find my energy insufficient to attend much of the socializing I scheduled. There is no money for a flight four thousand kilometres back home to the comforting arms of my partner, which is what I want most of all. I begin to consider a twelve-hour bus trip to my parents' home just one province away. They do not know that I have episodes of post-traumatic stress, but I know they would not want me to be suffering like this alone. The prospect of the bus ride is too dismal, so I drop the idea without telling them about it.

It takes a few days to understand that my reaction to the change of agenda at that meeting was so intense because it was also a reaction to several unresolved sexual assaults. I had fiercely, consciously, repressed my memories of violation and betrayal over much of the last eight years. That willful repression was achieved by living for the present and not looking back, but I suspect that pattern also created my occasionally very embarrassing memory problems. Even more significantly, repression and denial of my emotions left me depressed and unenthusiastic about life. I eventually had to face up to the horrible experiences I was trying to forget. At the time of the supervisory meeting, I was finally confronting my worst memories and participating in a weekly sexual assault recovery group.

* * * * *

I believe I have agreement about our agenda in advance. Then during the date, I find the situation changes in ways I am powerless to control. *It is as though the conversation about what I would and would not do had never taken place.* I test my opportunities for resistance only very carefully, wondering *if our agreements are worth so little: what value does my life have in the eyes of this menace who is my date for the evening? If I don't get to choose what my body does or what is done to it, how could any of my feelings or my very existence be relevant to*

*him? I feel powerless and afraid, which is exactly what the perpetrator wants. I have managed this before – I can lie here and think of something completely different. Eventually he will stop.* I become an easy victim.

\* \* \* \* \*

It is just over a week after that supervisory meeting that I finish my initial draft of this essay. In spite of my best efforts and the support of both counsellors and friends, I am too ill physically, emotionally, and psychologically to be able to work during four days of the week. Within ten days of the supervisory meeting I am feeling stronger again, and very clear about balancing personal growth and academic accomplishment. During my master's program, just two years before, this would have been a much bigger setback because my dramatic emotional reaction would have been almost a complete mystery to me. Only the work I have done in the sexual assault recovery group gives me the skills to understand the impact my victimized past is having on my present, so that I can separate the emotional jumble that is created and move forward reasonably quickly. I am told by the coordinators of the sexual assault rebuilding group, who have seen the process numerous times, that if I continue to release the hurt and anger that I have been holding in for a decade and a half, eventually I will be emptied of those emotions to the point that I can again feel powerful in my own life.

My experience within Canadian universities is not unique. There is an epidemic of violence perpetrated on one sex by the other. Adrienne Rich has aptly described the experience of being a female university student in terms of being prey. It angers me that while I endure the symptoms resulting from that violent environment and do my best to recover, my livelihood depends on keeping up with my excellent cohort so that I have access to funding and job opportunities. My academic career includes a seven-year interruption, during which time I incorrectly assumed I was not sufficiently intelligent for graduate school. Even now, sixteen years after the first assault, I am challenged to overcome the intellectual, emotional, spiritual, and physical impacts of my victimization. Despite the struggles stemming from my assaults, I have surpassed the requirement of graduate programs at two major Canadian universities and have done so within the time frames expected for those master's and PhD programs. I cannot help but wonder what I might have achieved had my initial post-graduate studies been conducted in a safe and supportive environment. In theory, another university shares responsibility for the harm done to me because two of my assaults happened in residence, and each of the five different perpetrators were university students at the time they forced themselves on me. In practical terms, years later and without witnesses, I doubt that much could be gained through litigation. Working to make universities safe and intolerant of sexual assault now is my greater concern. There is no doubt that rape is a frequently experienced problem for female students.[2] DeKeseredy, Schwartz, and Tait (1992) conclude from a victimization survey at a large Ontario university that the problem of sexual assaults and sexual aggressive behaviour is at least as bad in Canada as it is in the United States, which would mean that one of every four women students experiences attempted rape or worse.

This question of responsibility is crucial to keep in mind as we consider how to respond with more justice to sexual assault cases connected with the university. The university is providing an environment in which predatory males are supplied with classmates and acquaintances for potential victimization. After creating the link between perpetrator and victim, and in many cases also providing the location for an assault, the university does not take sufficient responsibility for the violence that takes place between students. Sexual assault is a unique form of violence because of the silencing shame that is experienced by almost all victims. Our criminal justice system is floundering in its ongoing efforts to respond effectively to sexual assault. Evidence shows that university years are a particularly dangerous time for women. Universities should do more to foster an environment that acknowledges the reality of sexual assault, expresses sympathetic support for the victims, and seriously condemns the crime for the horror that it is. It is not enough for women alone to understand this reality. I want to hear about the disgust felt by the good and decent men on this issue. Only a climate of intolerance of sexual violence will foster solutions that allow women the same freedom of movement that men (especially white men) currently enjoy.

Staying in after dusk to protect my bodily integrity is too limiting a solution. I have a hunger for autonomy and freedom of movement that can consecrate the simple experience of walking home with the joys of freedom, the clawing terror of oppression, and the thrill of resistance. A few courageously defiant strides remind me it is good to be alive.

\* \* \* \* \*

[walking fast] *This is much better than waiting for the next bus; only one dark block in the seven-block trip.* It gives me an emotional thrill and physical pleasure denied for so many years – a sharp crisp pace, I am almost strutting, my breathing strong, even, regular. *I almost feel like the old self I have rarely been since high school – confident, outgoing, fun-loving, ready to taste all of life. Shit, people ahead, teenage boys – god, how many of them are there? Two rows deep across the sidewalk. Stay behind, watch them? Baggy jeans, macho gestures, laughter. No, I can't watch them, slowing down means losing my power. Wouldn't have to worry about this if my partner was here. I could tell them he's big and strong. Lot of good that would do if they had you pinned down at your apartment, taking turns raping you. Just don't look up.*

"There's a guy wants to get by." I'm wearing an oversized jacket and loose jeans with my hair under a cap, so it is not very surprising that I am taken for male. In my good mood I cannot resist raising my eyes from under the brim of my ball cap in mock surprise to meet the eyes of the young face nearest mine. *More guts than brains – maybe it is the old me, there I go again.*

"It's not a guy," he says, grinning back at me. Passing them I feel thrills of power and freedom, momentary fear, predominant anger as I stride past six boys.

"Hey, you're beautiful." the voice comes from behind me. It's slightly tentative and questioning, not clearly mocking or threatening in tone. *Don't answer, don't answer, don't answer, ignore – which one, is it the*

*guy who smiled at me? I read his eyes and know I don't have to be afraid of him – we could enjoy a little harmless banter. No, there are too many of them, you're not safe.*

"You wouldn't be talking to me." I say it as a flat statement, almost threatening, definitely not a question. I look to see who is preparing a response. *Damn, not the one who smiled, this one's blond and besides, not okay: his face closed, defiant, hardened already at something like seventeen years of age.*

"Yes."

*Nothing flirty, nothing flirty, careful, careful, careful* – "Not a good idea … " *– firm, direct, I can live with that response, though I am wishing for the moment that it was a self-defence class, not a sexual assault discussion group that I am coming home from.* There is a lapse of about a minute before another of them speaks.

"What's in the bag?" I have my leather book bag over one shoulder and a canvas bag with more books in the one hand, but I am through talking with them and with my long gait am pulling away from them. "Your whip collection?" Momentarily I think, *maybe there is some appeal in his idea after all (could this crew be symbolically punished for all of the women threatened and abused on our streets?)* but quickly conclude *there is no way I could make a punishment fit for the crimes to this body;* damn that word "crime." It gives me memory flashes of the data on the inadequacy of the justice system for cases like mine. If I let that idea in, all of my fear and repulsion will come with it. *Block it out, I know you can, feel the cat-like energy through your body rising from the earth – that's it. Glad I answered him. Haven't felt this powerful in years.*

\* \* \* \* \*

As one woman who has been sexually assaulted, I am progressing in my efforts to survive and to be an accepted part of a scholarly community. Even during the most chaotic times while inside I was directly confronting the truth and the pain of my experiences, I have spent a lot of energy trying to "pass" as "normal" and "well." I have engaged in many hours of internal debate over the question of whether I should publish my real name on this revealing essay. That debate points to one aspect of the academy's environment in which change can be initiated now. I am trying to make room for my students and colleagues to stop acting as though the assaults are not happening. Although I am in a much more powerful position than my undergraduate students, I feel very strongly the pressure to present the composed and indifferent exterior that constitutes a "professional" scholarly image. It occurs to me simultaneously that the particular wounds I hide would not be there if I had not chosen to go to university. There is the staggering, nauseating frequency of sexual assault on campus. By maintaining the expectations of masculine composure at all times, we create a climate that protects the perpetrators and punishes the victims.

It is likely that a quarter of the women you encounter on a university campus have experienced some form of sexual assault. Everyone reacts in her own way, but victims may be experiencing any of a huge range of symptoms, from general nervousness through emotional numbness, severe insomnia, crippling fear, and memory loss. My internal ethnography raises a series of issues about how sexual assault impacts on student life and the academy's response. I am concerned that not enough acknowledgement and support are

provided to our students who are trying to survive in an academic environment characterized by violence against women. The experience of sexual assault is not a brief and passing invasion. It threatens women's academic success and often haunts the victim for years afterwards in complex and unpredictable ways.

## Notes

[1] In spite of winning scholarships and repeatedly proving my academic competence, for me, self- esteem is something to be constantly earned rather than just experienced.

[2] Donat and D'Emilio (1997: 12) summarize the results of an American study: Koss, Gidycz and Winiewski (1987) found that 27.5 per cent of college women reported being victims of rape or attempted rape; 53.7 per cent of women, including those who reported being raped, had experienced some form of unwanted sexual contact and/or sexually assaultive behaviour. These results suggest that sexually aggressive behaviour is experienced by the majority of women in "normal" dating relationships. This high incidence gives credence to the feminist conception of rape as being supported by our culture.

## Works Cited

Caplan, Paula J. *Lifting a Ton of Feathers: a Woman's Guide to Surviving in the Academic World.* Toronto: University of Toronto Press, 1993.

DeKeseredy, Walter, Martin D. Schwartz, and Kevin Tait. "Sexual Assault and Stranger Aggression on a Canadian University Campus." *Sex Roles* 28.5/6 (1993): 263-277.

Donat, Patricia L. N., and John D'Emilio. "A Feminist Redefinition of Rape and Sexual Assault: Historical Foundations and Change." *Journal of Social Issues* 48.1 (1992): 9–22.

Ellis, Carolyn, and M. Flaherty, eds. *Investigating Subjectivity: Research on Lived Experience.* Newbury Park, CA: Sage, 1992.

# Margaret Shaw-MacKinnon

# Portrait

The Fine Arts Professor
with her Mane of Black Hair
makes the students do paintings of automobiles
all first term because:
"Cars are our lives now."
Then, this Fine
Arts Professor
with her mane of black hair says:
"Paint what <u>you</u> want."

*Freedom is one of the elements –*
*air – breath – words –*
Cassandra, suddenly air-
borne
giddy and having *slipped the surly bonds*
feels the warm
currents hold her aloft. *She*
glides. Here
she knows it is time to paint
six portraits, having never had the chance
to paint portraits before. (Always before
the professors piled
junk in the centre
of the barn
said "paint" and left the room –
what means "paint?") But now
intuition kicks in.
Cassandra can begin
where it feels right.
She begins with portraits
of good friends.
She experiments –

some expressionistic,
some impressionistic,
hand and eye
involved in paint
as never before.
Proud
she brings them in.
The fine
arts professor with her mane
of black
assembles the class before the six portraits.
Cassandra climbs ever higher
having trusted, having taken the right road
she already knows the praise that will follow.
"These
are shit.
These belong in your grade twelve portfolio.
These are an example of what cannot be done
now at the end
of the twentieth century.
You dare
to paint portraits?
Don't you know anything?
Don't you know Fucking Anything?
Don't you think you're pretty stupid?
Any idiot would know
YOU CAN'T PAINT PORTRAITS
in the nineteen nineties …"
For half an expanding hour the class
collectively looks
to the floor to the walls to the ceiling
or sneaks sniping glances at Cassandra
who is stone
who is lying near dead
on the floor
somewhere …

*and now I remember*
*a small bird fallen*
*from one of the elms*
*in the backyard*
*and how in my six-year-old hand*

*I picked her up gently*
*tried to will her well again*
*the big boys*
*braced her broken*
*leg, took a ladder, climbed up*
*to put her back in the nest only*
*the mother bird smelled something human*
*pecked her head*
*so I was allowed to raise her*
*when I let her go at last*
*she came back*
*year after year*
*we always recognized her*
*by her difference*
*by the tuft of white feathers*
*on her otherwise black head*

Cassandra gathers herself,
doesn't break in front of
them,
comes back to do a nine by twelve foot
painting of war
and sex and violence
jagged in mudgreen and magenta
a playgirl male centrefold
with a president's head
and heat-seeking cruise missiles and death.

The fine arts prof with her black (h) air
gives it an A
and gradually begins to come to Cassandra
to tell her how
her cat is dying
of cancer
how her cat smells and looks
of death,
how as a small
girl
she loved
to draw cats
but soon learned not to …

*and George Santayana said*
*of the university institution*
*one hundred years ago*
*"All these friends of mine …*
*were visibly killed by lack of air*
*to breathe. People*
*individually were kind*
*and appreciative*
*to them … but*
*the system was deadly."*

*Is.*

# Terminus

# Randi R. Warne

"Terminus" is a poem I wrote after a former student of mine got a tenure-track position at his second job interview. One of the hiring committee members had been this guy's best friend for fifteen years, and the dean of the college was his former Catholic high school teacher, who, once he became dean, promised he would hire him some day. My former student, then a friend, called me up in Oshkosh, Wisconsin, where I was living a miserable life in exile, to talk about his merit and how he had earned this position by being the best candidate. I'm usually a lot more upbeat than this! But it felt, and still feels, like the truth.

## Terminus

I can no longer stand
   the stench
      of your privilege
   the reek that clings to your clothes
   your easy smile

Your lack of comprehension
   how angry, bitter I am
     my rape and your protection
my fault and your achievement

The comradery of ignorance
   wilful now, surely, after
   all these years of conversation

Things have not changed

Brother aiding brother, boots
   on our backs
   you lend your helping hands

# Lucy in the Sky with Diamonds

## Taina Chahal

By May Sarton's bed there are always books and flowers.
Handing me my passbook, Sylvia said,
some women have nothing else to do but write poetry in the afternoon.
But Audre Lorde says poetry is not a luxury and Alice Walker says:
having to almost die / before some weird light / comes creeping through / is no fun
And Anne Sexton warns: poetry is the opposite of suicide

phirst oph…
don't read the phollowing iph you are phaint of heart or
the sort who is ophphended easily, because phrankly,
i am phucken' pissed ophph

and he said (almost exactly what the other quivering-in-his-Rockports S.N.A.G.* said):
"There are strategies one needs to adopt to communicate."
and he said (almost exactly what the other quivering-in-his-Rockports S.N.A.G.* said):
"If I could give you some advice, you should really think about what you are saying so that you
don't hurt other people's feelings."
Can you imagine this? Saying this to a woman? When attending to the needs of others
at the expense of our own is what gets us into our mess of a mindscape in the first
place? Can you imagine this?
Saying this to a Woman?

[*Sensitive New Age Guy]

and then there's the Captain: Mr. let-me-tell-you-about-my-sexual-prowess
Booth-boy (who hides in closets) And proud of it. Thank you very much.

QUESTION:   Does your defence of artistic creativity extend to white people writing in the voice of
black people? of white writers writing in the voice of Native Canadians?
of men writing in the voice of women?

ANSWER:     Why yes. Emphatically. Yes it does. Why can't a white man write about a red man
            and a red man write about a white man?
                                    on and on on and on

QUESTION:   i believe the argument has to do with power relations, with access to publishing,
            markets, access to education, structural inequalities …
ANSWER:     on and on on and on
                    'til you feel like cryin'
                                on and on
                                        on an'
                                                on
            with the circuitous meaningless none-sense of the linear lovers, then
            spins 'round: I dare you to continue with this line of questioning.
            I dare you.

i have been phaithphully trying to phigure you out so   i can tell you how it is phor me –
and phor my phriends – without ophphending you    i have been pleasant  i have smiled   i have
been nice   i have been phriendly and sweet and good-natured   i have weighed my words
carephully, so as not to ophphend you or make you pheel bad – or look bad

  a stone
            a sharp shard of slate                                               brittle
                                                            detaching
                                            disengaging

help, said Alice, help. Is there not a spot?
is there not a spot?
see Spot.
see Spot run.
see Jane.
see Jane run.
see Dick.
see Dick run.
Run, Dick, run.
Run, Jane, run.
Run, Spot, run.
See Dick and Jane run.
See Dick and Jane and Spot run.
See Sally.
See Sally laugh.
See Sally cry.
See silly Sally.

See silly silly sally

she looked over her right shoulder and saw a dark woods on a snowy evening   Broken boughs
and blackened leaves lay half hidden under the snow  an old man wearing the robes of a priest
hovered in the dark, calling to her   he said he felt

                                                                                            Crushed.

I WILL NOT.                                                                        Be silent.
I WILL NOT.                                                                        Lie still.
I WILL be a virago a female fury a blazing she-fire of feminine justice a screaming hyena
I am Hecate witch of witches I will stew/brew spell/conjure   weave a web    of tangledness
spin my message my words spiral them into an ever-spinning outward bound whirling dervish
top spinning my female power gynergy gyrating erratically eternally outwards to strengthen hone
the sharp shard of jade to shine the stone the iridescent mother-of-pearl    shell    of my
existence    the pink cream fluttering white ruffled lipped beauty that I am     you will see me grow
strong like a fine delicate pale green slender     vine       I'll wrap my tenacious tendrils 'round
your trunk and strangle you   you'll shrivel up Die be left a stump of rotting wood grey lichen
and yellow spores and spongy moss and fungus mushrooms will feed on you and suck you into
a pulpy mess cry your vapid fears of lost meanings you're drowning disappearing under the rich
dark earth the steaming darkness will cover you and you are gone        lost
                                                                                  under the surface

BONUS QUESTION (worth 2 points):
How is being self-conscious/self-interested/self-reflective different/similar from being
out-of-one's-mind and/or different/similar to the notion of self-reflexivity in the postmodern
sense?

          he's phlip-phlopping on himself (again) …no, not the capital B bad warm fuzzy
          stern look from Mrs. Burns but, "You should be careful how you say things."
And the answer is: 1. don't say it that way. 2. I am censoring you. 3. this is a moral judge-
ment. 4. this is an ethical judgement. 5. meaning? you (again) contradicted yourself because
you said you feel uncomfortable when ETHICS are brought in.
Do you even know what you are talking about?

i have used my humour, my intellect, my wit, my compassion,   i have opened up and made
myselph vulnerable i have even buttoned my lips and zipped my mouth    so as not to ophphend
you or make you pheel bad – or look bad   i have walked on eggshells, threaded my way,
danced gingerly (in high heels backwards) and pussyphooted around you so as not to
ophphend you or make you pheel bad – or look bad

Overall, good work. Remember to strike a balance
between the political and the personal. You need to        just saying I'm too political
work on making your writing more personal, less           shows your politics, sir.
political. Try to balance the personal and the political!  And ma'am.

                                    Sir, don't you go tell me I'm too political
                                    Don't you go tell me that, too   don't you go
                                    put me in the red room
                                    *Critical Practice* for chrissakes.
                                    Don't you go tell me I'm too political.

            sorry i don't fit your fill-in-the-blank formula of sitting in class and middle-class
            calmly and comfy matter-of-factly with a question mark lilt at the end
            say/ask what i have on my mind

i have sat silent as a stone and inside a black raincloud – and I'm usually a lot of phun – but
phinally, I've had enouph   now I'm mad yes, angry  phrankly, i don't phit in your phiction    I'm not
a phawning phlirting phlatterer   i sleep with one eye open – but I'm not a phaultphinding phanatic
phascist ophph on the phar lepht phantasizing phiendish phelonies – but i do sleep
with one eye open     and phinally, i've had enouph

        why are my questions so troubling? If he has nothing to hide he need not fear my
                    probing
                                long

            barbs
                            that poke

            into his boxed-in stifled controlled
            tight-ass fraidy-cat play-it-safe-sam
            toe-the-line wishy-washy all-show
            all-surface all-talk but no walk upper-
            middle class yuppie van-driving world of
            kiss-ass   asshole capital F
            pretentiousness

Answer 3 (three) of the following. Each question is worth 5 (five) marks:

(a) Irigaray states: "Those who allow the imaginary pulsations to disrupt the symbolic order run
    the greatest risk of madness." True or false?

(b) In her article on male violence, Ann Jones states, "And when anger is at its worst, the angry woman is more likely to *smile* than to throw a punch especially if the person she's angry with is bigger than she is." Discuss in no more than two words.

(c) In class we discussed Turkle and Papert's work on epistemological pluralism. They assert that "Formal thinking, defined as synonymous with logical thinking, has been given a privileged status that can be challenged only by developing a respectful understanding of other styles, where logic is seen as a powerful instrument of thought but not as the 'law of thought.' In this view, 'logic is on tap not on top.'" Using one of the "other styles," discuss in relation to the missionary position.

(d) Henry Giroux's research shows that "there is little in the positivist pedagogical model that encourages students to generate their own meanings, to capitalize on their own cultural capital, or to participate in evaluating their own classroom experiences." Without utilizing the first person, provide obfuscation which repudiates the unsubstantiated misapprehension of the aforementioned.

> "no concrete ideas. not concrete enough"
> how ironic
> from Mr. Abstraction himself
> think I'll femail him a concrete poem
> my poem on concrete theory
> > in concrete walls
> the real foundation
> in this concrete cell of decorum
>
> is to lock me up in your prison house of language

back to Ari, Plato and the boys   transcend the body, they said
the earthly body   the carnal   sulphurous pit-burning, scalding, stench, consumption; fie, fie, fie! pah! pah!   define her shape her she's clay mold her no matter, she's matter, after all this add-on transcending bodies, genders, classes, races, sexualities mind/body split transcend to the human   whatever that is after your skin is stripped off   after your woman's body is gone

rabbit-eyes              glowing glaring          a black crow
sitting silent           tiger eyes               sitting silent
listening looking        cat eyes                 listening looking

2nd class more of the same I know my ists and isms let's make the class work I love discussion but don't forget I'm the white boy in power up here I love the structure actually let's do the add-on no feathers to get ruffled nothing to get disturbed you can't say I'm sexist if I've got a

couple of women on my outline now can you?…but all the poets are male and poetry is the apex of the hierarchical stacking of genres Who's on top? missionary position I'll give it to ya'All the female poets of the era are: Dismissed. seems no one female makes the grade only male poets we are to study seems they are the ones who best reflect the aesthetic rendering of the socio/political/historical landscape/mindscape the only scape worth travelling leads to phallic drift i.e., the strong tendency to shift towards the male p.o.v. that which is of importance to man now man apparently means woman too according to those who say that all those ists and isms have an agenda why we all agree on what is truly great and universal don't we? am I to conclude that males best express the temperament of the era? that men can best articulate the concerns of the times the themes the threads are best left in the hands the minds of men? the words of men will tell us about the women I suppose? what about the words of women? who will they tell? who will listen? somehow the landscape/mindscape I'm walking in seems troubled the phantom rain flies in the yellow fog seeps up along the butt end days slipping through the cracks the yellow wallpaper blankets the landscape boxes me into a linear path to the down

<div align="center">down</div>
<div align="center">down</div>

"Down, down, down. Would the fall *never* come to an end? 'I wonder how many miles I've fallen by this time?' she said aloud….
Down, down, down. There was nothing else to do so Alice soon began talking again. 'Dinah'll miss me very much tonight, I should think! (Dinah was the cat.) Dinah my dear! Do cats eat bats? Do cats eat bats?' and sometimes 'Do bats eat cats?' 'Now, Dinah, tell me the truth: did you ever eat a bat?'" (Lewis Carroll)

"could you get to the point, please?"
wrap it up
        shrink
            wrap it

 i am incensed inphlamed phrenzied phiery and phurious   i am pyromaniacal   i am tired of being nice     i am tired of putting myselph in only iph it phits     i am tired of being nice
              i am tired of smiling
i am tired of being nice
i want to be plain old ugly rude and nasty

Transgressive language:    FUCK  SHIT  MINDFUCKER   FUCKEN' FRUSTRATING
FUCKED UP WHITE BOY    FUCKED UP LOST-IN-ACADEMIA
FUCKED UP MALE PROFESSOR IN A FUCKEN' MAZE
IN A FUCKIN' BOX IN A FUCKEN' FUCK-UP
i can't even express the rage/frustration i feel
i can't even begin to tell my anger
i can't even express it

which makes me angrier
i don't have the words
it's a silent anger
a powerful silent anger
an all-consuming
                                        silent anger

so what am  i supposed to do? smile and fit in? smile and die? die a little each day as  i struggle
for a scrap of the quilt? have you heard about the politics of the classroom? have you? do you
know? you may know what gender is but you don't know what a woman is  you can't even
recognize one if she stands in full glory before you    only if she smiles. sits and fits. check.  one
of the builders of the community     but if fie, fie, fie, SHE'S GOT LANGUAGE IN HER EYE!!!

cursed be damned WOMAN – point the finger – you go back to being feminine  Then  Then   i
will deal with you. Don't you go being a WOMAN on me. Don't you try that stuff on me.
Sit. Listen. Smile. Abide by the Pauline dictates made invisible in 20th century pomo discourse.
Anger: You want Anger!!!??? boyboy you don't even know what a WOMAN's ANGER is.
Because i point out the way i see it, because i PRACTICE CRITICAL ANALYSIS!!! this is
ANGER!!?? SIR!!! how dismissive!!! Don't you know the number one way to dismiss a woman
 is to call her ANGRY!!!?????? dismiss her CRITICAL perceptions as self-serving narcissistic
 whining!!!!???? WHO, i ask, WHO is reproducing the status quo? Me…or you?

and iph  i have ophphended you, i am sorry, but maybe it's time you moved out oph your
middle-class complacency –
it's fatal to me.
and my friends.

climbing tenaciously       climbing voraciously
a fresh green shoot    spiralling dizzily       shooting skyward
wrapping myself    explosively
round and round and round and
tangled and free
                                        shooting skyward

You can't catch me!

                        don't be fooled by fools' gold
        the dull tarnished
                        lead
hidden inside the covers of the golden
                        jewel-encrusted chest
the first choice
in the lottery

the glittering one      goldilocks      goldenrod
                    K.C. and the Sunshine Band
                that's the way I like it
                                        uh huh uh huh
                that's the way I like it
                                        uh huh uh huh
His royal yuppiedom prince of puppydom
Arthur's court: young flits/flirts fluttering flattering
                    missy-mirrors smiling sillies panting panties
phantasizing phashioning phantastic phancies with
His royal phallus

Warning: don't pick the golden
                                    casket
if chosen, one loses all of one's possessions
all of one's bearings
and is stripped of Be-ing

                oh, i think so
                    [women in the British army have been expressly told to say
                    "zero," rather than "oh," which is regarded as too sexual.]
                oh, i think so, i really oleannaed him
                oh, we pegged him his libido is lurching in the lagoon
                oh, he has definitely stopped let's play that tune
                oh, i think so
                he really didn't expect that
                he never imagined in his wildest dreams
                of giving it to sweaters stretched tight across nubile breasts
                that words would come off the page
                and jouissance before him

                    i've called yr bluff
                    yu've met yr match
                    we're switching/shifting places/spaces
                    i will distract/disrupt
                    your song-and-dance
                    step on yr toes
                    make you stop      think      look
                    i will defamiliarize yr narrative
                    i am walking poetry poesy a posy
                    of female flowers

a rose
a thorn
in yr text
i'm unbuttoning
yr mask
i'm climbing inside
yr jacket

i'm looking listening
laughing
at the double-sided subtext
of yu

i'm her

your mother
your lover
your sky
your heaven
       as it is on earth
your saviour
your goddess

Her

for sure

you can't, of course,
ever know
it's all conjecture
it's all
    suppose
it's all
    maybe
    could be
    but you can never know

she looked over her left shoulder.  Up in the sky she saw a strong, beautiful Woman wrapping the colours of the rainbow around her.  The Woman's hair streamed around Her like a sea of rippling tall meadow weeds grasses rustling in the wind. Tiny little painted horses danced and pranced in the waves by Her throne. The Woman smiled and a warm rush of golden sunshine spilled across the sky.  Lucy took one last look at the glassy mirror, lifted her chin up, and

all in together girls
never mind the weather girls
put your coats and bonnets on
tell your mother you won't be long…
                  fell
                                the
            into
                                        sky

# Spunk

Carolynn Smallwood

[ScGael. *spong*, tinder, fr. L *spongia* sponge]. 1. a woody timber: punk b. any of various fungi used to make timber 2. mettle, pluck 3. spirit, liveliness 4. *Brit. slang*, semen

Alma mater,
(O fostering mother,
what has mothering got to do with this place?)
Hallowed halls, holy walls, wholeness.
Am I now whole,
     or still just a hole
since my summa magna
cum laude?
Come one.
Come all.
Come cum.
Here he cums down the hall.
His ejaculations
of happiness
now he's an Oxford fellow who
dons his swanky college scarf.
Before I can retreat
he cums:
in his cocky pedantic spunk
I am dunked.

(I am without
spunk.
Once, I had this
ignis fatuus
that I had it.
So I went to grad school.
But, how can a woman

who lost her voice
ignite these halls with her intellect?)

This institution is
swamped in spunk.
Observe:
Seminar Seminary Seminal
Magisterial Master Masturbator

Doctoral anecdote:
I deride your Derrida, professor.
*Différence* is deference to your
paradoxical philosophical phallogocentric
     phonocentricity.
Metaphysics of presence presents
Praxis as imperfect.
My inscrutable silence
Defeats your deconstruction.
I am deferral. I am absence.

The paradox of muteness is to desire to cry out but to remain closed.
Hallowed halls, like lips, are sealed.

Now I stand besmirched with his spunk.
This gaping hole,
my utterances impotent on my tongue.
(Déjà vu.)

I swallow them,
and withdraw.
My words
exploding
onto this page.

# New Year's Resolutions, 1997

## Jeanette Lynes

No more
extensions granted in the university parking lot;
extensions granted in the grocery store;
margueritas while marking;
listed phone number;
student papers in my front porch;
cafeteria meals;
student election pitches in class;
critiquing someone's boyfriend's girlfriend's poems;
authoring entire sections of master's theses;
graduate student parties at my place;
committees;
subcommittees;
completing conference papers in hotel rooms;
conferences on Visa;
white-out drives to off-campus courses;
dinner parties cooked by full professors' wives;
broken computers;
apologies.

# MOVEMENT FOUR

# Dee Horne

## Old Boys

Old Boys
in the
Ivory Tower

Boyohboy
Old boys
strike out
new voices,
playing their sameoldsong.

First base: it's a matter of
degree
Where did you get that PhD?
Second base: teach
Without tenure, you're not free
Third base: publish or perish
Old boys accepting all,
excepting some
new voices
calling OUT!

Women strike
back at the boys:
the old boys
and their net
works no longer.

*Keith Louise Fulton*

# The Possibility of Professing Changes

At the age of eighteen, I went to university as the major step to becoming my adult self – to learn about the world and how to enter it productively. I learned that I and others did not belong; that took three degrees and the next eighteen years. It is not just that I am a slow learner, but that I am so incredibly hopeful. The last eighteen years I have spent working to change myself and the university in the image of that hope.

My account here is situated where I am, sitting in the office as a new chair of the English department in a small university that I both love and challenge. I have just finished three years as coordinator of Women's Studies. This week I have signed for the still pitifully small teaching stipends paid to women with PhDs and babies. My own memories of nursing a baby while writing a dissertation in the middle of the night are so vivid that my breasts tingle with the echoing hum of the let-down reflex. While I have survived by changing what it means to profess, the change that I am part of has been made by and with others and is incredibly slow. The gender of the person who signs for the stipend won't fix everything. The system itself is gendered masculine, which means that it reproduces social masculinity and does not necessarily benefit many or even most men. Yet each detail of my work is critical, for my goal of creating a university experience that is equally beneficial to women and to men (all women and all men) requires that I rethink each process. I must not give up because I cannot do everything at once or even keep up. My story is about resistance, but also responsibility, mostly the responsibility taken up collectively to make opportunities available and to plan for changes. I do not write that if I made it, you can too. Yet I believe you can and I am working for that. Our institutions, including our universities, still welcome women as customers, but not colleagues.[1] We are making our possibilities by becoming our own colleagues.

I begin by unpacking the ideology of individualism with its attending narrative of solitary sorrow and achievement. I am part of meanings and processes I did not invent, and even my survival has come about through the work and structures supplied by others. My big break came when I was appointed

to the first Margaret Laurence Chair in Women's Studies in 1987. That position had been created through the efforts of women and men across Canada who envisioned a way for the federal government to assist the equality struggle of women. Locally, the position was obtained and funded through the enormous efforts of a relatively small group who obtained the endowed position for the University of Winnipeg and the University of Manitoba jointly and of an even smaller group who raised a matching half million dollars.[2] But there were many earlier breaks, not the least of which were the works of feminist writers. When I read Gilbert and Gubar's *Madwoman in the Attic* that 1982 summer in Saskatoon, I caught a glimpse of the oppression of women that went far beyond these scholars' argument about women writing in the nineteenth century. The attention they directed to the metaphors of authority and to the discoveries and covert expressions of so many women resonated with my own unease and energy. What I felt dimly was that *this* was not going to be easy, but it *was possible*! The *this* was my own unspecified participation in the world. My mother had gone to university, and I grew up with the expectation that I would too. Going to Stanford University in 1964 was a fulfilment of that expectation and also an escape that I had plotted for a very long time and for which my school grades were the means. What an upstart! I was very fortunate and also lucky. And unlucky. Recently, a young woman activist asked me how I had gotten through university and whether I had always seen the problems there. In the United States in the years of '64 to '68, we knew about the complicity of American universities in militarism and in the denial of civil rights, but the war in Vietnam and the wars of racism, what Gordon Lightfoot later called "motor city madness," were front and centre in our minds. Because of the draft, the most pressing problem was the war and how not to support it. What the mainstream press calls draft dodgers, I call war resistance, but as a woman, how was I to do that? In 1968 I married a man who resisted the war, and we immigrated to Canada to go to graduate school, he in economics and I in literature. When I left that marriage for the freezing dark of a Saskatoon winter fourteen years later, the university was still part of my expectation and escape. But now I thought of it in a far more focussed way as I struggled with the material realities of my dreams. Gilbert and Gubar didn't make the earth move, but they alerted me to the tremors I was feeling. I had three small children and a PhD on William Faulkner. I was going to the University of Manitoba to take up a leave replacement position in the English department. The tectonic plates for the world of my public consciousness were shifting.

Institutions were shifting as well. I came into the position of the Margaret Laurence Chair with a focus on institutional change in the universities, and I am still working in this area. A couple of years earlier, I had heard a presentation by Jane Lewis, a scholar from the London School of Economics who had been studying the affirmative action programs in North America. Her analysis of how these

programs were set up to fail opened my understanding of how individuals and institutions obstruct policies of change; it also unleashed such disappointment that I decided to take my own steps in affirmative action. Audre Lorde would call it locating my power and discovering how to use it. I decided to "vote" with my discretionary income – the very little I had outside rent, food, and kids' runners went to books. My promise to myself was to support women's writing by buying only books written by women. I thought it would be a hardship, forcing me to go to libraries to do most of my reading. Instead, I found a whole world of writing, far beyond what I had imagined could occupy the "margins" of literature. I also discovered that these books did not stay in print long, that they usually were not reissued, and that they were rarely taught in university. They are now, though they still do not stay in print long. I am proud that my work has contributed to that partial accomplishment. The ways in which women's writing is changing the university, and the world, is the part of the Women's Movement that I know best. While I know the importance of an organized movement, I draw comfort from the knowledge of thousands working away, changing the day-to-day dynamics, creating the language that makes our lives visible. My image for this aspect of the Movement is a Manitoba spring: raw winds, treacherous runoff, winter shit, a glorious sun on the shoulders, and the thawing of the earth. Each of us does a bit, warmed by the work of others. I joined the editorial collective of *Contemporary Verse 2*, read women's writing, and dreamt of solidarity and how to create it.[3]

In 1986 I was a single mother with three kids, and I was at the end of a term position at the University of Manitoba.[4] That summer, as I was hiking up a small deep canyon in Banff National Park, I was trying to figure out what I could do next that would make a difference, if not for myself, then for others. Looking across to the rock face on the other side of the stream, I saw a marker for the depth of the canyon two thousand years ago. And I thought, "I can be water." That poetic thought has sustained me and helped me think of collective action, while still relying on my own drive for freedom and dignity.

As songwriters and poets know, the lyric "I" sounds a personal space in the listener as well as in the speaker. The "I" is the partitioned self that the societies of Western civilization have, for the most part, confined and colonized in women, but also in men. Privilege, for men or for women, is not the same thing as well-being. Privilege is a system where well-being, the necessities of life, are gained by some at the expense of others. The unspoken condition of our privilege is always that our having it turns on depriving someone else. We buy into hierarchies, and each location deforms us and others; somewhere within, most of us know that, though we might feel it as guilt, shame, greed, emptiness, or longing. What do we do with that creature knowledge so vital to our commitment to justice? We freeze it. Poetry is a way into the stored toxic waste of our experiences, thawing our own information. Adrienne Rich reminds us "how poetry can break open locked chambers of possibility, restore numbed zones

to feeling, recharge desire" (xiv). Her insight is critical to understanding the relationship between women's writing and institutional change: that one of poetic language is "to engage with states that themselves would deprive us of language and reduce us to passive sufferers" (10). Our writing can un-freeze numbed zones and be "an instrument for embodied experience" (13). Women's Studies has been constructed on methodologies for retrieving experience as knowledge. Literature situates that retrieval within an individual woman's reach: a pencil and paper. When she writes, she changes the forms we have known. For example, women's poetry often opens the lyric "I" to express female agency, the ability to make meaning and to act on it. Both the "I" of the poetic voice and the "you" that the voice addresses include the reader. Changing the meanings of the subject position allows us to think about ourselves differently, in reciprocal and collective relationships where we are not alone. Our authority does not have to mean dominance or solitary expression; we can transform the systems of meaning within which we live, including the institutional systems.

We remake the university each day as we walk through the doors and take up our work there. Re-fusing to lay down important parts of ourselves and our communities as we enter reverses what we have been taught and reclaims ourselves and the institution. As a feminist student (graduate student, gradu-ate assistant, stipendiary teacher, sessional lecturer, leave replacement, endowed chair, faculty member, tenured professor, Women's Studies coordinator, department chair), simply joining the institutional epistemic structures will not help. The point of feminism is to analyze the conditions of oppression in order to transform them. Understanding is not enough; we will have to do things differently from what has been accepted and expected. But since each of us is there because we have succeeded in doing the accepted and expected, we are faced with a tremendous difficulty. The reality of the power structures in which we are enmeshed can combine with our social learning, and we can continue to think of our-selves primarily as powerless, unable to see our own possibilities and responsibilities.

The poet Audre Lorde points out that each of us has some power. We can use that power in the service of what we say we believe. If we do not use our power, she reminds us, someone will use it for us, and in our name: "So the only way for us not to be used as instruments of oppression is to actively engage ourselves in the liberation struggles" (*Womanist* 4).[5] As I try to identify my power, I connect her thought to the feminist slogan from the '70s, "the personal is political," and to Himani Bannerji's observation that the "relations of ruling become more visible where they converge most fully … in the structures of the daily lives of non-white women, particularly if they are working class, and I would add lesbian" (xix). Realizing that my location is constructed through the relations of ruling alerts me to the political dimensions of my personal life, not just as I have been a single white mother to three now grown children, nor just as I undertake to live as a lesbian, but also as I engage in my work as a

professor. I inhabit social and political locations from which I can learn about the relations of ruling (in which I participate) and where I can draw on the power stored in that site. Social location is an imaginary, theoretical name for how we live our lives. Our lives, then, contain energy that is being used to oppress us, but that can be used by us. Feminist theory, here, seeks to release that energy to transform social structures, cultural values, and personal lives. These locations in the global relations of power in patriarchal capitalism can be seen as interstices in a matrix, a web of relations. Within the imaginary and material conditions of that web, I have some feminist agency as well as responsibility.

The only person I have the power to change is myself. But when I realize that this self inhabits a political location, animates a political culture, and reproduces political power, changing the self becomes an important project. Audre Lorde talks about knowing where our power lies and how to use it. The self I know is my experience; it is also my agency – my power. I use "I" to foreground the change work that can and must be undertaken by an individual woman, but I am mindful of that woman's relation to community, culture, language, institution, and knowledge. Within the ideology of individualism, the possibilities of individual contributions to collective freedoms and responsibilities are disguised; the expectation of separate self-interest obscures the continuities between the self and the communities that constitute the public (and private) good. The power of the individual does not have to mean the right to amass property; as feminists we can change that meaning, as we have changed other social meanings, by building collective understandings of what has been regarded as non-sense.

After I have closed the computer on these thoughts, I must go to my next class, read a promising dissertation, meet with a student, attend a meeting, plan a timetable, prepare for tomorrow. Everything I do, I must do differently to embody my idea of a university. As I struggle and partly fail, partly succeed, I will build an analysis. The process is a praxis, a way of making change by learning from our actions and renewing our efforts. As the praxis becomes an acknowledged part of our pedagogy and curriculum, of our Senate and research grants, of our hiring and tenure, the possibility of professing changes. Women are finally coming to the university. This is the millennium when women say enough and mean it.

> I know you'll think of me,
> I'll be in your dirt      your flowers
> when I'm ready           I'll be taken
> up in your trees         breathed out
> into your sky            rained down
> on your mountains
> where I'll cut through stone
> and change everything
> I can be water

## Notes

[1] In 1989 I was part of a group of thirteen women who filed complaints with the Manitoba Human Rights Commission against the four Manitoba universities for systemic discrimination against women. The strategy is to call attention to the reality that the system of the university has a differential impact on women as a group. My argument is that the university is a publicly funded institution and has a responsibility to educate for equality. If it does not, then it is educating for privilege.

[2] June Menzies, Mavis Turner, and Elaine Adam did the fundraising. The province of Manitoba contributed generously, but the universities would not allow them to work through their system, internally or externally.

[3] The editorial collective of *Contemporary Verse 2* during the years of 1986-96, when I was there, included (for different lengths of time) Jane Casey, Jan Horner, Di Brandt, Angela Medwid, Naomi Gilbert, Uma Parameswaran, Patricia Rawson, Heidi Eigenkind, Diane McGifford, Laurelle Harris, and Janine Tschuncky.

[4] I applied for and got a SSHRC grant as an independent scholar. My project was on Edna St. Vincent Millay, the poet I had loved as a girl. I wondered why she had disappeared from the field of literature as I pursued it seriously in university. Was she really any good? She was. The category of independent scholar does not exist anymore; it is an example of opportunities that can be created for scholars who do not have a university teaching place. I have feminist scholars to thank that I was able to write and receive the grant.

[5] This discussion is from Audre Lorde's presentation at the International Feminist Book Fair in Montreal in 1987.

## Works Cited

Bannerji, Himani, ed. *Returning the Gaze: Essays on Racism, Feminism and Politics.* Toronto: Sister Vision Press, 1993.

Fulton, Keith Louise, and Michéle Pujol. "Women and the Universities Coalition: Systemic Discrimination Complaints (Manitoba)." *Towards a New Equality: The Status of Women in Canadian Universities.* Ed. Carmen Lambert. Ottawa: Social Science Federation of Canada, 1992. 31–44.

Lorde, Audre. "Power." *The Black Unicorn: Poems.* New York: Norton, 1978. 108–09.

——. "The Master's Tools Will Never Dismantle the Master's House." *Sister Outsider.* New York: The Crossing Press, 1984. 110–13.

——. "Untitled." *Womanist.* September 1988: 4.

——. *Shore Lines.* Audio tape. Commentary by Lorde in...

Rich, Adrienne. *What Is Found There: Notebooks on Poetry and Politics.* New York: Norton, 1993.

# A Guide to Academic Sainthood; or,

How to Survive the Ivory Tower; or, An Untoward Set of Advisements for Women Who Feel Called to the Book, the Bell, and the Candle, the Desk, the Library, the Classroom, and that Most Intriguing of All Conjunctions, the Department Meeting

## Aritha van Herk

### Appearance

Academic appearance is not so much rule-bound, as dowdy-bound. Under no circumstances is a woman to look sexual – that is, sexual as opposed to sexy. Sexy is tolerated as a version of fetish or personal statement (see STYLE). Trends are fine – piercing, cross-dressing, and androgyny approved of – but overtly occupying a sexually contented body is not acceptable, and ought never to be an image that any woman in any academic position projects. The tweed jacket with patches, the black blazer, the trouser suit with flat loafers are all acceptable. So is the dowdy skirt and sweater look. But garments playful or potentially funny – a bright red shirt, an embroidered pair of pants, anything asymmetrical – and you will hear sneers following you. Content yourself with outrageously seductive or silk underwear. No one need know the pleasure you're experiencing.

### Balance

Balance is the most difficult of all academic illusions to maintain, but essential. If at all possible, practice at home (if you fall on your face, no one will see you), using a high wire and a balance bar. You can set up such a contraption in the back yard. As a cheaper alternative, try walking up and down stairs with a minimum of three books piled on your head.

## Belligerence

If, however, you manage to keep your BALANCE, you will encounter belligerence, usually covertly, usually as a result of having pulled off an extraordinary amount of work or having published a significant article. Keep your BALANCE by remembering that belligerence stands in for congratulations; it means you are performing extraordinarily well.

## Bear-baiting

Bear-baiting might seem to be relevant only to those engaged in the study of Shakespeare, but it is actually a common occurrence in the academic arena. It involves poking verbal sticks at what appear to be the weakest or most defenceless participants in the game (sometimes graduate students or sessionals, sometimes undergraduates, sometimes secretaries, sometimes other faculty members). Although you will be implicitly invited to join in, it is better to avoid bear-baiting, however much fun it seems to be. Practice FEMINISM.

## Bearing

For bearing, see DEPORTMENT, although the exercises prescribed for BALANCE will also help.

## Carriage

Will be improved by balancing a few volumes on your head. See BALANCE.

## Conduct

Unbecoming or becoming, conduct is generally most scrutinized by those whose own conduct is less than impeccable, making them hyper-aware of such matters. Conduct can be difficult to pin down, but is a professional attribute. It manifests itself as a mixture of manners and speech, a clear window where actions speak louder than words. Think of yourself as an electric wire that allows the passage of a current without radiating heat or light. See DEPORTMENT.

## Comportment

Not quite the same as DEPORTMENT, although related. Implies compatibility, cordiality, and presumably professional conduct. Does not account for others' rudeness, ill-will, or impatience.

## Deportment

Declarative demeanor, subject to reading and interpretation. Do not whistle in the hallowed halls. Whistling, or – horrors! – out and out laughter, suggest delight, enjoyment, and a happy disposition. It is far more important to look melancholy, sigh frequently, and appear to be slightly harried or absent-minded (although it does not do to look downright unkempt – see APPEARANCE, see HAIR).

## Etiquette

While one expects rules for conventional behaviour, do not be surprised by the rampantly subversive and highly confusing etiquette that permeates professional life. If only etiquette were a ticket indicating a point of departure and a destination. Follow the rules of common sense and your own good nature. The rude will never be ashamed, but you will know they should be.

## Ethics

Professional ethics are exemplified by a set of unwritten, unspoken, enigmatically hazy rules only brought out from their mothballs when a questionable ethical situation has arisen. They then proceed to take on byzantine proportions and powers, especially if you are the complainant. See BEHAVIOUR. See APPEARANCE. See FEMINISM.

## Feminism

Currently an unpopular and shunned version of identity politics not often uttered or invoked in the academy. It makes colleagues bristle, makes students react, and leads to much bandying about of other isms currently considered to be much more important. Better to declare yourself a good girl and affiliate yourself with trendier identity politics. On the other hand, feminism as praxis is one way to live with yourself and will stand behind you when the going gets roughest.

## Gestures

Under no circumstances should you give anyone the finger, no matter how deserving or what the provocation. Arms crossed across your chest indicate that you reserve judgement. Peering down through your glasses suggests concentration on matters weightier than what is being discussed. Most academics keep their arms tucked close to their sides (a sign of both avarice and insecurity). You will find your body growing tighter and tenser over time. In order to counteract such constriction, go for long walks. Swing your arms. Sing. Do yoga. Lift weights.

## Government

Aspects of the administrative engine of the academy. Usually fairly neutral in substantive matters but quick to interfere in issues relating to money and time. If you are doubtful about their judgments, make them explain. See REVENGE.

## Hair

The academy hosts a big hair subculture. Tenured academics reserve high quality time to criticize other people's haircuts. The name of a good hairdresser is traded as if it were a mutual fund. Both good and bad haircuts are subject to personal vilification, usually at academic dinner parties attended by those who have no friends or life outside of the academy. Since critique is inevitable, wear your hair however you wish. See APPEARANCE. See SOCIAL LIFE. See STYLE.

## Inquisitiveness

A natural state for academics, especially those who have scant personal life (see HAIR). The stamps on the letters in your mailbox will be scrutinized – foreign stamps have more currency than local stamps and indicate that you have international correspondence. Courier or special delivery envelopes invoke intense varieties of academic envy. Any photographs you dare to display in your office will be covertly examined. Putting up conference notices on your door will incite comment, since the assumption is that you are attending that conference. Your posted grades will be scanned to determine if your marking adheres to the mysterious and intractable curve. Expect BEAR-BAITING.

## Judgment

That delicate balance between instinct and knowledge, experience and intuition that will do its best to assist you in making good decisions. Unfortunately, a woman's good judgment is required to relate to others whose goals and judgments are unabashedly Machiavellian.

## Knowledge

The combined gathering of all the information, analytical skills, and intellectual content that you have accrued over years and years of work. There are days when you will comfort yourself that knowledge is worth having for

its own sake. There are days when you will know that all the things you have learned and that you are capable of transmitting are worth less than a half an hour spent walking your dog.

## Leisure

Forget it. Women in university work twenty hours a day (teaching, marking, treading water) until retirement hovers on the horizon and they allow themselves to stop caring. Prepare yourself for a sleepless, endless round of late nights and early mornings, with an occasional half-day without immediately urgent tasks. You are likely to use that half-day doing laundry, washing floors, and getting a haircut. See HAIR.

## Method / Modus vivendi

Determine a method for damage control. Try to set aside a few hours when you do not have to answer the telephone. Do not permit e-mail to dominate your life. Stick to your office hours. Although it will be difficult, do not let any meeting interfere with your workout schedule. Remember to swing your arms when you get out for a walk. See GESTURES.

## Nausea

Academics love what makes them sick. Be selective about what you swallow.

## Nihilism

An enormous temptation that will suggest itself as a philosophical alternative after four and a half years of working in a university. Especially seductive will be its position that reform is only possible through the destruction of all institutions. When you find yourself looking for how-to-build-a-bomb sites on the Internet, it is time to take your nihilistic pulse. Be suspicious. Do not succumb. See BALANCE. See FEMINISM. See ORAL THUGGERY. Take a deep breath. Go for a long walk.

## Oral Thuggery

Will take place frequently, both overtly and subtly, and without provocation. Usually a response to your success, hard work, and the small portion of respect you manage to garner within your area. It will come out of left field and will inevitably take you by surprise, leaving you speechless. While you might expect that oral thuggery falls

into the realm of professional misconduct, you will learn that the institution is perfectly willing to countenance it and will even encourage subtle forms. Mostly, it proceeds under the banner of personal style or expression, despite it being an impertinently hostile form of warfare, not even intellectual, but certainly personal and effectively distressing. Its main purpose is to silence the other. In this instance, you are the OTHER. Be prepared. See METHOD.

## Other

The "Other" is difference, alterity, the inessential, the one who is not. FEMINISM can offer strategies for understanding and resisting othering, both of others and yourself. Most important of all, do not turn on yourself. See NIHILISM.

## Procedure

Institutions have a procedure for everything. First check to see if there are written guidelines; if not, check with someone who has managed to follow the particular procedure and ask her advice. Some people are delighted to help, some will scorn your request, but you will manage to weather a process that may be less than transparent. See GOVERNMENT.

## Praxis

How you manage to keep afloat. This is yours to devise. See FEMINISM.

## Pedagogy

An important aspect of academic life, teaching is one of the most rewarding, humbling, exhilarating, but dangerously seductive of academic activities. Beware of discovering that pedagogy has overtaken everything else and that it overrules your research, writing, and good sense, including LEISURE, JUDGMENT, and BALANCE. Beware of pedagogy as grail. Beware of pedagogy as hiding place. Beware of pedagogy as enslavement. Enjoy your teaching, laugh, have fun with knowledge. Your students will be grateful.

## Quirks

You will develop strange quirks, like washing your hands after department meetings. Take them in stride.

## Quixote

You may acquire quixotic tastes, like eating popsicles late at night when you are marking essays on *Great Expectations*. Cherry popsicles are best.

## Quotations

You will at some stage discover that quotations (the words of OTHER writers) have larded their way into your life. You will quote Shakespeare to the checkout clerk in the grocery store. You will quote Alice Munro and James Joyce and bpnichol at strange and unexpected moments. This is a mere hazard of the game.

## Responsibility

Always waiting, always there, always yours. Once you accept responsibility you are saddled with its weight. Be responsible but avoid responsibility. Do not feel guilty about this. How much responsibility are you being paid for?

## Revenge

Audrey Thomas says that "the best revenge is writing well." Sticking it out is good too.

## Social Life

Although it will be tempting to imagine that your colleagues and your institution will provide you with a social life, think twice about this. Parties are not an indication of goodwill and bonhomie, but are generally BEAR-BAITING circles that pretend to be genial. If you discover that you have become a party slut, cruising the hallways desperate for invitations, check your JUDGMENT, your LEISURE, and your incipient NIHILISM. Be elusive. Take a lover. Get a life.

## Style

How you do things. Personal style as a stand-in for good manners is now commonplace – choose your weapon (see ORAL THUGGERY). On the other hand, you may choose the high road and develop a style that is not institution-directed but all your own, that happy coincidence of pleasure and taste. And always buy good sunglasses.

## Tolerance

While tolerance is a virtue that the academy espouses, it is a rare commodity, and the sheer lack of courtesy and tolerance that proliferates in the academic world is shocking in substance and effect. See BELLIGERENCE. See ETIQUETTE. See BEAR-BAITING. See HAIR. If you are tempted, remember: putting up with others is less trouble than refusing to.

## Tone

Tone is sometimes inflected by style or distinction, even elegance, but can also be a matter of subjugation and resilience. Tone is one of the academy's trickiest subtexts. ORAL THUGGERY is primarily tonal.

## Usurpation

Occurs often, especially with political or physical space. If you are accidentally assigned a pleasant office with good furniture and a big window, expect to be usurped. If you are doing a good job on an energetic committee, that is running well and having a positive impact, expect to be usurped.

## Vivisection

The gossip that academics engage in. A disturbing tendency to trash the knowledge and abilities, but most especially the HAIR of other academics. See ORAL THUGGERY.

## Withholding

Expect scant approval, little appreciation, and less pay. These are all aspects of withholding. You are expected to be delighted with your profession and to take pleasure in its inefficiencies, its frustrations, and its insalubrious atmosphere. On the other hand, you too can withhold. Save some of yourself for yourself.

## Xerox

You will certainly become intimate with a copy machine, which will inevitably sigh to a halt when you are copying sixty exams for a freshman class that is due to begin in fifteen minutes. Anticipate this sabotage by machine, and be cheerful about it. If it makes you feel better, kick the machine.

## Yeast

Eat yogurt, several containers a day. Stress induces yeast infections.

## Zing

Imagine your life at a juncture where it enjoys laughter, grace, and a delight in what is possible. This is the zing that will return once you have followed all the other rules, seen through them, broken them, and finally come to the conclusion that rules do not matter a damn. If you are to enjoy this calling, you must sever the knots that the institution will magically wind around your wrists and ankles. Refuse to suffer from anosmia, anorexia nervosa, anorgasmia, not to mention ankylosis; do not pathologize your condition or your occupation. Rise to the occasion of the intellectual woman who works within an institution but also within the world, a public intellectual unwilling to bind herself to the rack and thumbscrew of confined knowledge and its discontents.

Zing, zap, zoysia! You'll wuther more than the heights.

# The Stress Tester
## Susan Phillips

As an administrative assistant, working for both an undergraduate and a graduate psychology department, my position holds its very own challenges. I can vaguely remember, once upon a time, that thought psychologists would be a mellow, stress-free bunch. After all, they work with the mind. They counsel people. They know stress, how to deal with it, how to avoid it, and so on. I was partially right.

Psychologists *do* know stress. They work with it. They counsel it. They live it. They can, on occasion, produce it. Mellow? Sometimes. Surreal? Often.

One night last week, just before drifting off to sleep, the idea for devising a Stress Tester kit came to me. The kit, designed to function as a self-tester, would measure my stress level during the course of a typical workday. I imagined myself trying it out at work. The scenario ran like this:

"Good morning, Mark," I greet Professor Mark Maxwell perkily as he walks briskly through the office door.

"Yes, it is morning, isn't it," he observantly replies before disappearing into his office. (Note: You don't want to go into that office. If you do, it may be weeks before anyone sees you again. I would be forced to phone 911 and I'm not sure even an emergency response team could find its way through the piles of papers, files, books, boxes, pop cans, and litter that lie in wait.)

Okay. So far, so good. No need to pull out the Stress Tester just yet. But wait. I hear Maxwell's voice. He is speaking in long, coherent sentences. Unfortunately, there is no one in the room with him, and he's not on the phone, so I'm not sure who he's talking to. Is it to me? Is he trying to get my attention? I feel a twinge of anxiety. Now seems like a good time to try the Tester.

Reaching under my desk, I pull out a large brown paper bag, unroll the top, and extract the Stress Tester cap. I admit that at first glance the cap looks somewhat like a dunce cap: cone- shaped with an elastic strap to place under the chin. But the words "Stress Tester Cap" are written impressively on the side in large black lettering, thereby differentiating it from any other type of cap. I put it on my head, snapping the elastic in place.

Reaching into the bag a second time, I pull out the Stress Tester measuring stick. This is the crucial part. Carefully, I connect the strings dangling from the measuring stick to my Stress Tester Cap. Then I stick one end of the measuring stick in my mouth, like a thermometer, which I blow into, like a whistle. Everything is set. I am ready.

Just in time, too. Dr. Minerva Randsom is puffing up the stairs. Papers are flying from her arms like paper aeroplanes and fluttering down the stairwell. "Oh, dear," I hear her say. After a few trips up and down the stairs, Dr. Randsom has arrived.

"I'm late!" Randsom cries as she passes my desk. Yes, she is late. Her usual five minutes. In a moment she is back at my desk, red-faced. Beads of sweat dampen her forehead.

"I need this for class!" a small jumble of handwritten notes falls onto my desk. There is a sudden pause as she hesitates, staring at me fixedly, pushing her glasses further up the bridge of her nose.

"Susan, what's that on your head?" She waves her hand in my direction. "Never mind. I don't want to know. Can you whip up these notes as overheads and bring them to me in my classroom?" Off she chugs, back down the stairs, to her first class of the day.

I blow into my measuring stick. It unfurls itself to a length of about two inches, give or take. Peering down the end of my nose, I can read the measurement: "Stress level, rising. Caution advised." Hmm.

After safely depositing the overheads with Dr. Randsom, I return to my office. The Stress Tester caused a few student heads to turn. Perhaps they were admiring the fine point at the top of the cap. I'm sure I caught a few envious, longing looks.

Dr. Maxwell is still speaking. I can hear him through his half-closed door. "Do you think this is the one?" he asks. "Yes, it must be," I hear him answer himself. "That's good," his first self replies. "We're doing fine. Up to snuff," his second self answers in a relieved tone of voice. I am happy to know that all is well.

The Stress Tester measuring stick relaxes into itself, resuming its regular, curled shape.

Dr. Jackie Lee, the director of the program, emerges from her office.

"Where is Dawn's thesis proposal?" she queries excitedly.

"On your desk."

Dr. Lee shakes her head emphatically. "I looked on my desk, it's not there. Come and find it for me."

"One moment, please. I'll be right with you." Now is a good time to blow into the Tester. It begins to unfurl. "Caution," it advises. Good advice at the best of times.

I enter Dr. Lee's office. She is standing by her desk, pointing at it. Stacks of papers and files are strewn across its top.

"See? I searched everywhere, but it's not here."

Quickly I scan the desk, looking for possible hiding places, booby traps, those kinds of things. It's a daunting task. The Stress Tester is unfurling. I don't need to look at it to know it is now dangerously close to the red zone.

Closing my eyes, I hold my hand out over the surface of the desk and wait, concentrating. I am not disappointed. Soon I sense papers detaching themselves from the rest. They rise from the desk, adhering themselves to the palm of my hand. I open my eyes.

"Here you go." Casually, I pass the thesis proposal to Lee. She looks amazed!

"How did you do that? You have to teach me that some day."

I shrug my shoulders as if the feat had been nothing. In fact, it has exhausted me. Staggering back to my desk, the Stress Tester is flashing in and out of the red zone.

"Need Chocolate," it insists. "Need chocolate."

Rustling for change in my drawer, I barely make it to the candy dispenser without collapsing. Fortunately, my favourite chocolate bar is soon melting its merry way along my nerves, soothing and caressing.

While acknowledging that the Stress Tester did not *eliminate* the stress I encountered throughout the day, I am satisfied that it still works great. It kept pace with the rise and fall of my stress levels. I knew when to breathe in, when to breathe out, and when to make a dash for the candy machine.

Maybe if I can come up with a true stress *buster*, I can patent it, make a million dollars, and open my own karaoke restaurant. That's when the Stress Tester would really come in handy, serving a dual purpose: stress tester by day, party favours by night!

# Avoiding the Fridge
## Mary Monks

20 March

Louise,

Sorry, sorry, sorry … I did get your three e-mails this week, but this is the first chance I have had to reply: finally a coffee break! I hope Orla's birthday present was on time, and that it fit.

We're both fine, thanks. At least, last time I glanced in his direction while rushing past him, Paddy was fine. I think I'm fine. Or, as Descartes said: "I think, therefore I'm fine." Or words to that effect. Oh – the phone. Just a mo …. Where was I? Oh, yes – fine. If you don't count tired, that is. I was up at five o'clock this morning, and half past four yesterday. I find I work best on my homework early in the day. At the end of a hard day's work (and it's really busy in the Co-op office just now), I'm too drained. Probably because I've started at half past four.

Must go – the kettle's boiling, and I need that caffeine. Give Alan and Orla a hug from their fond aunt, way out west.

Mary+

23 March

Wees,

How do I do it? I'm not quite sure. I know it's essential not to think about it. I get through one day at a time and, when the going gets tough, one hour at a time. You develop little tricks and shortcuts, like getting my head in gear for the desk that confronts me while I'm walking from class back to the office. And when I'm doing homework and need to think, I clean the bathroom or kitchen. The trouble with that strategy is that, later, I can't find my mop or the Tilex, or I find it looking out at me from the fridge. But you could

probably teach me a thing or two, between running a business from your home, helping Dermot run his business – also from your home – and keeping your family fed and clean.

I sometimes get the feeling that the liberation of our gender has had unforeseen consequences, we being all so frantically busy. Even full-time mothers seem nowadays to be always rushing, what with driving their children to a multitude of activities, helping them with homework, and caring for aging parents. Life was so much more leisurely back in the '50s – or is that just a rose-tinted view of childhood?

Actually the last time my life was leisurely was just after I came to Canada eight years ago. I knew nobody, other than my new in-laws. I couldn't work while I was waiting for an appointment with the immigration people; I couldn't phone home because I couldn't afford the long-distance phone bills. I spent long afternoons and evenings, while Paddy was at work, writing dozens of letters home. I used to think that homesickness was a sort-of wistful longing; I found out then that it is actually quite painful – almost as if everyone you loved had died at the same time. Enough! I think I'd better think about something else – like work.

Hope you and yours are all well, little sister, and can't wait to see you at the end of May.

Mary+

27 March

Lou,

I don't care which of us is taller, you'll always be my little sister!

Just before your e-mail popped up on my screen, I was talking to a student and putting him right about my accent, which he thought was English. When I told him I was from Dublin, he told me that a lot of Irish people live in his country. Where was that, I asked him. Libya, he said. And a lot of the Irish people who live there are IRA. I politely told him that I hope they stay in Libya.

Well, just two more weeks to go. Two weeks, two assignments to hand in, and an exam to study for. Damn, it's that wretched phone again – oh, oh: look who's calling. (My phone display gives the name of callers.) It is she of the long-winded, circuitous manner of asking for something. Yesterday she spent seven minutes updating me on something I didn't need to know anyway, and finished by threatening to keep me in the picture. I'll wait for her voice mail. Where was I? Oh yes, just two more weeks, and freedom from class and homework for four whole months. At last I'll be able to clean the house.

I do not look forward to tackling the fridge. There are about six covered dishes in there, some of them for more than two weeks (Paddy hates throwing food away). I dread lifting a saucer and finding something blue, hairy, and oozing. I'll have to do it the night before garbage collection. That way it can't fester for too long amongst the rubbish. And you should see my kitchen table. Do you have any idea how much paper is assembled when doing a research project? Just a small mountain. And that's only the kitchen table. There

is also the dining room table, the computer room, the bed in the spare room – well, you get the picture. One good thing about the clutter, it distracts the eye from the dust.

Fondly,

Mary+

30 March

Wees,

This place is driving me crazy: I need a short escape. I was hoping to get some homework done during my coffee break, but my chances of concentrating on grammar don't look very good. The phone never stops ringing, except when I'm using it to arrange job interviews for the students – and when I hang up I find eight messages waiting. Three people are having a laughter-filled conversation at the other end of the room and someone is making a loud telephone call behind me – probably because of the noisy conversation. I can't think.

I'm really looking forward to the weekend after next. Paddy will be away for his company's annual planning meeting, and I will be able to spend two full days studying for my exam. But first, on Saturday morning, I'm going to meet a friend from the Irish Women's Network in Gastown to have a long chat and a real Irish breakfast: rashers, sausage, egg, tomato – otherwise known as a heart attack on a plate – with, of course, real soda bread and a pot of tea. Then I – hang on, I'll be back.

Excuse the interruption. A student came to see me about an interview I've arranged for him. He wanted to know what would happen if he changed his mind about the job and didn't go to the interview. I felt like saying I'd slap him, but I showed considerable restraint and merely suggested that he wait until after the interview to reject the job.

Well, that's all I have time for today. I'm going to take a bathroom break. I think I'll bring my grammar book.

Lotsa love,

Mary+

8 April

Lou,

You remembered! Thank you. Yes, I finally got my major project finished this morning and handed it in. I was up at five o'clock again, thinking that I would be finished in time to get to work at eight thirty. Some thought! Imagine anything actually being ready before it is due. Parkinson's Law (work expands to fill

the time permitted) prevails – with Murphy's Law (anything that can go wrong will go wrong) ensuring that it does so. But I did get to work in time to bind three copies of the report and walk into class at one minute past twelve. That's the good news. The bad news is that Paddy wants me to do a presentation of my research report to the planning meeting (I did tell you I was doing my research project for his company, didn't I?). That means that in the next three days, I have to print and bind a dozen copies on my (oh, so slow) ink jet printer, as well as put together and rehearse a presentation. That's apart from studying for my exam next Tuesday, going to work, eating, drinking, and sleeping. It also means that I'll have to postpone my leisurely Irish breakfast and chat.

Enough of this idle chatter. I have a desk that's beginning to resemble my kitchen table. It even has two coffee mugs and some crumbs! I'll write next week and tell you how my presentation went.

Lol,
M+

17 April

Louise,

I hope I never have to go through anything like that again. A major row erupted at the planning meeting, and a split in the organization looks likely. When I arrived at the conference room, everyone was thin-lipped and grim. The presentation was delayed by small groups of directors slipping out on the balcony for conspiratorial discussions, while I stood there feeling like an unwelcome intruder. When they all finally settled around the table, the atmosphere was oppressive, and their reaction to the presentation was muted. I was glad when it was over. The row, however, is not over; and the next time you see us, Paddy may be jobless. However, knowing Paddy, he'll probably have two more jobs by the end of the summer.

There was a much more pleasant gathering on Wednesday. The Irish Women's Network – which, you will recall, I started last April – was celebrating its first anniversary. As I think I told you, my plan for a low-maintenance organization has worked like a dream, and the group, of about a hundred members, is very active. On Wednesday, we had a dinner organized by the White Rock members and to my great surprise, I was presented with a wooden plaque, stained dark green, with a bronze Celtic design and creamy white lettering: Woman of the Year, 1999. It is something I will always treasure. In the midst of chaos and frenzy, life can be beautiful.

Lots of love,
Mary

# Nathalie Cooke
## Mad Dogs

My husband and I are just about to end a twelve-year commuting relationship. Our relatives and children were shocked to hear the news, to say the least, and we're a bit dazed ourselves.

We have decided to live and work in the same city, and have actually been able to make it happen. For most, I know, this sounds absurdly normal. But for us, it's something very new. We haven't done it since the early days of our marriage. Back then, we had settled down to spanking new jobs (mine as a math teacher, my husband's as a lawyer), a small car, and a dog. Things were very orderly, predictable. We lived in a suburban condominium (clean, well-managed), drove a white Tercel (dependable), and both came home for dinner at night (served promptly at 7 p.m.). The one wild card was that the dog – Barney – who had looked so handsome at the SPCA, was actually part wolf and had an unpredictable urge to lunge at various people we passed and (no kidding) foam at the mouth. Had we been able to figure out the rationale behind the lunging, we might have been able to anticipate and counter it more efficiently. But we never did. The only sure target was our neighbour, the wife of the police officer (wouldn't you know it?), the one with the distinctly high-pitched voice and a clear dislike for unpredictability and incivility. She wore brown polyester pants. (Now they'd be lycra and chic, but back then they weren't. These were the type with the fake crease sewn down the front of the legs and a slight flare at the bottom.) She took her little dog for a walk at the same time we went out with Barney. So every morning we would brace ourselves for Barney's charge toward the brown pants. And gradually Barney's straining against the leash and the constraints of his daily rounds at the condominium started to look a lot like the way I was feeling – frustrated – and my grip started, dangerously, to loosen. Was this all there was going to be? Things seemed a bit too neat with wedding over and degrees in hand. After a few months I decided to sit down and have it out with my husband, explain that I wanted something more, something different. Luckily, he felt exactly the same way. So, relieved, to say the least, we both set about charting a new course, one that took us both back to school in the States, toward more years at university while we retrained, new careers, and commuting. Barney went to live outside the city limits himself, on a farm.

Sam and I went to Cornell. The story goes that we chose Cornell because it had strong graduate programs in English (for me) and in business (for my husband). But there was also something about the flavour of the campus that we both liked. Could it have been that Cornell is the only university that legislates a dog's right to roam freely on the campus? Ezra Cornell, it seems, was a dog lover.

In any case, we didn't last long at Cornell without a dog. Enter Trevor the Retriever, bought as a puppy while we were at school in the States. He came to lectures with me (a dog's right and all that) and then, when I returned to Toronto to do doctoral work in English, travelled back and forth between Ithaca and Toronto. But Trevor always had a sense of pride. He left us frequently to prove his point, behaved impeccably with the various kind souls who took him in ("He's *such* a lovely dog," they would say, as we came to collect him. "He can visit anytime."), and refused to look us straight in the eye or acknowledge any sense of warmth toward us when we came to collect him. Although he was there to receive our first son (who came home one month after I took my comprehensive exams), he quickly decided to run away in high dudgeon. It was clear, after all, that his share of the attention was diminishing far too rapidly for his liking. That time, I believe, Trevor headed south, toward parks and food. The next time, soon after the arrival of our second son (born two months after I defended my dissertation), Trevor actually took the subway and headed west. When the phone call came, from someone who turned out to be a rather nice-looking and distinctly natural fibre and presumably childless sort of young lady, we were told that he'd followed her down the subway and stuck to her for the rest of the day. Can't say I blame him. By the time our third son came (we were now in Montreal, and I was degree-in-hand and two years into a tenure-track job), Trevor was getting older but no less shrewd. This time he found Norene Gilletz, dog lover, cookbook author, and extremely good cook. When my husband and the older boys returned from collecting him, they were delighted with Trevor's choice.

So, too, were we impressed by the family he chose when son number four arrived. By then, of course, we knew that Trevor would go walkabout soon after the baby's arrival. To avert this, we took him around the neighbourhood and lavished ridiculous amounts of attention on him for the crucial period. It must have been during these walks, we now realize, that he came up with a plan. Despite our best efforts, he wandered off one day. We found him quickly, just a few doors away, lying grandly on the front steps of a very smart-looking house owned by a wonderful family. A pretty and kind mother who went for daily jogs, two well-behaved children, and a father with a job in the same city as the house and who came home every night.

We couldn't help but admire Trevor's taste. So we were sympathetic to his frame of mind as we came to collect him, and as we came again and again over the years to collect him from the family and lifestyle to which he aspired. He never left us completely, physically or emotionally, but he did visit the other family on a regular basis and made it quite clear that their saner lifestyle was a welcome break from the pace and quirks of our family life. Sadly, Trevor died last year at the age of thirteen. The other family bought a retriever puppy.

As for commuting, my husband was working in Pittsburgh when our first son was born, in Mexico when the second son was born; and I was based in Toronto. When our third son was born, the family was living in Montreal. Although my husband was home and off work, wonderfully, for a few months prior to his birth, he signed the contract for a new job in Toronto on the day our third was born. The family moved from Montreal to Toronto the following year, so when our fourth son was born, I had already begun the commute to work in Montreal. So, you see, Trevor may have had a point.

The boys and I have been thinking about getting another dog. My husband has been adamant in his refusal, saying that we have quite enough on our plates, thank you very much, without a puppy in the house. "When *you* stop commuting," he once commented after the five of us had pestered him for a good long time, "we can get a dog." I think that time has come.

# My Sartorial Ruin; Or,
## Wardrobe 101: How to Wear Your Angst on Your Sleeve in the Halls of Academe

# Jeanette Lynes

I have always felt like a charlatan in the academic world, a female Huck Finn in the Holt Renfrew of higher learning. I have struggled with "the construction of identity." I have never fit the professorial mold very well; students have commented on this (the fact that I don't look like a professor) in ways that seemed complimentary but have puzzled me somewhat. I have seen the raised eyebrows of colleagues in the esteemed halls of the academy. I have heard the mermaids singing to me – you look ridiculous. Others seem to have a more clear sense of what a female professor should look like than I do. Three-piece suits? Silk blouses? Whatever it is, it's a hard act for me to swallow.

Much of my angst about being an academic was channelled into my wardrobe. Clothing became a metaphor for my neurotic and turbulent existence in the university. My closets and floors were a mausoleum of cast-off identities. Truckloads of clothes and shoes were picked up by the Sally Ann only to be replaced by more clothes and shoes. Remember the final scene in Orson Wells' *Citizen Kane*? – that vast room full of sculptures and paintings that revealed Kane's insatiable, compulsive need for acquisition, his restless search for some intangible thing he could not quite grasp. My closets were the equivalent of that room, a theatre full of costumes piled on the floor in huge mounds, draped over furniture, hanging over curtain rods. There was something quite catastrophic about it all. A sartorial ruin.

The theatre imagery is no accident. Performance anxiety, in my case, was directly related to wardrobe angst which was, in turn, rooted in a deep personal insecurity. A hundred nineteen-year-olds could stare at me for a whole hour three times a week times three (courses). That's a lot of watching, voyeurism. There's a taking away of privacy in academic life. You get watched a lot, noticed. Assumptions are made about how much access others have to women academics (a lot).

Some may thrive on the public dimension of academic life, but I have often been ambivalent. Sometimes I wish universities would just issue school uniforms to faculty: thick, flowy robes to hide under.

A wardrobe tells a story, a personal history. There is so much information in a closet. When I look back at my own sartorial history within the academic context, I get scared. Three things emerge: one, I was completely neurotic; two, I was engaged in an intense struggle to situate myself within a world that did not necessarily want me; three, I was confused. I believed that if I looked a certain way, I would be accepted, maybe even liked. See how naïve I was?

There were distinct landmarks in my history of academic wardrobe angst over the period circa 1982–96. It's not that I'm better now. I just don't have as much time to think about it.

## Grad School: Punk Rocker-Reader

I was confused about whether I wanted to join the Ramones or do a doctorate in English. I was sure, though, that thinness was the secret to success. The great fast of 1982 turned me into a five-foot-ten-inch rake. Approximately 115 pounds. My uniform was black. I got army boots. I was going to kick some intellectual ass. Put together the emaciated fragility and the army boots, and you get one big contradiction. I liked to sit in the donut shop at Bloor and Walmer Road, not eating, of course, but smoking and reading Derrida.

## Shoulder Pads: Get Outta My Way

It was such a mistake for fashion to appropriate football. I was a graduate T.A. who looked like a quarterback. I told my class I had a job interview, that I was nervous about giving a talk at it. One of my students (a guy, for what it's worth) said, "You'll be okay, you've got all your notes with you in your shoulders."

## Real Jobs, Sort Of

The real clothing crisis hit when I became more or less gainfully employed. I mean that I went from one contractual position to another for a few years. Things got confusing. As a grad student in Toronto, I was consistently bizarre. Now I had regional differences to contend with, changing climates. My Vancouver clothes didn't work in Thunder Bay. My cowboy boots looked fine in the classroom in Alberta, but strange in New Brunswick.

## Glasses

It would be remiss not to tell you that my academic wardrobe angst extended to accessories. Shoes, handbags, scarves, jewellery, socks, and eyewear. I wore glasses without a prescription in them. I didn't need glasses. I hoped they might make me look more intellectual. The people in optical places were always puzzled when I asked for plain glass.

## The Laura Ashley Years

Around 1988, I completely changed my style. I switched over to flowered, cotton clothes. Not Birkenstocks. (I wasn't that far gone; besides, I've never gone in for sensible shoes.) Liz Claiborne made a lot of money from me. Laura Ashley was preferable, if you were going the flowered route, but Laura didn't venture further east than Montreal. The flower phase lasted for quite a while, until the early '90s. It didn't stand me in very good stead. Cotton has a poor shelf-life. I hated how all those long, long skirts flapped around my ankles. I felt like a character in a Laura Ingles Wilder novel.

## The Thunder Bay Look

After joining the English Department at Lakehead University in 1991, I stuck with the flowers for a while. But they seemed out of place in the wilds of Superior. I never liked them anyway. I was eager to move on. It suddenly became okay for women academics to talk about clothes; I enjoyed that. One female colleague said, "When you get tenure, you can wear whatever you want."

## Post-Tenure Threads

In some ways, this phase was the worst. I was still in Thunder Bay. I reached new, dizzying heights of sartorial chaos. Maybe it was the heady freedom from the annual employment problem. Whatever it was, I went through a head-spinning array of looks. Very, very short skirts with zippers, Doc Martin boots, baby-sized backpacks, little denim jumpers, a fringed buckskin jacket, a red leather bustier, a belt with the crucifixion on it, fingerless gloves, vintage dresses with lots of rucking, over-the-knee socks, white cowboy boots, polypropylene pants, a flowing Shakespearean jacket with a ruffled blouse to wear under it, red platform shoes, lots of

shiny tops. I built shopping time into conferences, which augmented my wardrobe greatly. I also bought some very expensive clothes on trips to Toronto. Anne Klein this and that. An impossible DKNY red bodysuit. I didn't always get up the nerve to wear these things, but there were certain constants: the short skirts, the buckskin jacket, an endless array of men's suit jackets from the March of Dimes, black tights. I wore fishnet stockings to a couple of faculty social events. Fishnets in thirty-two below zero weather are not much fun. I wore some really high boots to a wine and cheese for faculty. A male colleague told me I looked like Emma Peel. Who is Emma Peel?, I asked. I was in a pub with several colleagues one night, and the student-waiter came to take our order. He looked at me and said, "I know you, you're the mini-skirt professor."

## Academic Attire at the Millennium

Did I really want to be "the mini-skirt professor?" There were other things going on that I haven't told you about, and won't. But if you think that we, in our technologically advanced society, have gotten beyond thinking that a woman in a short skirt is, somehow, "asking for it," I can tell you, we haven't.

I have reached the sad and somewhat grim conclusion that if a woman professor wants to be taken seriously by her students and colleagues, she has four basic wardrobe rules:
1.	Wear sensible shoes and hemlines past the knee.
2.	Keep your body covered as much as possible.
3.	Mail order from L. L. Bean and Land's End.
4.	Buy very, very expensive – but you will have to mortgage your house or not eat, so this becomes an only marginally attractive option for most women, even those with good taste.

Where am I at now? After twelve years of wardrobe hell and maxed-out credit cards, I was granted a sabbatical. I got to wear blue jeans for a whole year, except when I gave talks. That was deeply therapeutic, so wonderful to blend into the crowd, to not be watched so closely. Of course, you have noticed how contradictory all this is. On the one sleeve, I've said I don't like being looked at; on the other sleeve, I haven't exactly been low-key in my choice of campus wear. How much can you blame on being a Gemini? Maybe you have all this figured out. Maybe you are the kind of woman who lays out her work clothes for the next day, neatly folds them over a chair the night before. Maybe you don't spend an hour and a half changing your clothes until you find something to wear to campus, and then twenty minutes preparing your lecture. Maybe you graduated from Wardrobe 101 a long time ago. For your sake, I hope so.

# Higher Education
## LORRI NEILSEN GLENN

You stand
across the doorway
of your wordthick office, and
give audience, nodding,
nodding. Just
so.

Middle-years co-eds, frightened
by rumors of a desert Out There
wait to drink from your
tongue, your hard
round lips jut, naked
from the soft beard.
Poised,
like your feet,
in position, just
just so.

O, patriarchy! the women
weep. It is not just. O, hegemony!
O, truth. No truth, no
justice. And so,
and so, nodding,
you give good confession
and they wail, touch
your wordbeads,
wipe their tears,
bless you for
your time.

Yes, justice. And
it is so. I close
my door to your altar, open

the window, watch the moon, sailing
over hallway gods, drawing water
moving time, casting light.

    Elsewhere as
your wife, wrapped in a warm
box, bathes your children, keeps
your supper, puts
her mind to bed.

# MOVEMENT FIVE

# Vigilance
## Uma Parameswaran

This is where we are now.
We
Who once raised hell on campuses
and stormed citadels of power
and brought dons and deans to their knees;
Who once raised lovers to passionate pitch
til clouds reverberating across continents
thundered down in torrential rain;
Who once raised our nurslings
tending and crooning them to golden wings;
Who once sang from sea to sea,
sweeping rivers into a chorus of joy
and passed each other never touching;
Now have come together to hold hands,
silenced by missiles from powers that be,
in silent thought for those by lovers slain
or randomly killed by anti-feminist rage,
mutely mourning children streetwise but unspared.

We
Who soared into skies of desire in our men's arms,
Who kissed asleep and hugged awake our children with a prayer,
now start the day holding each other,
in thought or over telephone wires to say,
Take heart, hang in there.

O my sisters, my loves,
as we circle the flame
that once was Wilma, Susan, Anne-Marie,
Michele, Sonia, Genevieve,
do we know, how not know,
it is our own vigil we hold
in quiet despair.

This poem is a public tribute to activists everywhere, and a private tribute to the signatories of a systemic discrimination complaint against universities in the 1980s.

# Cerulean Blues
## Vivian Hansen

It is the steep blue of the sky that breathes my peace today, the colour that life becomes in old age. Cloudless. Cerulean memory at the flatline of horizon, at the curve of Nose Hill. I think I can gaze at this peace for twenty-five years, the past becoming ever present. A dome of blue inviting my growth.

The same sun in this steep blue sky seeps into my skin, aging crisply since I came here in 1975 when I was eighteen years old and just out of high school. I was looking for a job in the "park-like" setting boasted by the University of Calgary at that time. I was well fortified with shorthand, an impressive typing speed, and the pride of knowing I took matriculation English when none of my Business Education classmates had. With those qualifications, I confidently appeared in what was then Employee Relations.

The tired woman at the counter told me that there were three jobs available for junior clerks: in the steno pool (I knew I wouldn't be happy swimming in there), the Department of Religious Studies (a stronger interest), and the Faculty of Social Welfare (I wanted to see for myself what they did). So I chose Social Welfare.

The memory is still sharp.

I manage to find the faculty offices on the eleventh floor of the Social Sciences Building. The woman who interviews me insists on snapping her chewing gum between statements. (Sssnap.) Jaw working precariously, like old plumbing. "Your typing speed is pretty good." (Sssnap.) I notice that her gum is a lighter shade of pink than her tongue. I try not to fixate on either. (Sssnap.) "You probably won't be able to use your shorthand, though. Is that a problem?"

"Nooo, I'm more excited about working in this area."

(Sssnap.) "Umm hmm. Well, I'll show you the office. When can you start?"

"Oh, I have to finish school first, but I can start right away in July."

(Snaaap.) "Hmmmmph. Well, that'll have to do."

I feel guilty for some reason and want to apologize, then realize I likely won't be heard above her chewing gum, which is fervently skipping in a dangerous wad from one cheek pocket to another. It occurs to me that this Social Welfare place is very relaxed.

I notice that my future office window overlooks Nose Hill, and the shape of the hill is curved, molding a June-blue sky. I think I could be here for a lifetime.

* * * * *

Preparing for a graduate admission meeting in 1976, I pull files for Deryl, a graduate student in Social Welfare. I have learned by now to be humble and address all faculty by their professional designations. Few of them correct me to say "Just call me Bob." It is a habit I continued into my twenty-fifth year of employment with the academy. Faculty like to have their currency count. Academic stratification remains desirable.

But for now, Deryl is just Deryl. He has asked me to speak his name. When Deryl finishes reading, he calls to me: "Vivian, come in here, I want to talk to you." Years later I might say "What for?" But then I said timidly: "Okay."

"So", says he, "who are you going to vote for?"

"Me?" blubbers the young me. Someone cares what I think. "The Conservatives."

Deryl frowns. "Why?"

"Um … because I think they've done a good job." But now I am not so sure, because I have been asked to think. This *is* university, after all, and Deryl is a graduate student who is much smarter than I am. He does not make me feel stupid, so I like him and I am pleased by the notion that I can think. It is Joe Clark's Alberta, his Canada, but instead of blindly supporting him, I have been asked to think. This is what you learn in university.

A steep blue sky. Unattainable in height. One should soar into its changing colour, like a bird on an up-draft, seeking soul.

* * * * *

My own soul soars into time that circles into today, twenty-five years later. I press my face into this sky, my smile soaking rays. I am sitting with Ron, a Social Work professor I got to know so many years ago. His retirement party is tomorrow, and we are all planning the roast, the memories that will be charted.

Ron tells me that a blue sky is the colour of life in old age. I sense this as wisdom. In the Academy, I have learned more about the binary oppositions of wisdom and foolishness than I have learned anywhere else in this last quarter century, because here is the place where foolishness is courted and whored, its initiates hazed mercilessly within the currency of intellect. Wisdom costs: often the price of a PhD, or even less, an undergraduate degree. Your sense of what is real is eroded along with your tacit approval in the process.

I stopped at a BA in English. It was all I could take; all I wanted. From this vantage point, I knew I could never be Queen. Even the BA was done over eighteen years, part-time, an education grafted onto my life, or was it the other way around? Academia is grafted from experience, appropriating process and stuffing it to empirical ends. Even so, I loved sewing all the seams together. I just wanted to know about Stuff. Literary Stuff. Poetry Stuff. The Stuff(ing) of my degree.

That was years ago, in blue time.

Ron is relaxed and ready to retire. He is just as reflective as I am today. Says he did it all "My Way." The expression on his face warns me that he is serious, and I must not accuse him of being Frank Sinatra. I don't know what "My Way" means, but it seems reasonable to guess that he resisted hazing his students, asking them instead to look inside themselves for the flotsam and jetsam of truth, which in turn could be grafted onto the Academy, not the other way around. This, I think, is the essence of "My Way."

\* \* \* \* \*

I remember an old September; there is an error in the Fall Session timetable. Some practicum placements cannot accommodate the number of students registered in corresponding course lectures. The bubble gum supervisor sits me down in Ron's office and lets Ron conduct the training process. "Phone them and tell them to switch lectures. I want the registration numbers even in each lecture. Pick a name. Any name. Tell them to switch around."

I do not see the point of this autocratic system. Shouldn't the students have a choice? and what if … they can't? Shouldn't we be thinking about babysitting troubles, work schedules? I decide to approach things differently. I am passive at eighteen, but I am thinking. The first student answers the ring. "Would it be possible for you to switch to lecture three instead?" I say, trying to be accommodating. "Yes, I know. It's an earlier time slot than you were in. But could you consider it?"

Ron hears my strategy. Waits for me to hang up before he carves me up. "Dammit, Vivian, you can't ask them. They *have* to move! Tell them!" The tone of his voice shocks, and my body cannot decide whether to piss or cry. Instead, I storm out of his office, body checking him vehemently against the doorframe. I hate bullies. I hate him for humiliating me and not … thinking.

\* \* \* \* \*

Steep blue softens. Here he sits beside me, a lifetime later, each of us enjoying each other's company. I let the sky soften my skin as the memories drift off with the clouds. Everything seems so warm, now.

"What will you do in your retirement, Ron?"

He grins. I note the ley lines in his fifty-eight-year-old face. My own ley lines are creeping into middle-age as well, worn with the cares of things more important than what student moved to what practicum lecture twenty-five years ago.

"I like shingling roofs," he states, grinning at me.

"Ah, therapy," I nod knowingly.

He recognizes this as *my* wisdom. "Yes, yes," he says softly. "It is."

"You know, Ron. The biggest decision I ever made in my life was taking a job in Social Welfare when I was eighteen. I was only there for three years, but it affected my life in far-reaching ways. I would never have met my ex-husband, never have had my daughter, never have continued friendships I began then, I wouldn't

be sitting here with you now. I had a choice: the Steno Pool, which was closed a few years later, Religious Studies, or Social Welfare. What would my life have become?"

"You might have been sitting in a temple in Tibet." He laughs, knowing I do not belong in any temple in Tibet.

I have loved working and living on the margins of academia. The English course I took in high school eventually bought my admission to an English degree at the University of Calgary. Eventually, I transferred out of Social Welfare to go to the registrar's office, where I was promoted to admissions supervisor. The need to know more about Literary Stuff seized me. W. O. Mitchell, a writer-in-residence of sorts at the U of C, entertained me one morning on my coffee break. I realized then that I wanted more out of life than a great job. Being Queen was a tedious business, I thought, best left to others who could practice the necessary rituals. Somewhere along the way I had become a woman of wind and knowing, and steep blue skies.

I transferred, yet again, to a part-time job in the Faculty of Kinesiology, continuing my peripheral place in academia. By day, squeezing in whatever English course fit my schedule; by night, hoping I could get home from my class in time to carry my little girl to bed. An hour here, a coffee break there, Ondaatje read four times before a final exam, breathing Marlatt's poetry like fresh fern air, I finished. I finally finished. The only semester in all those eighteen years where I actually went full-time was the semester I survived Literary Theory. I could not read the back of a cereal box after that semester. I was worried I would never read again, until a scuffed John Grisham's *The Firm* saved me. I read it through and actually enjoyed it.

I was a driven woman in my last semester, unnaturally focused on achievement. My brother was dying of a brain tumour. I was taking a Women's Studies course and working on a reproductive technology project. I was also taking an English course and writing a paper on *Frankenstein*. Oddly enough, words tracked through my head: "My brother is dying. I will read just one more Shelley/*Frankenstein* critic." Piecing the parts together, I searched unconsciously for a way to excise my brother's brain tumour, hoping that someone in Mary Shelley's fan club had cracked the codes in her work, the word-liturgy that would save my brother. It was not to be. Instead, I achieved a perfect 4.00 grade point average and succeeded in making a metaphoric link between modern Oncologists and Victor Frankenstein.

I was a single parent with a dead brother. I did it my way.

\* \* \* \* \*

Steep Blue Sky. Cerulean Memories.

Birds winging script into a steep blue sky. *Writing what is learned.*

I turn to Ron in this moment of Presence. Somewhere in our time together, he has asked me to speak his Name. He offers me another coffee on this May afternoon, his tie tight against his neck. He speaks of his grandson and the circles of life.

In that moment I know the things I will speak about at his retirement party. Birds have scripted this for me in the *tabula rasa* of Blue Sky. I hold some of his memories as well as my own. We have spoken each other's names in peace.

# Climbing the Walls of Academe
## Kay Stone

In 1998 a short poem that I was reading to an English honours class brought me unexpectedly to tears. It was P. K. Page's "On Educating the Natives," and it went like this:

> They who can from palm leaves and from grasses
> weave baskets of so intricate a beauty
> and simply as a girl combing her hair,
> are taught in a square room by a square woman
> to cross-stitch on checked gingham. (21)

I wondered how this seemingly simple poem that I'd chosen specifically for the students in the square room could have such an effect on me. I had long ago found a way out of my own early cross-stitching schoolrooms and into university, where I'd learned how to weave ideas, as student and later as teacher. But when I read the poem and heard those words in my own voice standing in front of a class of students sitting in a square room, somehow I felt like that square woman. It was time to retire. The odd thing is that I never *was* that kind of teacher, and in fact I managed to turn square rooms into round ones from the very start, long before "learning circles" became part of pedagogical methodology. It wasn't that I was ahead of my time – I just did things my own way and no one bothered me. The courses I taught – folklore and, later, storytelling techniques – were not exactly mainstream courses in *any* English department, so I was left to my own weaving devices.

Let me tell you briefly how I ended up in a university classroom in the first place, since it had never been my intention to do so. As always, there are many places to begin describing a long adventure, so I'll take the easy path for the moment and return to my elementary school years in south Florida, when I planned to be a horse doctor. I was at the beginning of what my mother called "Kay's Horse Craze Phase," a passion

that lasted through my junior high school years, but I have no idea where the "doctor" came from. I soon discovered that math and science were required so I decided to be an artist instead, drawing horses and not doctoring them. My passion for drawing and painting stayed with me into the first year of university. I grew up in the in a 1950s working-class family, the second oldest of six, where girls like me were supposed to be preparing for husband and family and not for a professional career. Quite unexpectedly I won a work–study scholarship to the University of Miami and my parents encouraged me to be the first girl in the family to go beyond high school. My mother and her three sisters didn't even get that far.

That is how I found myself in university, studying subjects I'd never even heard of before, since they were not yet part of high school curriculum. I was fascinated by anthropology, geography, sociology, philosophy. Even the more familiar history and English classes were thrilling to me, a thirsty traveller who had been in the desert for a long, long time. I found that at the end of the first year, art was no longer the centre of my life. I switched to anthropology and then to cultural geography, and the next thing I knew I had a master's degree. I worked as a cartographer in Miami for a year, then moved to Chicago where I became an assistant geography editor for a modest encyclopaedia company. I loved that job, the best training I could have had for academic writing, and I also loved being a single "career girl" in an exciting city. But after two years I actually missed being in school and thought I might take a year or so off work and return to graduate studies, never intending to complete a degree.

I learned that Indiana University was only a few hours away and offered a graduate program in something called "folklore." This sounded more like fun than work, and I found that I could combine my interests in anthropology and geography in new ways. I never got back to Chicago. To my amazement (and my family's too) I was on my way to a PhD in folklore. But before I could become Dr. Mitchell I became Mrs. Stone. Now that is a *very* short version of quite a long story. To shorten it even further, becoming Mrs. Stone brought me to Winnipeg (after a year in Poland), where my husband Dan was offered a job in the history department and I struggled to write my dissertation.

One day, after I'd spent an entire morning playing solitaire to avoid working on my dissertation, I decided – urged by Dan – to propose a folklore course to the English department. I was certain they would reject it and I could get back to solitaire, but to my dismay, they put it in as a non-credit course the very next year. So that is how this working class girl who planned to be a horse doctor and then an artist ended up climbing the walls of academe as a folklorist.

Now, almost three decades after my first class and enjoying early retirement, I am still wondering how it all happened. I'd never planned to be a professor and never quite got used to it, though I did learn how to teach roundly in square rooms. I was lucky because the university at that time was still expanding, and I was also persistent, and I think that is why I was still going around in circles after twenty-eight years. To put it simply, whenever anyone said "No" to something I'd asked about (an office, say, or a limit on class size,[1] or sessional status, or promotion), I simply said, "Why not?" I was polite but persistent, and clear on what it was I really wanted. An office, a limit on class size, promotion. This oversimplifies my adventures in academe, but it's a true story.

Why my tears while reading Page's words, then? I still have no easy answer to that question, but I suppose the poem somehow put voice to my abiding fear that I was a fraud, that I didn't belong inside those walls at

all, and that no amount of climbing would do any good. I was also compelled to look back at what I had actually managed to do in almost three decades of teaching and to appreciate the many good moments. There were helpful colleagues and some superb classes, times when everything seemed to flow and the people who were there actually wanted to weave and not cross-stitch. I also loved to write, for the joy of the challenge, and succeeded in publishing dozens of articles and one whole book.[2] So why did I continue to feel like a fraud? Those square rooms? Square teachers?

There were two events in particular that compelled me to reconsider my fear-of-fraud feeling. The first happened early in my career, the next much later when I was quite comfortable teaching. The first happened in my second year as a lecturer, when someone in English or Continuing Education forgot to list my non-credit folklore class. As a result I had no students. The English department was sympathetic, but there was nothing to be done, as I had no continuing contract. If I'd given up at that point, that would have been the end of my teaching at the University of Winnipeg. I learned, happily, that there is often something that can be done no matter what the situation. I called a few friends who I thought might be interested, and they brought other friends, so there were more students than the minimum needed for a course to go on. We had a very fine year. My department was astonished that anyone would do something so bold, but perhaps this encouraged them to keep me on with seasonal contracts (I wasn't even a sessional then), until I worked my way step-by-step into a permanent part-time position. It took twelve years for me to reach tenure-track status and another seven to become a full part-time professor, mostly by remaining present and by saying "Why not?" at every opportunity. I must admit that this probably would not have happened if I had not had the full support of the union, which had to write a special clause in an early contract to cover my odd situation.

I'll simplify this account by skipping over the many stories between that adventure and the next that took place some years later, as I waited for a bus in Budapest. I was participating in my first international conference on oral narrative, an important one that took place only once each five years. Dan was also attending an international conference in Poland and would be doing research afterward, so our thirteen-year-old daughter, Rachel, came with me. She was good company, and she could speak enough French to order our meals from Hungarian waiters who knew a few words of German and French but only "Coke" in English. Our inexpensive little hotel was a long bus ride away from the conference and the larger hotels where other participants were staying. I left after breakfast and came home every day for lunch and then supper with Rachel, which meant that I didn't have much opportunity to take part in the informal socializing, the heart of any conference.

Midway through the meetings, as I waited for the bus to take me back to lunch, I began arguing with myself silently, grumbling about my situation and wishing I were freer to take part in the conference. My own still quiet voice asked me politely what my priorities were. In a flash I remembered that Rachel was absolutely my priority, not out of guilt or duty but simply because she *was*. In that moment the conflicts disappeared. I want to stress that it wasn't a matter of choosing my child over my academic interests – there was no need to choose since I no longer felt any conflict.[3] I find that trying to explain this in words fails to capture the clarity of the moment. It was a matter of attitude rather than situation. All I can say is that in the several years that followed, I never again felt that my life was split between home work and school work.

Because my own conflict was gone, I had more energy for teaching and writing – enough, in fact, to finally complete *Burning Brightly*, my book on contemporary storytelling, which I'd been struggling with for eight years.

* * * * *

As I said earlier, I was lucky. I happened to be around when universities were expanding and not contracting – though it took a good while for me to actually have a firm contract. I also did not *have* to teach since I had someone to support me financially, though I might still be playing solitaire if I hadn't taken up the challenge. Nor did I ever have to teach outside of my fields of special interest, since I worked part-time by choice. But also, I was quietly persistent, asking "Why not?" at every opportunity. And I made sure I was present for more office hours than were necessary for the amount of teaching I did (one course each term). More important, I wanted to be around for socializing with colleagues. It is too easy to see this as peripheral, when in fact it is central to a full academic life. I also went regularly to department meetings so that people wouldn't forget who that odd folklorist was.

I know that it is now even more difficult to find a university position than it was thirty years ago. I'd hoped that my own struggles would be of benefit to other women, especially those opting for part-time work or job-sharing.[4] It looked as if this kind of flexibility was possible when I was climbing the walls in the 1970s and 1980s, but it now seems that everything has gone back to square one, and square rooms (despite all the new group learning methods). Still, I am an optimist, and perhaps that is another reason why I managed to stay within the walls for so long, taking the constant tension as a challenge. Why not? I believe that there is always opportunity – indeed, necessity – for creative action, for making your own circle within the square, which, by the way, is the form of the archetypal mandala.

If the academic situation ever became so inflexible that wild ways were no longer possible, it would be time to climb the walls, raise the roof, and head for the hills – as my southern-born mother was fond of saying. And that is where I am as I write this, in the hills of North Carolina only one hour away and across the mountains from where my mother was born in 1911.

I thought I'd miss the classroom, as teaching was a challenge and a joy for so long. I'm surprised to find that I do not. At least not yet. I am enjoying the free, unpressured time I have to write this piece and others and am beginning to understand that writing *is* my teaching now. The room can be any shape I wish, since it exists in my imagination. I can do without a room entirely when the weather is fair. In the first months of the millennial year, I taught my own non-credit class at home in my own odd-shaped living room and loved it. I will do more of this in the future.

I read P. K. Page's poem to Dan last week when he asked what I was writing about. I was surprised to find that I still could not get through the last two lines without tears. The cross-stitching on checked gingham still bothers me, as it should. I like that.

## Notes

1. In my first years of teaching there were no caps, and I had anywhere from 70 to 112 students in my classes.
2. I am currently working on my second book, exploring dreaming as an art, which began in the English honours class in 1996.
3. Of course if Rachel had been three instead of thirteen, there certainly *would* have been a conflict. At that age both Dan and I sometimes took her (and her brother Nathaniel) into class with us when we had no alternatives. This was not our regular practice, and I do not recommend it.
4. I was delighted to hear Carol Shields tell me that she had used me as an example to encourage the University of Manitoba to make her position there more regular. So I was of benefit to at least one person I know of, and perhaps to others that I don't.

## Work Cited

Page, P. K. "On Educating the Natives." *Cry Ararat! Poems New and Selected.* Toronto: McClelland and Stewart, 1967, 21.

Stone, Kay. *Burning Brightly: New Light on Old Tales Told Today,* Peterborough, ON: Broadview Press, 1998.

# JANE CAHILL

When I was an undergraduate only two of my professors were women. I thought them pitiful. They dressed strangely and looked odd. One of them lived with her mother and the other lived alone. The academic life didn't serve them very well. The first committed suicide and the second was murdered – in her office, at her place of work.

As role models they didn't offer much, and yet, as soon as I embarked on studying for a graduate degree, there was not much chance that I could avoid becoming one of them. My area is Classics. If you have a PhD in it, you teach it. They don't want you anywhere else. There is a certain perversity involved. When everybody tells me not to bother with something, it makes me want to do it all the more. In the 1970s it wasn't considered crass for a man, even a learned one, to announce in front of a female doctoral candidate that he believed that women weren't suited to academic life. (He was a chauvinist, and he'd make no apologies, ha ha.) At least, it wasn't considered crass by other men. I thought it absurd, but rarely dared to say so. Keeping one's mouth shut was frequently the price of success in those days. Mustn't appear too "strident," or too "pushy." There was a whole thesaurus of words applied only to women with ambition. I learned to smile a lot. And I made it. I was the first woman to graduate with a PhD in classics from the University of British Columbia and I got one of the two jobs I applied for in 1976, thus becoming Assistant Professor of Classics at the University of Winnipeg. I was twenty-six years old.

At the meeting of the Faculty Council to introduce its new members, the chair of our department of three people stood up and announced, to loud guffaws, that his department was now "one-third female." It was quite the joke. But the reason it was funny was that in any normal circumstances, on any rational assessment, it was an impossibility to have a department that was one-third female. I felt rather sorry for him that night. All the other chairs (we still called them "chairmen" in those days) with the exception of the chair of history, who also had a female recruit, had both a new colleague and the new colleague's "lovely wife" (I am not kidding) to introduce. The "lovely wives" stood up and took a bow. It was a lucky thing that my then boyfriend lived in Calgary. If he had been in town, he would have insisted on coming in drag.

I could have done with a lovely wife in those early years. We taught ferocious loads in the Classics Department. The administration wanted us to give up teaching second, third and fourth year Latin and Greek because few people wanted to take those courses, and we wouldn't agree to do that, so we had to teach them on our own time. My departmental colleagues were dedicated men, hardworking beyond

belief. The chair never took a lunch break and scorned those who did. He believed we should be represented in every academic session and on as many committees as possible to counteract the notion that small departments were dispensable.

In my first year I taught fourteen classroom hours each term plus intersession in the spring. In my second, it was eighteen hours plus the spring. I was on the Library Board and Senate by the beginning of my second year. I was also on Valium. I couldn't keep up. I worked morning, noon, and night. My departmental colleagues taught even more hours than I did, but they both had wives. If they worked so hard that they didn't have time to do the laundry, somebody would do it for them. But if I didn't have time, I ended up in dirty clothes. They had built-in company at home, but I had to find the energy and the time to go out and meet people, and I couldn't find either. When I was at a meeting that ran into the late afternoon, I was painfully aware that almost without exception, everyone else at the table, and certainly those of my colleagues who droned on endlessly and irrelevantly and were in no hurry to leave, had someone at home who would have a meal ready for them. I was angry and resentful and lonely. Quite depressed; not suicidal, but horribly sad.

I don't know if it was true that women had to be better than men to be as well thought of. I do know that there was a perception that they couldn't be better. I think that because I was pretty and fashionably dressed, an assumption was made that I was also lightweight. In truth, I think I made it myself. I didn't try to publish, rarely spoke at all the meetings I attended, and hardly ever conversed with other professors. I drank coffee, if I drank it at all, with secretaries and library assistants. This led to some enduring friendships, but it didn't do anything for my career. To this day I eat lunch alone in my office, too nervous to join colleagues, male or female, in the cafeterias unless specifically invited, surely a holdover from those early, lonely times.

In those days, people didn't always believe that I *was* a professor. A person who didn't know me would walk into my office with me in it and ask when Professor Cahill would be back. One evening, I locked myself out of my office and needed to get back in. I approached the receptionist in the main office (who, to be fair, worked only in the evenings and was therefore less likely to know who was who amongst the faculty) and asked politely for the pass key. She asked why I needed it. I told her. She said I would have to prove that I was who I said I was by showing her some I.D., and I said I couldn't because my purse was in my office and I couldn't get in. She said that was too bad. I wondered out loud if reciting the fourth choral ode from Euripides' Medea in the original Greek would prove that I was indeed who I said I was. She was not impressed. I had to go and find someone to vouch for me. A male professor, whom the receptionist also did not know, told her who I was, and she gave me the key.

Sometimes being female taught you how your associates treated women generally. I had one colleague accost me at the photocopying machine, tell me that I was not allowed to use it, announce that he would report me for my insolence in continuing to do so, ask for my name so that he could do just that, and then apologize when he heard it. "If I had known who you were," he said, "I would not have spoken to you in such a way," as if being rude and hateful to office assistants was par for the course.

I remember being at meetings in the early days where I simply couldn't get heard. Older professors, men in their sixties, had lived through too many years of assuming that only the male people in any given room were important. This was generally a safe assumption. That's how life was. It simply didn't occur to them that times were changing. When men such as these were chairing meetings, they would not see my raised hand or hear my request to speak. A more enlightened colleague would have

to say "It's Jane's turn now" and then I would have my chance. There were occasional direct, deliberate insults. Once, in a Faculty Council meeting, I spoke in defence of a Library Committee resolution that I had helped to draft. The man who spoke after me expressed the hope that the eardrums of the assembled company would be able to recover from Professor Cahill's hysterical outburst. He insulted other women too, and ended up as vice-president of the university.

All my female contemporaries remember being at meetings where everyone else was male. Even the language excluded us. They would talk about "four-man subcommittees" and the like. The worst bit was always when the coffee arrived. We had a choice. We could either pour it, as was the expectation, and even for us that felt comfortable – we had been brought up to serve men, after all – or we could sit there, hands resolutely occupied doing something else, until someone twigged that maybe *he* could pass around the cups just as efficiently as a woman could.

Problems with students have been relatively few. Of course, there was the one who threatened to kill me (he ended up in jail) and the one who wrote to the president of the university to complain that for the entire duration of my lectures, I allowed my gaze to linger provocatively on his crotch. On four separate occasions, sometimes for weeks at a time, the administration has assigned me my own personal bodyguard from amongst our security officers, because of unwanted attention from students. Perhaps women are perceived as more vulnerable; perhaps we are more inclined to reveal aspects of our private lives in class that pique the interest of disturbed students. I don't know. But I do know that there is a flip side to these horrors that is truly wonderful: gifts for my babies, gifts for me – I like the chocolates best – and, when my sick daughter was at her sickest, an atmosphere in my classes of such heartfelt though often clumsily expressed concern (it is, after all, an unusual thing to hug one's teacher) that I was much comforted. On one particularly bleak day, a student came to the hospital bearing a basket filled with cold chicken, salads, fruit, flowers, and teddy bears to sustain my family in every way she could think of.

I have tried, as the years have passed, to see the world through the eyes of my students. Oh, it was easy when I was young. I knew how it was to be poor and overwhelmed with essays. I knew how infuriating it could be to have to jump through someone else's hoops. I looked like them; I liked the same music; I felt the unfairness of the world in the same ways. They had no trouble believing that I was a sentient, fully functioning, sexual human being. If they sometimes had trouble keeping their distance, it didn't bother me and was handled with a laugh. In retrospect, I'd give a good deal to have a male student address me as "Hey, gorgeous!" just one more time.

There were a few years when I couldn't connect with students at all. My life outside the university, consisting as it did of looking after small children, making playdough, and dealing with ringworm, contained nothing that I could draw on in class that would have been of interest to them. I was totally immersed in that life. Nothing seemed to me to matter beyond the welfare of my children. The only teenagers I knew socially were babysitters, and I had no clue about young people's musical tastes, the television programs they might watch (indeed, my home was sans TV so that my children would play musical instruments instead), their leisure activities, the big names in popular culture. A group of students in a mythology class performed a skit based on the "Who Shot J.R.?" episode of *Dallas* and they had to explain the entire thing to me.

It's different again now. My own children are the same age as my students. When I mentioned one day that my younger daughter wanted to get a tattoo and admitted I felt some discomfort over this,

students lined up after class to show me, or in some cases to describe, their own forays in this direction. It was amazing. Some of the nicest of people have the strangest of markings in the oddest of places. Even the eyebrow rings don't faze me now.

When my elder daughter first took a job at McDonald's, I began to understand what students meant when they said they couldn't take a test at a scheduled time because they had to work. Until then I had said huffily, "You'll just have to decide what's more important, won't you – your job or your education," and sent them away. At last I clued in that many of them are paying their own way, that some of those are not living with parents, but alone, and are often working not one but two jobs with little ability to control the hours that they work. When the boss says "Come in to work," you come in to work or find yourself replaced by some other young person.

I have tried, then, to allow for the fact that students are often under stress. I accept late assignments with minimal penalty; when a student dozes off in class, I refrain from sarcasm and let her sleep. In addition, I learn all students' names (yes, even when there are more than seventy in the class) and try to remember what they tell me about themselves and their ambitions. I worry about them – the ones who look as if they are tired or hungry, the ones who don't seem to be able to organize their lives, the ones who I suspect are taking illegal drugs, the ones who, like my own daughter, live with a serious illness. It would seem as if there should be no down side to this; I try to treat them with the respect I accord my own children. I know how to talk to them and what to talk to them about. I am gentle with them, humane, understanding, sympathetic. So how come, when I give a poor grade, or refuse an extension, or won't allow a rewrite, they roll their eyes, scowl, and stomp angrily away? Because they think I am their mother, that's why – a person who belongs in the lowest class of human beings, put on earth only to serve, to be reviled, and to be taken advantage of. And consequently, and this is the really sad part, they don't pay the least attention to anything I say.

I am told there is some evidence to support my claim that students view a middle-aged female professor as they view their mother, and not all of it is anecdotal. Apparently students with tests in two courses on the same day are more likely to ask the female professor to make a change than the male and more likely to be annoyed with her if she refuses. They expect a female professor to award them higher marks than a male and are less likely to believe factual information that she gives them. They are not frightened to be critical of her and are more likely to make a complaint about her.

I accept all this without much liking it, but I am making a plea for two changes. First, I would like to put an end to the "totally ridiculous request" epidemic with which my students are currently afflicted. It is true that my own children occasionally make ridiculous requests of me. It is also true that I occasionally give in to these requests because I love them (the children) and/or I like a quiet life. This sometimes leads them to attempt to get an even more ridiculous request past me. Other parents clearly do this too, but the problem is that their children cannot tell when a request is truly absurd and should only be tried on mothers, and not on overworked, desperately-trying-to-be-humane-professors. These are from the last three years: there was the student who enquired whether I would change the time of the make-up test (not the regular test, you understand – she had already missed that) from morning to afternoon, because her brother had the car in the mornings and she didn't like taking the bus. There was the student who wouldn't be in class for two weeks because her sister was having a baby. Would I call her after each class (that would be six classes) to "touch base" and tell her what we had covered? There was the student who phoned to say that he wouldn't be in class, but would I please give

a message to his girlfriend, who would be in class, telling her where to meet him for lunch? Finally, there was the student who needed some material from a reference book that was in the branch of the public library nearest to my home. Would I, she asked, stop in on my way to work and photocopy the relevant pages for her? The answers to these requests, for the record and in case there is anyone out there who hasn't got the point yet, are no, no, no, and (this one regrettably unspoken) "are you completely out of your tiny mind?"

My second plea for change is this: since I am falling over backwards to treat my students with humanity and compassion, to get to know them and help them a little in the daily struggle, I would like them to make an effort to understand that I too am a human being, that I have feelings and a life. "Where are our essays? Haven't you marked them?" asked one young woman, two days after sixty-five essays had been handed in. And on another day I asked at the end of class whether somebody could please help me up to my office with all my paraphernalia – a pile of projects, a map, my notes, hand-outs, texts, empty tea cup, and purse. This must have seemed too much like being asked to empty the dishwasher at home, since everyone in the class ran out of the door faster than you could blink your eye. "You should get a backpack!" one of them called over her shoulder as she rushed to make sure she was not the last one left in the room. And then this: on Christmas Eve, 1998, my mother died. I left immediately for England to arrange and attend her funeral, missing the first three days of classes of the January 1999 term. A colleague announced to my students on my behalf that their essays, originally due on the Friday at the end of that first week, would not now be due until the middle of the following week. But one young woman who didn't get notice of the change left a panic-stricken message for me on my return. Bad weather had delayed her – her essay was not done. I was exhausted from jet lag and grief, but I called her. "Your essay isn't due tomorrow after all," I said. "It's now due next Wednesday. I was called away. My mother died." "Oh that's great, I'm so glad," she said. "Thank you VERY much!" Well, at least she said thank you.

I'm not sure that the pattern of my career has been typical. It has certainly been affected by my personal life. My PhD had been completed and I had taught for three years when I married and began my family. If maternity leave was available back then, I don't remember being offered it. My first daughter was born in July 1980 and I came back to work in September of that year, still teaching overload. I didn't much like it. I brought my daughter to work with me often, at least until she began to crawl, and though she was wonderfully socialized, I was exhausted and my marriage couldn't stand the strain. I wanted another child. In 1981 I applied for a sabbatical for the 1982–83 academic year, got pregnant, and (thank heavens) was granted the leave. That second pregnancy, initially so empowering, was stressful beyond belief. I taught two intersession courses and had to deal with a deranged and hostile student, a threatened miscarriage, and later, the news from my obstetrician that the baby in my womb was not growing at a normal rate. The students of both classes solved that problem. Together we harnessed the power of positive thought. At the beginning of each class, I wrote the words "Grow Baby" on the blackboard. Every time the students saw the words, they were to think them, and then the baby would grow. And she did. She weighed eight pounds thirteen ounces when she was born in October of 1982.

I had almost a full year at home with that second daughter, for which I am eternally grateful, but I had overestimated my ability to work at my typewriter (how archaic this sounds in these days of computers!) with an endlessly enchanting tiny new child in the next room. I was paying a babysitter to have all the fun. It seemed absurd. I went back to teaching in the fall of 1983 and hated every minute of it.

I wanted to be with my children. I resented being away from them. There was no doubt that for me, work came a poor second to spending time with my daughters. I enjoyed going to playgroups more than I enjoyed attending meetings. I enjoyed reading *Hop on Pop* more than I enjoyed teaching Latin. And so I asked the dean if I could work part-time and he, kind man that he was, said yes. The faculty was newly unionized at the University of Winnipeg at that time, and our union washed its hands of me. I was told by its officers that if I had only agreed to wait a few years before "going part-time" they would have worked out a deal with the administration that I could share in. I pointed out that it was my children's preschool years that I wanted to be home for, and they said that was too bad and asked me to sign a waiver releasing them from the obligation of supporting me if I ran into trouble. They were worried that if I made a poor deal and they were backing me, their negotiations would be prejudiced. It wasn't all bad. The Classics Department actually benefited, becoming a three-and-a-half-"man" department during the five years I worked part-time, and a four-"man" department after that. I kept my office and all privileges, taught a fixed load instead of overload, and was able to relax and enjoy both my children and my job.

I feel successful in my career. On paper, I would not appear to be so. I have not been promoted beyond the associate level and would have to win the Nobel prize before that would change. My publication record stands at one book and not much else. And I don't have as many friends at work as I would like. But I love to teach and there is a certain gratification in the plaudits of students, too, particularly those that are given in the grocery store or at the dentist's office years after graduation. Some of my students this year are in my courses because their parents were. I feel successful also in my personal life. I am married to my second husband (both have been academics), have three children now, and have never sold any of them out for professional gain. And there is satisfaction in being part of a social change that will not be complete for many years. It's like being part of a winning relay team. I didn't run the first leg. Miss Sheila Spire and Dr. Edith Wightman, the women referred to in my first paragraph, did that. I ran the second leg, can pass the torch on in a few years' time, and will then watch someone not yet running cross the finish line.

# Tenure Tracks
## deborah schnitzer

Like many other women in university settings, I am always writing some part of my letter of resignation. I am tenured, in the middle of a typical ranking system that moves from assistant to associate to full. I think of the place "full" represents. By training, interest, and inclination, I am a two-legged, three-footed human. Neither on one side *or* the other, nor on one side *and* the other, I take my place from all sides, the if and the in-between. That means I live in a number of settings simultaneously and understand that they do not easily co-exist.

When I first entered university in the late 1960s, I knew a little about the techniques and terms that legislated my kind in the academy, for I could name on a personal and individual level the parallel domestic and familial systems that had raised me: I was expected to serve, to welcome assessments based on appearances and the ability to please, to accept as illusion the request that I be taken seriously, and to realize, of course, that my most compelling vocation would be some altar designed as the logical extension of my spring convocation.

It was 1972: I did locate a prospect, though he appeared more rags than riches while I grew more itch than balm. Married and mothering, still I refused the exclusivity of the kitchen, the cradle, the supporting role and returned to purchase graduate degrees. I did so more fully aware of the odds against me and, as vulnerably, for the degrees I sought were determined by processes that were unable and unwilling to see who I was. How can a system that has been organized for and by male experience and privilege respond effectively and respectfully to the realities of women's lives? How can a system burdened by a dependence upon a ritualized transmission model, restricted and often mechanical standards of measure, esoteric official languages, and limited ways of defining what constitutes knowledge comprehend those who work within frames of reference that are dialogic, inclusive, multidimensional, and organic?

There was my cerebral cortex, the bowling ball I heaved down hallways, sometimes guttering, sometimes striking in a series of course papers and seminars. The cerebral cortex, however, was and is attached to other parts of my body and being, as necessary to life and as unacknowledged in relation to the academy's tunnel vision now as thirty years before. I am a freak of the academy's nature. Visible from the neck up in terms of brains; visible from the neck down in terms of female body. Body parts,

biological clock, body politic. The neck, as Margaret Atwood observes in *Surfacing*, is meant to be a conduit; the head, as Gertrude Stein observes in *Tender Buttons*, is more than a "little top" or covering. The fact that my neck is stiffer, my top blown more often, testifies to the tensions that sever connections between my "upper" and "lower" halves.

And yet, I am also a freak of my own nature, wanting to inhabit the academy and transform its practice and pretension, in love with my discipline, inspired by teaching, overwhelmed by the inconsistencies, determined to confront them. I am not alone in my freakishness. There are madwomen everywhere who conjoin scholarship, teaching, and activism as matters of their course.

I note, however, that I am increasingly tired, less and less able to figure out how to continue. That's when I write more of my letter of resignation. I am reading parts of this letter and talking it out loud with Barbara, my American cousin who went to law school, single parented, remarried, practised divorce law, and phoned me one evening a year ago, desperate to figure out why she could not stand the nature of her practice. So Barbara moved into mediation, gradually, carefully, and happily. It is a move she can live with.

Barbara helps me understand my intention. "Look," she says, "don't give up now. Why not take advantage of the privilege you enjoy? Use your rank and tenure to subsidize what you really want to do. Think of it as sinecure." We test out her theory. I can continue to initiate programs and processes that work toward changing the landscape in which I work, that express as fully as possible the challenge to systems that colonize and disenfranchise people.

Barbara advises that I take the money and run. Not away but into. Apply pressure that will open the circumference of the tenure track that is so narrowly defined. Use my expertise and orientation in a meaningful way beyond an individual course and a traditional research record. Name and define that practice consistently in ways that are not self-defeating and apologetic. Demand that we look seriously at our practice, that we stop blaming students for deficiencies that more properly express our lack of training as teachers and thinkers.

And, live with the fact that the system cannot be dismantled.

"Accept," Barbara offers, "the possibility that there are small and isolated changes that have small, isolated, and meaningful effects. Accept that the elitist points of view that are intrinsic to the very nature of the academy will thrive and flourish because those who invest a great deal of energy to qualify for admission into its ranks admire the system, know how to live within it, intend that it should thrive."

I listen carefully to my cousin Barbara. She and I visit with each other every summer. Always, we spend one of those days in this way.

I tell Barbara about the colleague with the sturdy publishing record, immersed in a new and funded project, who greeted me at the end of term with "I do not know how you can be on so many committees and work with so many projects and still get your own work done." I remember the response I had been writing in my head, the one that insists that administrative, teaching, and research responsibilities necessarily inform one another, even as I remember that I did not articulate that response aloud. Part of the reason I censored myself has to do with my own shares in the imposter syndrome that plague so

many in institutional settings. Part has to do with the continuing feeling that I should, after all, "grow up" and accept the fact that I have bought into a system whose time-honoured criteria does not comprehend the variety and co-equality of the work that can be done in universities. Part reflects my sense of the time it takes to open the interiors of those who have no interest in the reconceptualization of culture "my work" represents.

These parts of my understanding intersect. They are integral to the three-footed nature I possess, which has been trained, in part, by and in the languages of justice developed by the super/women's movement. The tension created often leaves me spent, diminished, overburdened, refocusing at the beginning of this twenty-first century, considering alternatives: early retirement, withdrawal, separation, revenge.

I had hoped to do it all. I sat on committees that explored issues of retention and access and respectful learning environments and innovations in research, teaching, and technology and alternate course delivery and design and gender equality and community liaison. I have written articles and published books. I taught with heart and head. I continue to do so, as I can and in my way, determined to redress the insult that students experience when constrained by university processes that disrespect their authority, co-equality, experience, and skill.

But I see patterns endlessly repeated. People green with an enthusiasm for administrative service and institutional change that is palpable. Green people turned grey, exhausted by the wasted breath and time, the lost strategic plans, unanswered memos, the good ideas filed under "valiant but forgettable." Older now, in the middle of their middle age, they look anew at how they compare with peers who, seemingly uninspired by any desire to democratize the system that has hired and promoted their welfare, quietly and steadily ascend, carving their niche in specific fields, finding their way into journals and conference proceedings, editorial boards – adaptable as parts of the very industry whose foundation even they might acknowledge requires some serious review.

Barbara carefully observes the rise in my voice.

I am not even talking about how we collectively exploit sessionals and stipendiaries, depend on their expertise, vulnerability, and good will even as we underpay and overwork them so that we can consider the rungs above and below for our own benefit.

Well, what to do. Why battle for change? "Look, Barbara," I say, "I might be dead or even retired before there's a tentative shift in the model." I am not unaware that I have the seeming option of "growing up." Universities have always been this way. Accountability means simply that the critique is invited and the status quo preserved. I imagine myself putting down my pen, my alacrity, and my capacity for the absurd. I sigh heavily. Do I bite this bullet? There are retirement plans to consider, which have to include at least some analysis of the revenue lost if full professorship is not pursued in the conventional manner, if the very review process that simply counts things up is not to be tolerated. Do I hope that if I were to withdraw, abandon the self-review and the critique of the elitist system that pays my way, I might return with even more legitimacy, pick up my pen and serve a purpose larger than my own self-interest?

Barbara raises a single eyebrow.

I know. The risks are high. The energy diverted from issues of justice within the communities in which I work. The lure of institutional legitimacy that often renders the participation in institutional reform less attractive over time. The sense of betrayal that nibbles away at things like self-esteem, for the movement up the ladder is not easily reconciled with the critique of the ladder itself.

Barbara touches my cheek as she moves toward the sink.

I was always so hopeful at the end of May. I would think. "Aha! Classes are over, my grading is done. I do not have to teach in the third term. I can put things away, complete my service on committees, build new courses, refine teaching strategies, continue those initiatives that don't depend on the university calendar, develop the research project that did not advance during the fall and winter terms. And. And. And. Pretend that 'frantic' is not the first name my children call out as they sight me and my to-do list cramming their July and August." Exhausted, I would come back to September and consider anew the endless jokes about our profession: the yellowed notes, droning lecture halls, the individual research interests that "win" teaching releases, requiring that we are unavailable to make our office hours, meet with students, serve on committees.

Of course, a system built by incentives and rewards such as these requires that others assume more and more responsibility for institutional review. And, indeed, there we would be, back at the committee meetings, looking even more carefully around us, our pens and awareness stranded in the upper air. Those of us in tenure tracks would know the extent to which we wanted to at least count in the tracks that stabled us even as we railed against the way they insulted our perception and diminished our will; would know the extent to which we had been trained to overlook the contributions of those who were not tenure-tracked at all – the administrative assistants and staff representatives whose ongoing commitment was taken for granted; would know that together we would continue the work even as we understood that the odds stacked against it left us with too little hope, too little strategy, raw.

We meet in halls acknowledging one another, telling each other not to take on so much, to say "no," to put ourselves at some further distance from our students, to more ruthlessly pursue our private interests, to stop sitting on committees and arguing about the way things are done or not done, to give ourselves a break and slow down, take care of number one and think seriously about separating ourselves from the work that could achieve equity, accessibility, varieties of excellence. And in these quick exchanges, moving from one task to the next, we affirm our respect for the fire that inspires our analysis and action, as well as our fear and anger – we do not know how to continue without burning up, out. We –

I put down my letter and lower my reading voice. Barbara smiles. She's making challah. It's Friday afternoon. July. I sigh. We agree that it is very difficult to write a letter of resignation you can live with. Barbara nods toward the cornmeal, nudges me so that I'll sprinkle the bottom of the pan. She unsticks her hands and covers the bowl. Together, we'll pull at mugs of tea and wait for the dough to rise. "Of course, Debbie," my cousin Barbara says, "there are always other kinds of work one might consider …"

# When She Is Gone

## Kristjana Gunnars

The leaves have all fallen. The river valley is grey, with a touch of sage and paprika where the baseball field is. Patches of snow linger where the shade is. It has snowed, winter started, and then it got warm again. Today, for example, the pale sun lights up the northern hillside just below the downtown skyscrapers of Edmonton. And the buildings themselves, the ones made of glass and steel, are shining back brightly. It is cool but not cold, warm but not hot. A good day for a walk among the barren branches, watching small cakes of ice forming on the North Saskatchewan River.

It would have been nice to be able to call my mother this morning. I used to call her on weekends, to tell her whatever good things I had to tell. I only spoke of good things to her. Just to make her happy. I could tell her about a new rug I got, a lovely rust-red and olive coloured rug, and how nice it is to put my bare feet on. No one is as interested in the little things of my life as my mother. But she is gone. Someone else is living in her house now. Some other phone has her old number. I have to think of these things by myself; wonder to myself as the red sedans and vans roll up and down the streets leading into the downtown hub.

This is the start of my tenth year as a professor. That is why I live in this town, which I otherwise have no reason to live in. Like all other academic people, I have gone where the job is. We get uprooted without design or reason, and deposited wherever. That is the beginning of the loneliness of our profession. Removed from parents, children, aunts and uncles, and friends, we end up having to start over. But that can be done, and most of us do, although many have told me the first few years in the new job were like the ninth circle of hell. "I cut a triangular swath for three years," one colleague told me, "between my apartment, my office, and Safeway." A triangle.

One of the least expected of the strange experiences I had during this decade was the realization that writers and professors don't mix in Canada. I was a writer for a decade before becoming a professor. As a writer, I conducted workshops; mentored with writers' guilds; gave as many as fifteen readings a year; published a lot of poems, essays, stories, books; edited other books; had many interviews and public conversations; appeared on numerous panels, at least once a month; acted on many juries, both federal and provincial; and

got many grants. It was a pretty good life, but very busy and unpredictable. Reason says it is good to settle down and go for security, get a job in a university. I was tired of living out of a suitcase – the suitcase I never actually unpacked. I got weary of looking at that black thing in the corner of my bedroom.

But a few years after I became a professor, the writing world seemed to slip away. I eventually discovered that I was losing my community, the writing community, because there is a deep-seated distrust of the academy among artists and writers. Suddenly I was on the other side of the fence: I was establishment. My job represented power. I had a salary and did not need to be part of things. Readings slowed down. The conference circuit went on without me. I applied for grants to get time off to write and was rejected. When I asked some professor–writer friends of mine why I was no longer getting grants, they said such grants were not handed out to professors. Something had set in, I felt, and I did not understand it.

But I was pretty staunch and undaunted, so I thought it would not be the end of things to be cut off from that community. I turned to the community of academics instead, and discovered more strange things. Not only do writers not care for academics, but academics have a distrust of writers. They are not bona fide. Not real and don't belong. So the writer–professor is caught, as the song goes, "between the devil and the deep blue sea." I recall the many debates over whether to accept creative publications as real publications during faculty evaluation time. Most English departments did not. One of my colleagues said, during a talk she gave to the department, that people are publishing too much creative stuff and most of it "isn't worth the paper it's written on." But I was used to hearing that sort of thing, so it didn't really register at the time.

While I was adjusting to these changes in community relations, my mother was dying. It took her two years to get herself through her illness, and I took the airplane across the Rockies to see her at least once every six weeks. I disliked waiting in the Vancouver Airport the most. Usually it would be a two- or three-hour wait, and that was before they spruced up the airport and put in all those coffee and sushi and oyster bars. But usually when I got into one of those United cigar tubes that flew us over the state of Washington, I was in another mode. I switched from academic to sojourner mode, and started to get happy again. Usually the sun would be shining on the tops of Mount Rainier and Mount St. Helens. The deep blue sky would be sliced by the stark white snows of the mountains. And beyond, the great Pacific Ocean. Every time I looked down on those landscapes from the little piece of tin we sat in, I wanted to cut loose again, be on my own.

Then I would find my mother, a little worse than last time, a little frailer and thinner. But we would hop into her blue Jeep and drive to the coast where she had a beach house. The cabin was always cold and damp, and it took several hours to warm it up, which we did by lighting a fire in the fireplace. My mother gathered all sorts of sticks and logs and stuffed them in the fire. We opened a Henry Weinhard and unpacked a cache of smoked albacore tuna we had picked up from the Siletz Indian smokehouse on the way down. Then we munched and told stories and laughed at this and that, the wind picking up in the pine trees as evening came on. The pines that leaned in one direction inland, from years of being blown that way. I read aloud to her from interesting books, and she said, "I feel like I'm being dragged up from a deep dark hole." I was sorry she was lonely. Yet out here in the silence of the coast, without neighbours or jobs to do, we were not alone anymore.

I realized slowly that the academy does this to people: over the years, it alienates and displaces. And I learned with surprise that this happens to women much more readily than to men. Women come into de-

partments frequently younger and less experienced, and have to work with groups of men who are older, more plugged in, networked, and they are taller, larger, and their voices are louder. Women are hired for being different, but when they arrive they are frequently unable to exert that difference. Often women come as single, since it is impossible to get PhDs and also create families, and then they move into a couples culture that is fully entangled. Sometimes they are single mothers and so are unable to join the rest of the group for beer after work. Or perhaps they are lesbian, or they are removed from their growing and grown children. In general, they become misconstrued, misconstructed, and mistrusted because they are either less visible and therefore thought to be absent and uninterested, or more visible and thought to be brazen. But the truth is, they are more often than not working, working, and working, to keep their place and not get behind. And running around being the tie that binds uprooted families together.

About me there was always the rumour that I wanted to leave my job. Whenever I met someone from my former life, that person would always ask if I was "still there." It felt like no one expected me to hold out. I had a friend in another department who had trouble getting tenure because she had asked for stress leave once, and this was construed as meaning she couldn't handle the job. But I always say "yes, I'm still there." I know a good job when I see one. Even though I'm getting stupider every year from not having time to read books – ironically, since it's a book-reading profession – I still know a good job when I see one. I figured I would stay until my world got so small that it would finally implode. I always expected that to happen during one of my trips over the mountains to see my ailing mother.

But then she died. When she is gone, I find everything different. I cannot phone her to tell her little things. I cannot have the inconvenience of needing to go see her all the time, going broke every month on airplane tickets, feeling conflicted about my duties as a daughter and a teacher. Feeling guilty wherever I was, for not being with her, and not being at work. On days like this I look out at the blackening vista, the river valley turning grey in the dusk. I look at the phone. Everything eventually dies down. When she is gone, a lot of other things are gone too. Like my ability to feel the conflict of life versus workplace. My desire to cut loose is gone. It mattered more when she was still there. I have been led to wonder about the relationship between mothers and women's careers.

I discovered that these jobs that can be so destructive to women and women's lives don't implode on you. They don't stand up with some disaster in their hands yelling "Quit me! Quit me!" They just peter out like a lousy story. Chance brought you here and chance will take you out. I have just been reading a short story by one of my many students. In this story, a young man goes to the casino in West Edmonton Mall. He is hooked on gambling. He puts down fifty dollar bets, two hundred dollar bets, and loses them all the time. Yet he goes back. One day he is in there and looks up. He sees his mother up on the mezzanine of the casino, walking to a blackjack table, her familiar purse swinging at her hip, and is surprised. I returned the story to the student. "Nice conceit," I said. "Life's a crap shoot, isn't it."

Maybe it's true for everyone, what I have kept as my own little secret. Some day I think I will wake up and find, just like the coastal mountains of Washington below the airplane that issued me back and forth between work and life, everything will suddenly seem surprisingly clear. I will know how it all is supposed to fit. The secret combination will be waiting for me when I land.

## vintage vignettes
# Delores Keahey

| mid-fifties | | (single, no kids) |

*mid-fifties*     **at a post-grad professional school in London, England**     *(single, no kids)*
my (female, single) piano prof: *I don't know why I bother teaching girls; they just run off and get married!*
[I thought she probably just expressed a general English point of view, though she herself was an exception to her own idea.]

*late fifties*     **mid-M.Mus. degree at an east coast university in the U.S.**     *(married, no kids)*
my (male, married) piano prof (upon my crying at a lesson for the first time): *Are you pregnant?*
[Although I assured him I wasn't, he was a smart man. A couple of weeks later I learned that, in fact, I was!]

*later fifties*     **first post-grad teaching position in a midwest college in the U.S.**     *(one kid)*
chair of Music Division (male, single): *Well, you did it! You had us all worried!*
[Having scheduled a chamber music concert only a month after child #1 was due, I was a bit alarmed when she arrived two weeks late. But with baby sitting in on the rehearsals and the concert, and with the aid of cushions for me to sit on, the event came off without a hitch.]

*early sixties*     **pre-PhD degree at a university in Texas**     *(two kids)*
dean of the School of Music (male, married) upon my enquiring about an assistantship or scholarship: *Absolutely not! We consider women a bad investment!* Angrily, I retorted that in that case I wasn't interested in entering his graduate program under any circumstances.
[The head of musicology (male, married), also chair of the school's budget committee, threw a stormy fit over this in the upcoming graduate committee meeting and arranged, within the period of a few days, for my immediate acceptance with full assistantship and choice of duties.]

*later early sixties*   **mid-PhD degree, just moved to teach at a college in Texas**   *(still two kids)*
head of Department of Music (male, married) upon my arrival: *I'm sorry, we do have a full-time position for your husband, but our budget can't accommodate you as I had earlier promised. However, I can give you a sessional teaching appointment.*
[Only a verbal contract was given me prior to our move, as the school's nepotism law apparently forbade giving the wife of a professor a contract before the beginning of the school year; at that time an "emergency" would be declared. As we had already moved our belongings to the new location, leaving did not seem to be an option, so we stayed on. I taught piano in the faculty lounge kitchen.]

*mid-sixties*   **mid-PhD degree, summer not teaching at the same college in Texas**   *(still two kids)*
daughter #1 (about four years old, standing in front of the ironing board with tears in her eyes): *Why don't you ever play with us, like you always used to?*
[During the teaching year, all time at home after work was spent with the kids, with housework done only after they went to bed. I had thought that my being at home for the summer would delight the children, but realized that I was doing housework most of the time, and that the quality of my time with them had gone down significantly.]

*later mid-sixties*   **still mid-PhD degree, now teaching at the same college in a small practice room instead of the faculty kitchen**   *(three kids)*
new head of Department of Music (male, married): *I'm sorry, but the college administration has just decided to enforce strictly a nepotism law, and you will no longer be allowed to teach at this institution.*
[Period.]

*late sixties*   **still mid-PhD degree, just moved to teach at a university further east**   *(four kids)*
head of Department of Music (male, married) upon my arrival: *Yes, we'd like to have you teach here, along with your husband, but I do question whether married mothers really ought to be working outside the home.*
[I mentioned that my experience showed that quality of time was more important than quantity (see "early sixties"), but he seemed dubious.]

*early seventies*                                                                    *(four kids growing)*

**still mid-PhD degree, teaching at a university in western Canada**

head of Department of Music (male, married) to a colleague, upon my refusal to start my sessional teaching year once again without a contract: *She is much too shrewd a businesswoman for me!*

[In previous years I had always taught a full month or so before receiving a contract.]

*mid-seventies*                                                                        *(kids all in school)*

**PhD degree, still a sessional instructor at the same university**

new head of Department of Music (male, married) upon my request that I be considered for a regular, rather than sessional, appointment: *Look, I know you aren't going to abandon your husband and family, and I know there is no other university in this city to employ you, so I'd be crazy to give you a better position with more money. It's nothing personal!*

[This said under the watchful eye of his computer-generated pin-up girl, larger-than-life-size up on the wall next to his desk!]

*late nineties*                                                                         *(kids all married)*

**just retired from teaching**

Retirement advisor (female, married?): *As your retirement funds are significantly less than your husband's, you will want to plan your financial strategies accordingly.*

[I am continuing to work part-time, mainly because I love teaching, but …]

Postscript: Looking back from the year 2000:

The above stories are typical of the traditional anecdotes shared with glee around the family table when parents, children, spouses, and grandchildren have gathered for special occasions. I myself lead the laughter, with wry comments about life's strange vicissitudes. However, I was surprised to find that upon thinking of putting together this short list in written form, possibly for public consumption, I became quite depressed, to the point of being nearly unable to set it down in writing. By keeping the stories anecdotal and light through the years, I have avoided confronting their uncomfortable and incredible impact upon me and on countless other women like me. In spite of the fact that many of us have become very successful in our professional and academic life in recent years, there is a residue of remorse that dates back to our vintage vignettes; I think it never quite leaves us.

# Donna Langevin

## Three White Cranes

for my *ESL beginners

Three white cranes made from shell
stand on my mantlepiece. I don't remember
the names of the students who gave them.
Over the years, faces blur, stories blend,
colours in a river. They come from
every country, their voices
in the mother tongue leaping like gazelles,
or swelling orchards with
strange exotic fruit.

*In English, this is a pear, this is an apple.*
Their voices stumble over
*happles and bears,*
get lost in tangled forests
filled with new sounds.
[*Pär*], I repeat
until exhausted, fantasize
a monastery where I speak only with
my eyes, fill my life with
simpler tasks – planting, churning milk,
sweeping the courtyard.
After school, I sink into a cloud,
close my door to family, friends.
At night my earplugs muffle
street noises, any human cry.
I lose myself in silent movie dreams
until I wake up to another day of
three white cranes,
beaks long as wands
pointed at the sky,
words folded like wings.

*English as a Second Language

# Contributors

**Beharry, Daisy** ("Women in Difficult Spaces")
Daisy Beharry was born in Trinidad and migrated to Canada in 1994. She has a BA in English (University of the West Indies) and an MA (University of Waterloo). She lives in Kitchener, Ontario and is a high school teacher.

**Bhandari, Aparita** ("Untitled")
Aparita Bhandari completed a BA (English Lit.) at Delhi University, followed by a master's degree (English Lit.) from the University of Toronto. Currently she is an intern at *Saturday Night* (*National Post*) and, displaying more signs of madness, plans to pursue a doctorate in the near future.

**Blais, Denise M.** ("plain M.A. in blues"; "(avoid) kicking sacred cows")
D. M. Blais is a prairie-dyke-writer-activist living in Montreal. Her work has appeared in *Arc*, *Contemporary Verse 2*, *Room of One's Own*, *Atlantis*, *filigranes* (France), and the anthology *À l'envers des images escarpées*.

**Braley, Susan** ("Immoderate Musings")
Susan Braley is a professor of English literature, women's studies, and liberal studies at Fanshawe College and at the University of Western Ontario in London, Ontario. Her academic interests include the constructions of Virginia Woolf by her biographers and Woolf's own fictive selves in her autobiographical texts.

**Cahill, Jane** ("A memoir only sometimes funny")
Jane Cahill has taught in the Classics Department of the University of Winnipeg for twenty-six years and has raised three children during that time. She is the author of *Her Kind: Stories of Women from Greek Mythology* (Broadview 1995) and is currently writing a novel based on myths in which women use the textiles they have woven to kill men.

**Chahal, Taina** ("Lucy in the Sky with Diamonds")
Taina Chahal is a PhD student in women's studies at York University, Toronto. Her research interests include women's writings, post-colonial literatures, feminist theories, critical race theory, and critical pedagogy. Her dissertation explores language and subjectivity in diasporic Africaribbean women's novels. Her current publishings include papers on Finnish/Canadian women's shifting subjectivities, poetry as a necessary intervention in the social sciences, and, in "Snow Queen Finds Her Tongue," the intersections of the psyche and sociality.

**Cook, Méira,** ("E-mail from Méira Cook")
Méira Cook has, to her enduring surprise, recently become a mother of three. She is a post-doctoral fellow and is working on a book about the place of ghosts in contemporary Canadian fiction.

Cooke, Nathalie ("Mad Dogs")
Nathalie Cooke and her family live in Montreal, where she is an associate professor of English at McGill.

Dewar, Tammy ("Circling Women")
Tammy Dewar is a self-employed training consultant and freelance academic who spends half of her time in the academic world teaching, researching, and writing in leadership and learning. The other half is spent consulting with industry to help clients convert existing training programs to delivery over the Internet. Her own dissertation was a nontraditional one that combined fiction, poetry, and collaborative learning circles to give voice to her research participants, and she continues to mentor learners who want to find their own voices in their research projects. Other research interests include on-line learning and facilitation.

Donnan, Mary Ellen ("Slow Advances: The Academy's Response to Sexual Assault")
The "confessional" nature of her piece in this collection leaves M. Donan thinking it best to stay semi-anonymous until she has a secure full-time teaching position. At the time of publication, she is writing her doctorate, teaching undergraduate classes, and has enjoyed several years free of p.t.s.d. symptoms.

Fulton, Keith Louise ("The Possibility of Professing Changes")
I got my first name from my mother, my last name from my father. Through their labour and my own I went to Stanford University and then left the United States. I did an MA and a PhD at the University of Western Ontario. My three children taught me to mother, and women taught me to struggle. I work at the University of Winnipeg in literature and women's studies.

Graham, Jill Watson ("Cogito ergo mum")
Jill Watson Graham survived her PhD dissertation. She currently teaches English at a university in Maine, contrives a home life in New Brunswick, loves her children, and keeps hoping to write.

Green, Fiona Joy ("Juggling on a High Wire")
Fiona Joy Green has been teaching as a sessional lecturer on contract in women's studies at the University of Winnipeg for a dozen years, while occasionally lecturing in sociology at the Universities of Winnipeg and Manitoba. Juggling her chaotic teaching load with her responsibilities as a mother, a life-partner, and a graduate student has often made her feel like a madwoman in the academy.

Gunnars, Kristjana ("When She Is Gone")
Kristjana Gunnars is the author of five books of prose-fiction, two collections of short stories, and six books of poetry. Her latest prose work is *Night Train to Nykobing*, and her last book of poems is *Exiles Among You*. A forthcoming title of poetry is *When Chestnut Trees Blossom*. Her work has won provincial writing awards in Manitoba and Alberta and has been nominated for the Governor General's Award and the Books in Canada First Novel Award. She is also professor of English and creative writing at the University of Alberta in Edmonton.

Hansen, Vivian ("Cerulean Blues")
Vivian Hansen's non-fiction has appeared in *Our Grandmothers, Ourselves, Study in Grey*, and *Threshold: an Anthology of Contemporary Writing from Alberta*. Her poetry has appeared in *Prairie Fire: Queering the Prairies*, *Room of One's Own*, and *Mocambo Nights*. She has poetry forthcoming in *Descant* and *Amethyst Review*. She is currently working on a poetry manuscript entitled "Hand Prayers."

Hilder, Monika B. ("This Three-Horned Bronco of a Life")
Monika Hilder, together with her husband Emanuel, parents three wonderful children. She also teaches English at Trinity Western University and is a PhD student in education (children's literature) at Simon Fraser University.

**Horne, Dee ("Old Boys")**
Dee Horne writes, travels, and enjoys spending time with her family. She teaches twentieth-century literature at the University of Northern British Columbia. She loves to listen to, read, and tell tales.

**Karumanchery-Luik, Nisha ("Teaching for Legitimacy; or, Tea-ching from the Margins")**
Nisha Karumanchery-Luik is a feminist anti-racist educator and activist. Her research and personal interest in these areas stem from her experiences of growing up in Toronto, Canada as a South Asian female and recognizing the impact that race, ethnicity, and gender have in our everyday lives. Nishi is the co-author of *PLAYING THE RACE CARD: Exposing Power and Privilege* forthcoming from Peter Lang Publishing.

**Keahey, Deborah (Editor; "Nine Steps toward a Twelve-Step Program for Recovering Academics")**
After realizing the full extent of her own madness while editing this anthology, Deborah Keahey resolved to find a better way and began training as a personal life coach. She continues to teach on-line for the University of Winnipeg from her home in Prince George, B.C., but she now also works supporting academics, professionals, and other busy women in reducing stress and redesigning their lifestyles or careers to reflect the lives they really want to lead, rather than work or other people's needs dictating their life. She's the author of *Making It Home: Place in Canadian Literature* and *Waking Blood: Poems*. You can reach her at debbie@lifescapecoaching.com or on-line at www.lifescapecoaching.com.

**Keahey, Delores ("vintage vignettes")**
Negatives that plagued Delores's life in academia were more than matched by positives of supportive colleagues, friends, and above all, family. All four children were surprisingly eager to relocate when better career opportunities arose, and when asked whether they would prefer to have mom at home, baking cakes and fresh bread, responses included "What on earth would you do with your time?" and "I don't like cake!" Delores has been a professor of music in universities and colleges in Manitoba, Alberta, Tennessee, Texas, and South Dakota, with degrees from Yale University, the University of Texas, Augustana College (S.D.), and the Royal College of Music in England.

**Kelly, Jennifer ("Dancing on the Lines; Mothering, Daughtering, Masking, and Mentoring in the Academy")**
Jennifer Kelly completed her PhD in English from the University of Calgary amidst the joyous arrival of Anna (b. 1997) and Paul (b. 1999). With partner/dad Al, they live in Pincher Creek, Alberta. Jennifer teaches part-time at Red Crow Community College.

**Langevin, Donna ("Three White Cranes")**
Donna Langevin has had poems published in many Canadian and American journals. She was awarded third prize in the *Arc* 1998 Poem of the Year Contest. Her first book of poems, *Improvising in the Dark*, was published by Watershed Books (2000).

**Lee, Monika ("Mother as Prometheus")**
Monika Lee is the mother of two girls and an assistant professor at Brescia College in London, Ontario. Her poems have appeared in many Canadian literary journals, and she has written her first poetry book, *birds of the milky way*. She has also published a few articles and a book on Rousseau and Shelley.

**Lynes, Jeanette ("New Year's Resolutions, 1997"; "My Sartorial Ruin; Or, Wardrobe 101: How to Wear Your Angst on Your Sleeve in the Halls of Academe")**
Jeanette Lynes has taught at numerous universities and colleges in Canada and the United States. She is currently an associate professor of English at St. Francis Xavier University in Nova Scotia. She is the editor of the anthology *Words Out There: Women Poets in Atlantic Canada* (Roseway) and the author of the poetry collection *A Woman Alone on the Atikokan Highway* (Wolsak & Wynn). She is also the recipient of the Bliss Carman Poetry Award for 2001 and *Grain Magazine* writing prizes in 2001 and 2002. Her next collection of poems is forthcoming in May 2003, and she is also at work on a novel involving the lives of various madwomen.

**MacDonald, Tanis ("A Valediction: of the Booke")**
Tanis MacDonald is the author of *Holding Ground* (Seraphim Editions) and the 1996 Acorn-Rukeyser Award Winner for *This Speaking Plant* (Unfinished Monument Press). She is a doctoral candidate at the University of Victoria.

**Mendis, Ranjini ("An Academic Defence")**
Ranjini Mendis, originally from Sri Lanka, is a member of the English Department at Kwantlen University College in British Columbia and the president of the Canadian Association of Commonwealth Literature and Language Studies (CACLALS). Her current interests are life-writing and post-colonial pedagogy.

**Monks, Mary ("Avoiding the Fridge")**
Mary Monks is a graduate of Print Futures, the professional writing program at Douglas College in New Westminster, B.C. She had her first story published at the age of ten in the *Imeldist*; her fee was a rosary. Since then she has written and edited a half dozen newsletters and has had articles published in the *Celtic Connection* and *Coquitlam Now*. Mary immigrated to B.C. from Ireland in 1991. She has served on the board of the Ireland Canada Chamber of Commerce and in 1998 founded the Irish Women's Network of B.C. Mary is currently publications and documentation specialist in the Systems and Computing Department of Douglas College and also provides a range of writing services to business.

**Neilsen Glenn, Lorri ("Higher Education")**
Lorri Neilsen Glenn (L. N. Glenn) is the author of several books including the award-winning *Knowing Her Place* (1998). Her poetry has been published in *CV2*, and *Room of One's Own*, among other journals and anthologies. She is completing her first collection of poems and working on a book on the lyric impulse in inquiry. Her research focuses on the role of writing in women's lives.

**Panofsky, Ruth ("Commencement")**
Ruth Panofsky is a member of the Department of English at Ryerson University in Toronto. Her recent publications include *Lifeline* (Guernica Editions, 2001), a volume of poems; *Adele Wiseman: Essays on Her Works* (Guernica Editions, 2001); and *Selected Letters of Margaret Laurence and Adele Wiseman* (University of Toronto Press, 1997). Her articles, reviews, and poetry have been published in literary journals and major Canadian newspapers.

**Parameswaran, Uma ("Vigilance")**
Uma Parameswaran had her early education in India and has lived in Winnipeg since 1966. She earned her PhD in 1974 and is now professor of English at the University of Winnipeg. She initiated a creative writing course and the first women's literature course at the university and has been on the boards of various women's and writers' associations over the years. She is married to a mathematician and they have a daughter.

**Phillips, Susan ("The Stress Tester")**
Susan Philips currently heralds from Langley, B.C., but is originally from Saskatchewan. She claims that she remains a prairie girl at heart. Although presently employed with a television station, she worked in the university setting for over seven years. Susan's writing credits include honourable mention in the Children's Literature Category, Saskatchewan Writers Guild contest, publication of creative non-fiction and poem in the Langley Writers' Guild's *Voices from the Valley*, vol. 4, and publication of creative non-fiction in Lighthouse Publishing's *Idiots of the World*. She has also written several short plays that have been produced locally and has been a volunteer writer/editor for the *Compassionate Healthcare Network* and *Christian Women Today Online*.

**Pillipow, Joan ("Winter Afternoon at School")**
Joan Marie Pillipow lives in Winnipeg, Manitoba. She graduated from the University of Winnipeg in 1997 and from the University of Waterloo in 1999. She loves dogs, books, and singing in choirs.

Ramirez, Helen ("Teaching for Legitimacy; or, Tea-ching from the Margins")
Helen Ramirez is an independent scholar and video maker. She is a wonderfully cranky 43 year old.

Rogers, Kate ("The Reign of Ice")
Kate Rogers is originally from Toronto but has lived and worked in Asia for the past three years. Currently, she is teaching English as a Second Language and Academic Writing in the new associate degree program at the University of Hong Kong. Kate's poetry, reviews, and interviews have appeared in a range of Canadian and British periodicals including the *New Quarterly, Canadian Woman Studies, CV2,* and *Orbis International.*

Russell, Sharon ("Day Cares")
Sharon Russell is a mother of twins living in Port Moody, B.C. She returned to the post-secondary education system to make a career change shortly after the birth of her children. Currently, she works from home as a freelance technical writer and takes full advantage of her flexible work schedule to balance career and family.

Schnitzer, Deborah (Editor; "Tenure Tracks")
*A Story:* I've written about interarts possibilities in *The Pictorial In Modernist Fiction*, made poetry in *Black Beyond Blue*, contributed to collections like *The Pictorial in American Fiction, Dropped Threads, Children of the Shoah* and co-edited the anthology *Uncommon Wealth: An Anthology of Poetry in English.*
*B Story:* In building this collection and in working to discover educational forms open in heart and mind, I am reminded of the intense, faceted and moving experience that lives in what writer, musician and advocate Carolyn McDade calls "the shape of justice."
*C Story:* deborah schnitzer, associate professor in English literature, under the usual guise of sublimating her need for approval, told a colleague one step ahead on the escalator how smart this he/she colleague was. The colleague had been telling deborah about a fine book project that he/she was engaged in as part of his/her promising research agenda. Having deferred to the smartness of said colleague, deborah named herself an intuitive rather than a smart, whereupon the one step ahead and upward bound he/she turned back, like Orpheus, noting: "One must use what one can." Always Eurydice bitten by the academic, deborah grabbed the I-am-smarter-than-you-are shin of her colleague and threw herself down the up escalator. They tumbled, lost their bearing entirely and disappeared in that ever so small slit at the base of the escalator whose vaginal teeth devour and deliver, one rung after another, night after day.

Shaw-MacKinnon, Margaret ("Portrait")
Margaret Shaw-MacKinnon is a writer and mother living in Winnipeg, Canada. She writes for children, young adults, and adults. She has a background in both visual and literary art, a BFA, and an MA in English. Her literary fairy tale *Tiktala*, illustrated by Lazio Gal, was published by Stoddart in Toronto and Holiday House in New York. *Tiktala* was awarded the Parent's Choice honour in the U.S., is on the list of Notable Children's Books in the area of social studies, and won the 1997 McNally Robinson Books for Young People Award. She wrote twenty one-page stories for the National Film Board's (Montreal) youth website on the Internet. In 2001, her essay, "Birth, Death, and the Eleusinian Mysteries," was published in *Dropped Threads*, an anthology of women's writing edited by Carol Shields and Marjorie Anderson, and she was commissioned by Parks Canada to write a reader's theatre for children, titled, "Beaver and Crow and the Circle of Truths: a Journey into Manitoba's History." She is currently working on a series of short stories.

Smallwood, Carolynn ("Spunk")
Carolynn Smallwood holds a BA (Honours) from the University of Winnipeg (1992) and an MA in literature from the University of Victoria (1996). She works full-time as a bookseller in Winnipeg and occasionally as a university marker and researcher. She is currently doing research for her own writing project and volunteers on the board of the literary journal *CV2.*

Srivastava, Aruna ("Dancing on the Lines")
Aruna Srivastava teaches at the University of Calgary in the department of English. Her research interests are critical, feminist, and anti-racist pedagogies; critical race theory; institutional critique; diasporic literatures; and post-colonial studies. She is active in community anti-racism work.

Stone, Kay ("Climbing the Walls of Academe")
Kay Stone is a folklorist and a professional storyteller who taught in the English department at the University of Winnipeg until her retirement in 1999. She has written extensively on folktales, women in traditional tales, and storytelling as a performing art. Her book on storytelling, *Burning Brightly: New Light on Old Tales Told Today*, was published in 1998.

Sulliman, C. Celeste ["(M)othering in the Academy"]
Celeste Sulliman is a doctoral candidate (University of Calgary) and an assistant professor in communication at the University College of Cape Breton. Her doctoral dissertation focuses on the multiple voices of mothers in the academy. She lives with her husband, Paule Marshe, her sons, Matthew and Bryan, and her "furry kids," Soldier and Jenny Mae.

van Herk, Aritha ("A Guide to Academic Sainthood")
Aritha van Herk writes fiction, non-fiction, prose, and furious fractions. She has most recently published *Restlessness*, a novel, and a historical exploration called *Mavericks: an Incorrigible History of Alberta*. She teaches Canadian literature and creative writing in the department of English at the University of Calgary, and she exercises her Madwoman readings and writings in many other sites.

Warne, Randi R. ("Terminus")
After spending three years rebuilding a women's studies program in Oshkosh, Wisconsin, Randi Warne returned to Canada. She is currently President of the Canadian Society for the Study of Religion and professor in the newly configured Department of Philosophy/Religious Studies at Mount St. Vincent University in Halifax, Nova Scotia.